The Photographer's Guide to

LANDSCAPES

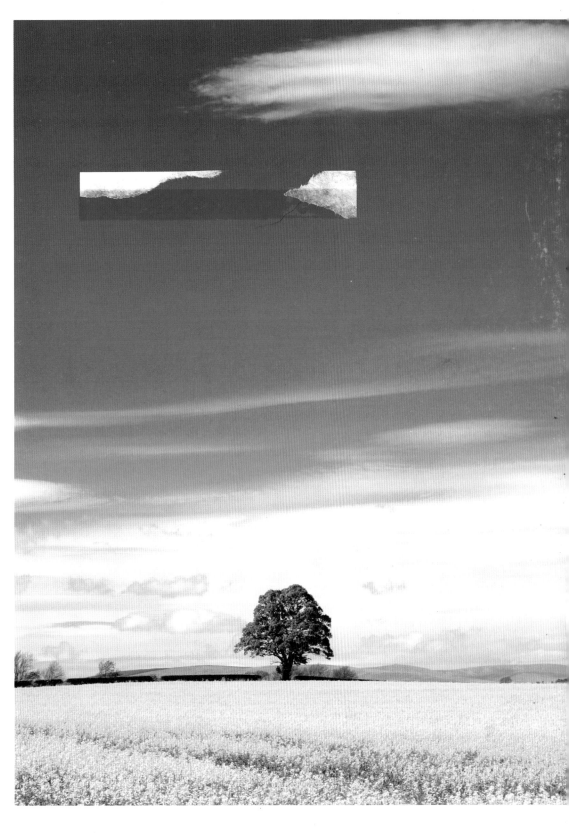

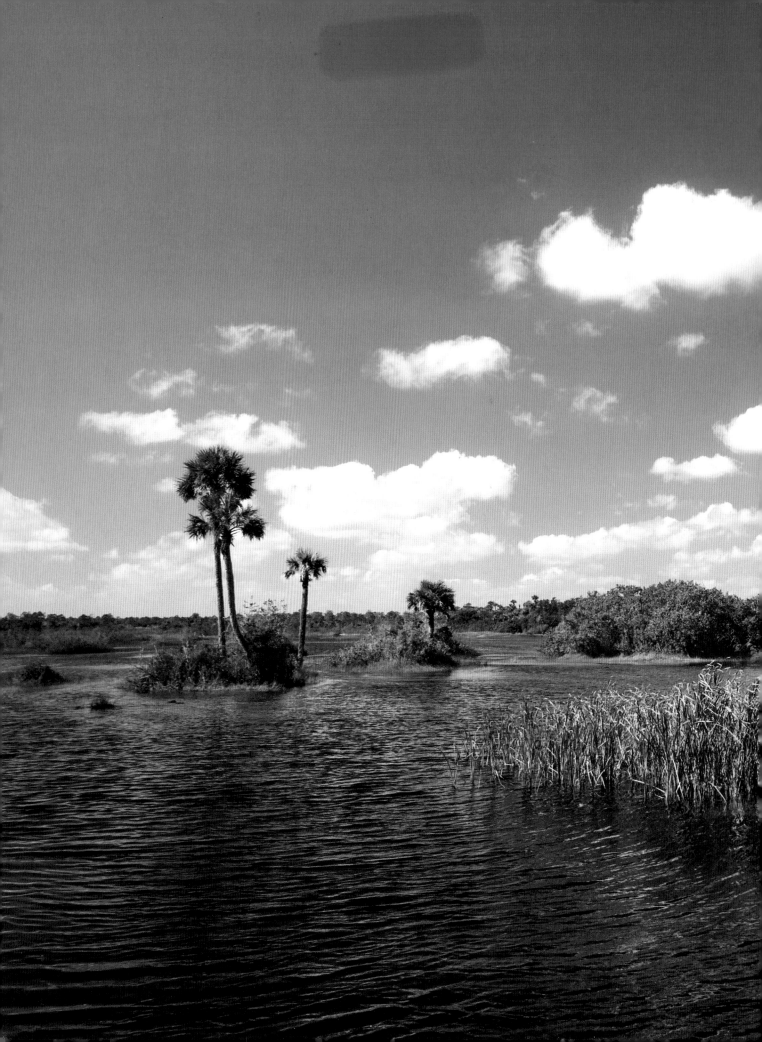

The Photographer's Guide to

LANDSCAPES

John Freeman

COLLINS & BROWN

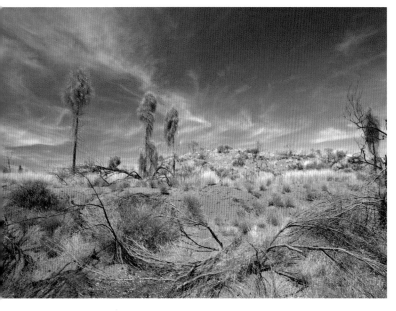

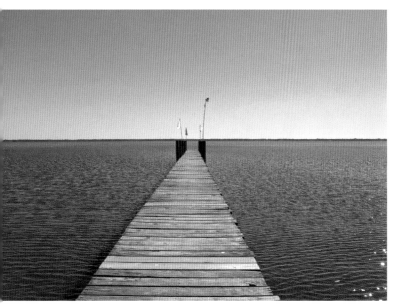

For my sister, Chris

First published in Great Britain in 2005 by
Collins & Brown Limited

An imprint of Chrysalis Books Group plc

The Chrysalis Building
Bramley Road
London W10 6SP

Distributed in the United States and Canada by
Sterling Publishing Co., 387 Park Avenue South,
New York, NY 10016, USA

1 3 5 7 9 8 6 4 2

British Library Cataloguing-in-Publication Data:
A catalogue record for this book is available from the British
Library.

ISBN 1 84340 176 2

Commissioning Editor: Chris Stone
Copy Editor: Ian Kearey
Proofreader: Andy Nicolson
Design: Grade Design Consultants
Digitial Systems Operator: Alex Dow
Jacket Design: Jason Godfrey
Reprographics by Mission Productions Ltd, Hong Kong
Printed and bound by Kyodo Printing Co Pte Ltd, Singapore

Contents

Introduction

Of all the subjects that we photograph, landscapes have to be one of the most popular and enduring. Whether it is a shot from a faraway country that we have visited on holiday or an area closer to home, which we might otherwise take for granted, a well-exposed, beautifully composed photograph of a landscape view gives both photographer and viewer a great deal of pleasure.

And of course landscape photographs can be more than just a grand vista – they can be an isolated tree, a small area of arid desert or rock strata on a cliff face.

For centuries painters have been recording the earth's physical beauty in paintings, and photographers took up the challenge as soon as the medium was invented. Today there is a new challenge with digital photography. For many this is a medium not to be trusted. However, as the technology improves – which it is doing at breakneck speed – many photographers have embraced digital as the new era of photography, and for many it has provided a renaissance in their work and the way they go about it.

Results that far outclass the prints in the old wet darkrooms, with all the harmful and polluting chemicals that are inherent in the process, are now achievable. It is a strange irony that those who want to hold on to the old methods, and who eulogize about the quality of a particular landscape bromide print, are using the very materials that destroy the environment they are looking at in that print!

Achieving really good landscape photographs can be a lonely experience that is not easily shared. For a start, the best light usually occurs very early in the morning, and depending on where you are in the world or the time of year, you may need to be up before the sun. Many of the shots in this book are a result of this determination to be in the right place at the right time.

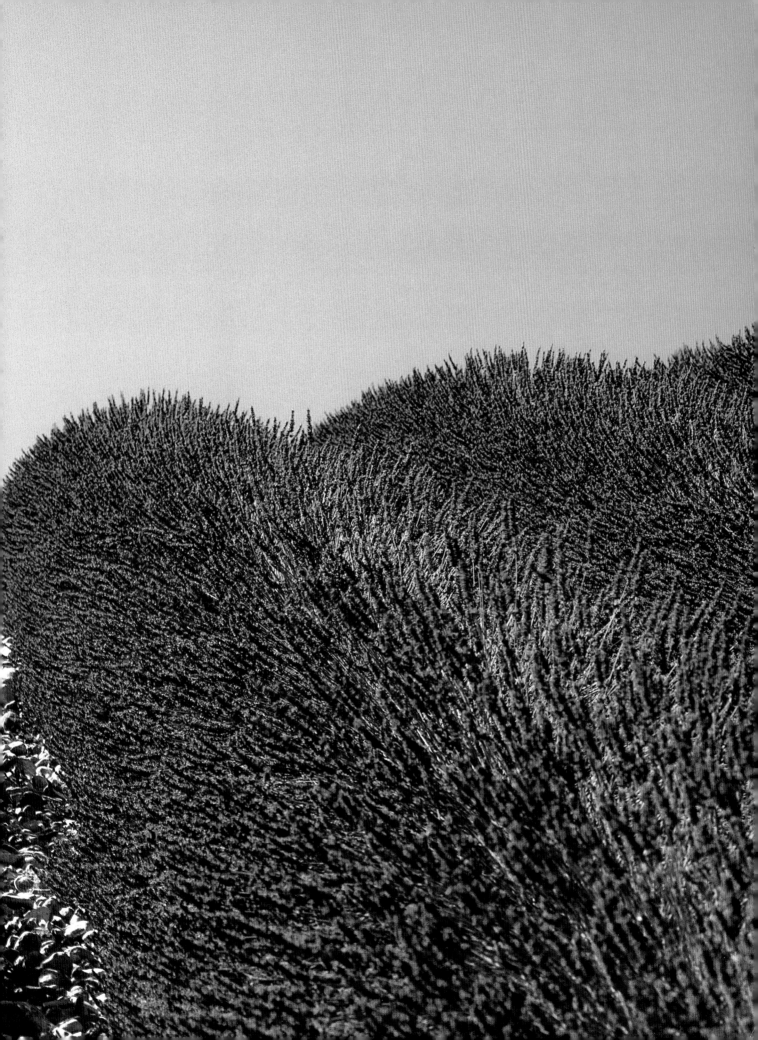

I remember once driving to Antelope Island, Salt Lake, Utah, USA. When I arrived it was still dark, and although I had only seen the area for the first time the night before, experience told me exactly where the sun would rise and what it would be shining on. Sure enough it was just as I had expected, and as the sun crept over the horizon, it hit the hills opposite, bathing them in a fantastic glow. They in turn were mirrored in the water they bordered, and the scene was one of the most spectacular dawns I had ever experienced.

However, something then happened that I have seen many times before at this time of the morning when photographing landscapes where water is involved: even before the sun was completely above the horizon, the water began to ripple and the mirror image all but disappeared, making the scene a shadow of its former self. If ever there was a lesson in being ready in plenty of time, this was it.

Of course there have been times when I have got up just as early, only to find the sun obscured by clouds. This happened quite recently in Australia, when I was trying to get a dawn shot. After five consecutive days of pre-dawn readiness I had to move on, and I never did get what would have been a wonderfully evocative photograph. This also illustrates the advantage you have, as a landscape photographer, if you are surrounded by stunning scenery: you can go to the best spots day after day until all the elements are right. Naturally enough they never will be, because there is always something different – no matter how subtle. This is what makes landscape photography so compelling and explains why a great photographer such as Ansel Adams could spend much of his life shooting landscapes in a specific area, Yosemite National Park.

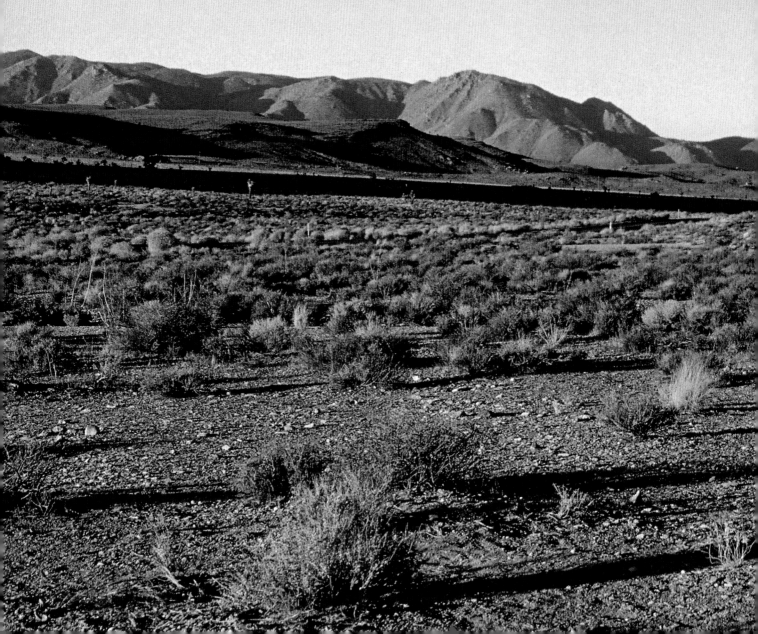

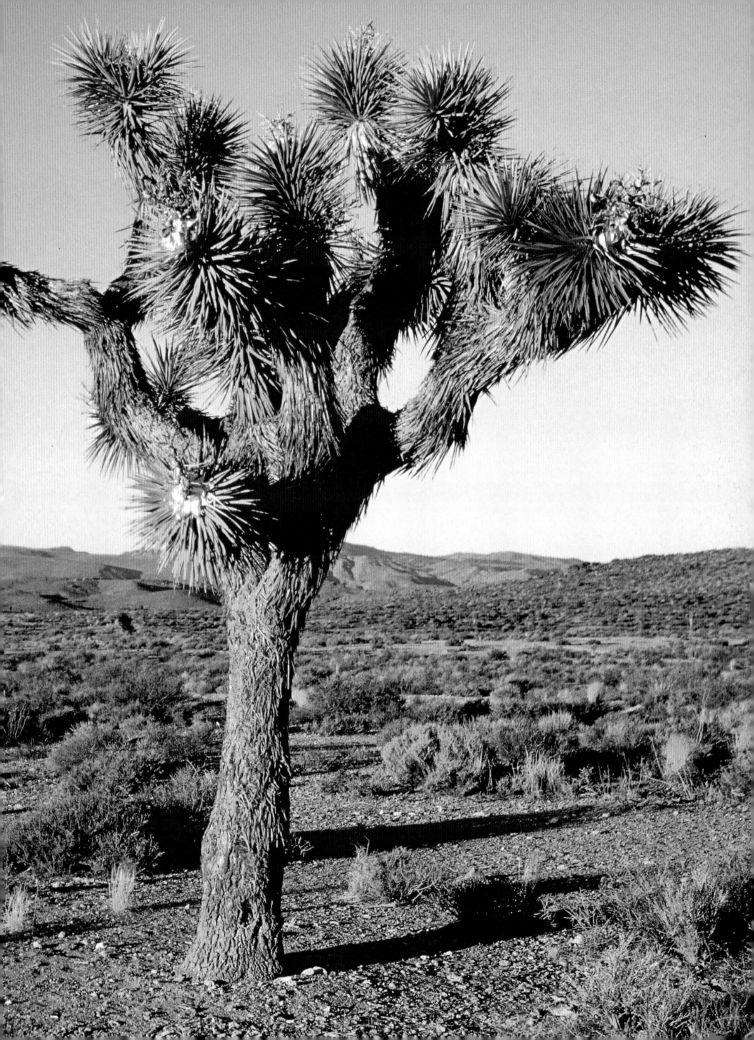

Observing your surroundings in this way can also teach you much more than just patience. It also shows you how light can alter the way we experience looking – even at what most people think of as ordinary or mundane things. Once you start seeing like this, nothing, in visual terms, can be straightforward ever again. If you get the bug – getting up early, driving or walking miles in the dark to be in a specific spot, waiting for a particular light or weather that might not materialize – in time you will be rewarded with spectacular results and the most stunning landscape photographs.

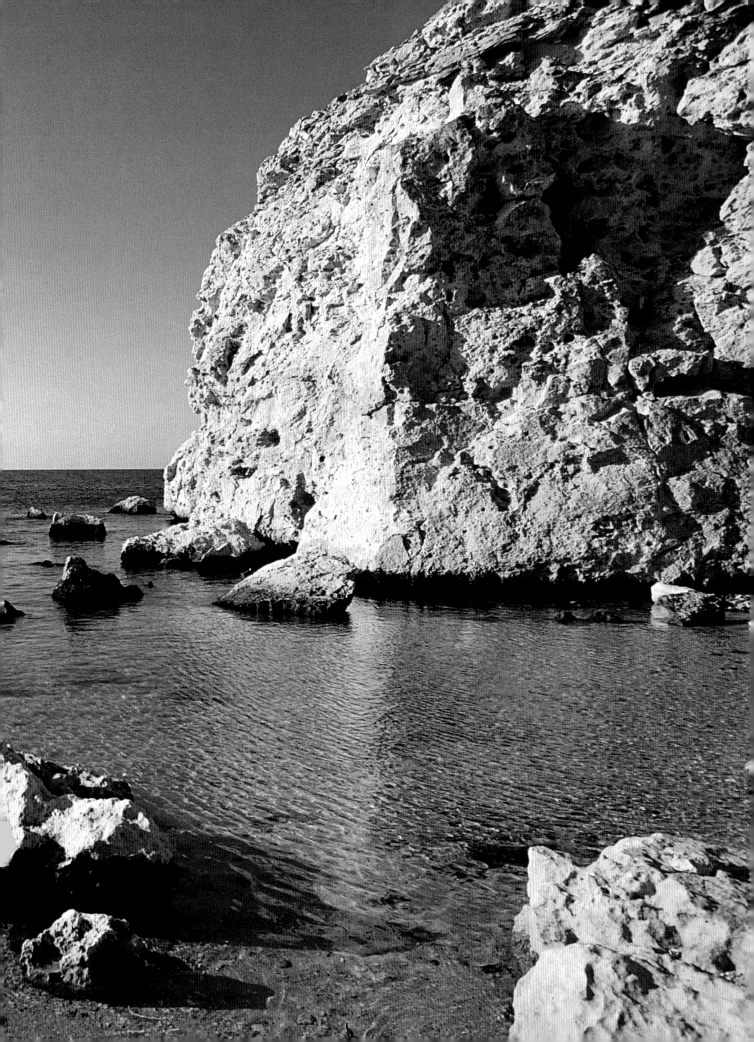

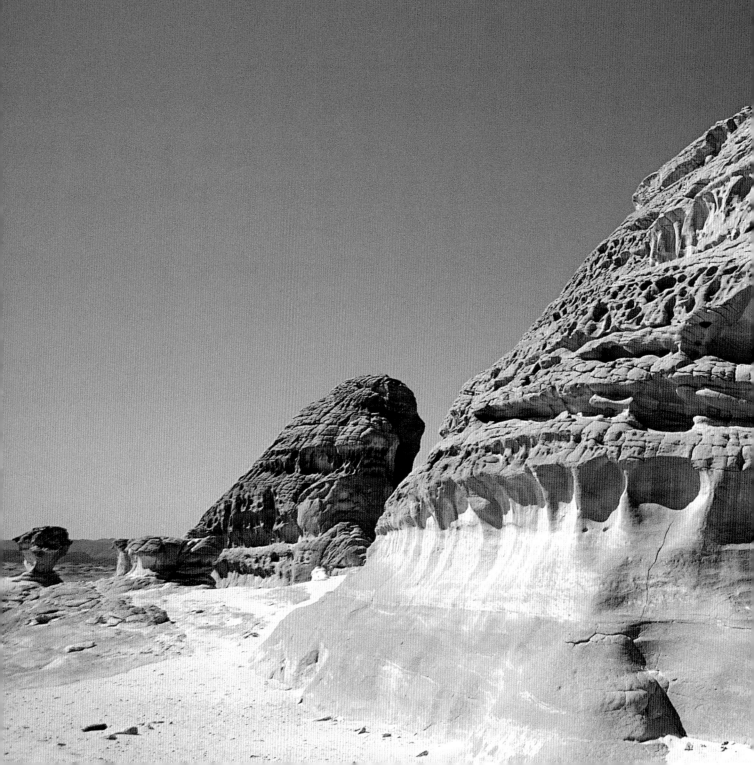

i The Essentials

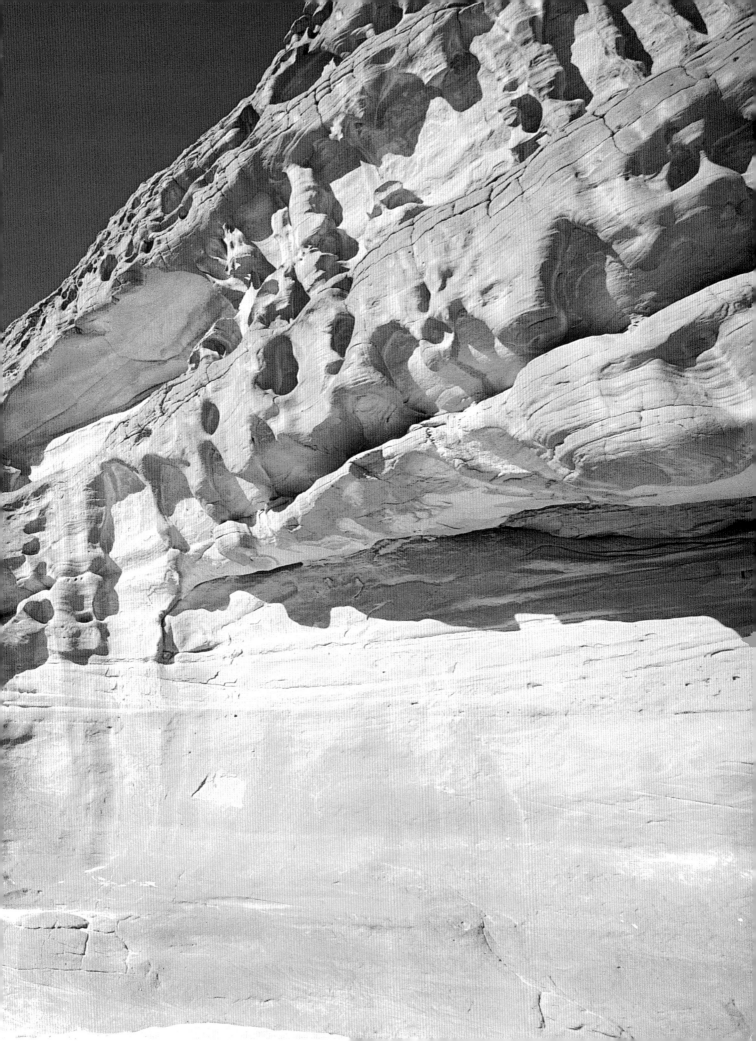

Basic Equipment

Despite the claims of some manufacturers, there is no single piece of photographic equipment that will do all things in all situations. Landscape photography is no different to any other discipline, and while some cameras might give competent, even spectacular results in certain situations, in others the results might border on the mediocre.

The camera that has proven to be the most versatile is the single lens reflex (SLR) camera. When you buy such a camera, you are really buying a body on which other elements are fitted. These can be lenses, filters, extension tubes and, in the case of medium-format SLRs, different film backs or high-end digital backs. 35mm digital SLRs are growing in popularity, and at the top end of the market full-frame models are becoming more easily available.

The great thing about using digital cameras is being able to see the result of your shot on the camera's LCD. This means that you can perfect the composition and viewpoint, and examine the histogram to ascertain that it is correctly exposed, so that every shot can be as you want it to be. As opposed to traditional film cameras, which require you to carry around a lot of bulky film and maybe a Polaroid as well, digital cameras are very compact, as you only have to carry memory cards in addition to the camera kit itself.

You also need to decide which lenses are the most useful for landscape photography. A good starting point will be the purchase of three different zoom lenses, which should cover most landscape situations: 17–35mm, 24–70mm and 70–200mm. The better the quality, the better the results will be. If you can afford it, purchase zoom lenses where the widest aperture is constant throughout its range, such as f2.8. Many cheaper lenses have variable apertures such as f3.5 when set at 70mm, and f5.6 when the lens is adjusted to 200mm – this means there is a loss of speed, which could be crucial when the light is low, as a slower shutter speed is then necessary.

If you are really enthusiastic about landscape photography, you might want to consider a panoramic camera

1. Medium-format SLR camera
2. Panoramic camera
3. Digital SLR camera
4. 24–70mm zoom lens
5. 70–200mm zoom lens
6. 16–35mm zoom lens
7. Extension rings
8. 2X lens conventer

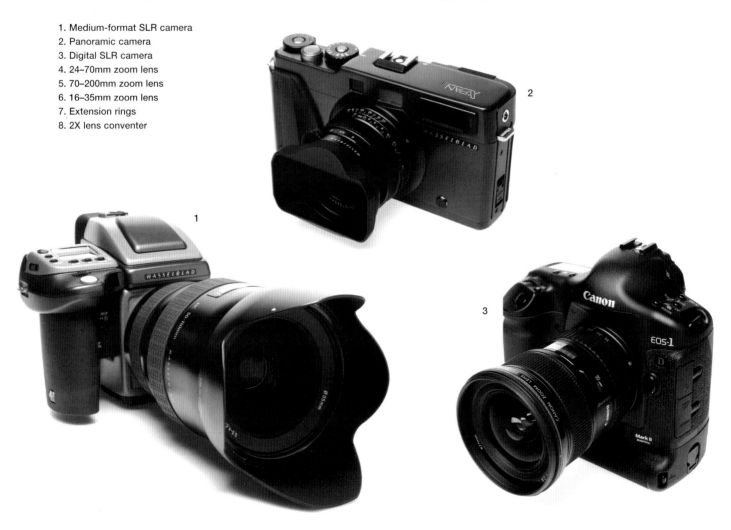

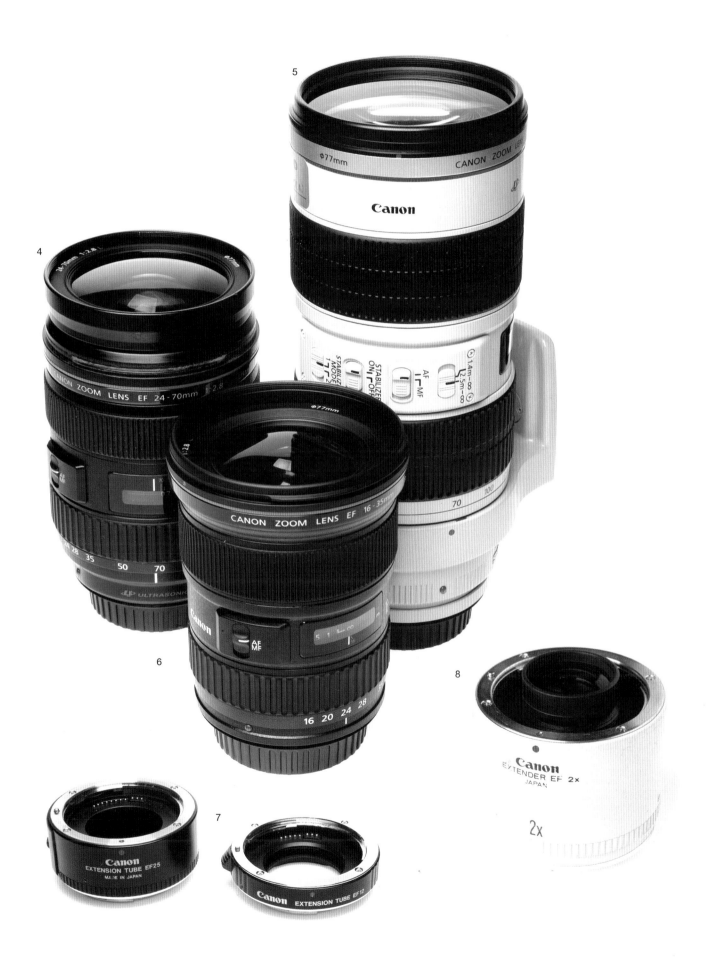



Basic Equipment Continued

(see pages 126–129). Such cameras are relatively expensive and have certain limitations but many of the world's top landscape photographers favour them, and their results are breathtaking. Some photographers still use large-format cameras for landscape photography, but their bulk and weight mean that only the most diehard enthusiasts use them now.

There are a few other key pieces of kit that you should not be without. One is a good light meter, which is essential for getting accurate light readings. With a light meter you can take incident light readings, where you read the light falling on your subject, as opposed to the light reflected from it, which is how built-in meters operate.

Another very useful accessory is a set of filters. These might be a couple of neutral density graduated filters of different densities, which help to retain detail in skies while keeping the foreground correctly exposed. Another filter that enhances skies in landscape photography and improves the quality of seawater is the polarizing filter; the circular type is essential if you use

ultra-wide-angle lenses a lot. These two filters types can be used for shooting both digitally and on colour film. When using black-and-white film, consider adding a yellow filter, which brings out the clarity of clouds against a blue sky; a red filter darkens a blue sky to give an almost night time appearance.

Give some thought to purchasing a 2x extender. With this your 200mm lens can act as a 400mm one, but will be a lot lighter to carry than a large, separate item. The only drawback is that you will lose 2 stops, so that a f2.8 lens will in effect become f5.6. A set of extension tubes, which enable you to get in really close to your subject, is another accessory that should not be overlooked.

A really good tripod is essential. Although this may appear to be a really bulky item, it is probably the most important item after the camera itself. With a tripod you can take rock-steady shots at very slow shutter speeds, get accurate horizontal images for building panoramas and precisely position graduated filters, among many more applications.

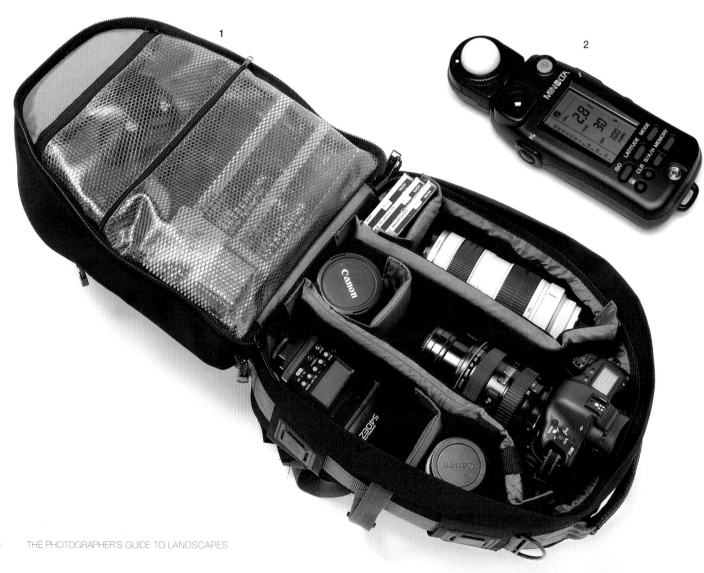

1

2

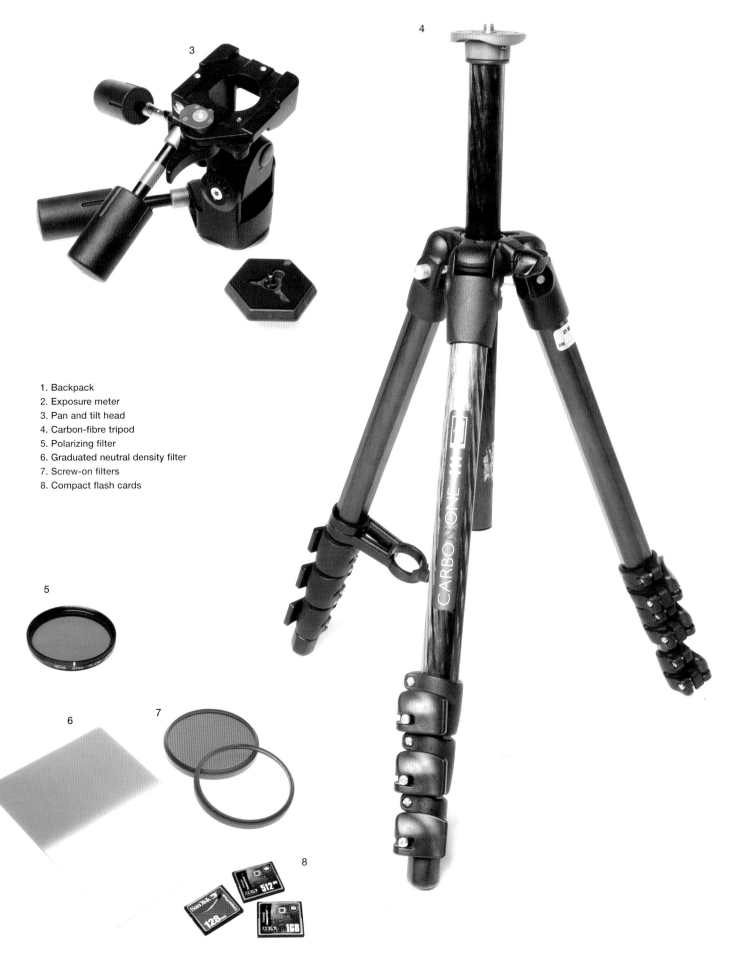

1. Backpack
2. Exposure meter
3. Pan and tilt head
4. Carbon-fibre tripod
5. Polarizing filter
6. Graduated neutral density filter
7. Screw-on filters
8. Compact flash cards

Normal Lenses

With 35mm cameras the normal lens, or standard lens as it is sometimes called, usually has a focal length within the range of 45–50mm.

When shooting with a 6 x 6 medium-format camera, the focal length of the normal lens is 80mm; with a 6 x 7 medium-format camera, the focal length of a normal lens is 90–110mm; and with a 5 x 4 large-format camera, the focal length is 150mm.

With digital cameras, the sensors that record the image are usually smaller than a full-frame 35mm film camera. This means that a 50mm normal lens used on a 35mm film camera is equivalent to a small telephoto lens when used on a standard digital camera, and what would be a wide-angle lens with a 35mm camera would be more like a normal lens when used with an average digital camera. However, as digital camera technology advances and sensors become more sensitive, a full-frame 35mm equivalent is likely to become more available in a greater range of models.

Because normal lenses have roughly the same angle of view as the human eye, they are excellent for capturing the scene in much the same way as when you first see a potential shot. This means that when shooting landscape pictures, you are not going to include a lot of unwanted detail, such as an uninteresting sky, as might be the case if you were using a wide-angle lens. On the other hand, if you were shooting with a telephoto lens, the reverse could be true and important detail, which could have been used as a compositional tool, could get cropped from the shot.

Using normal lenses is an excellent choice when studying and perfecting composition – because you do not have the greater depth of field of a wide-angle lens or the facility of "compressing" the picture, which can be the case with a telephoto lens, it is down to you to choose the correct viewpoint, frame the picture with precision, and select the appropriate aperture to give the desired depth of field. This exercise can help you see and shoot better pictures.

Above: Because normal lenses have roughly the same angle of view as the human eye – 40° – they are ideal for recording a view in virtually the same way as you first saw it. In average daylight conditions and with the camera set at 100 ISO, these lenses can give you excellent depth of field. This means that you can keep the foreground in focus as well as the background, as can be seen here. This is a great asset when you are trying to emphasize foreground interest.

Below and below right: The term "normal lens" refers to the focal length that is roughly equivalent to the angle of view of the human eye. This varies depending on the format you are using. For example, with 35mm cameras the focal length of the lens is within the range of 45–50mm, whereas when using a camera with a 6 x 6 format, it is 80mm. The sensors used by the majority of digital cameras have a smaller area than that of a full-frame 35mm camera, so a direct comparison cannot be made, as a 50mm focal length lens gives an image that appears to have been shot with a short telephoto lens.

Opposite: Another advantage that normal lenses have over wide-angle or telephoto lenses is that they are less likely to distort your photographs. For instance, when taking a shot like this with a wide-angle lens, the background can recede into the distance, making the image look as if it was being viewed through the wrong end of a telescope. On the other hand, a telephoto lens can give the appearance that the shot has been compressed, and the feeling of depth can thus be lost.

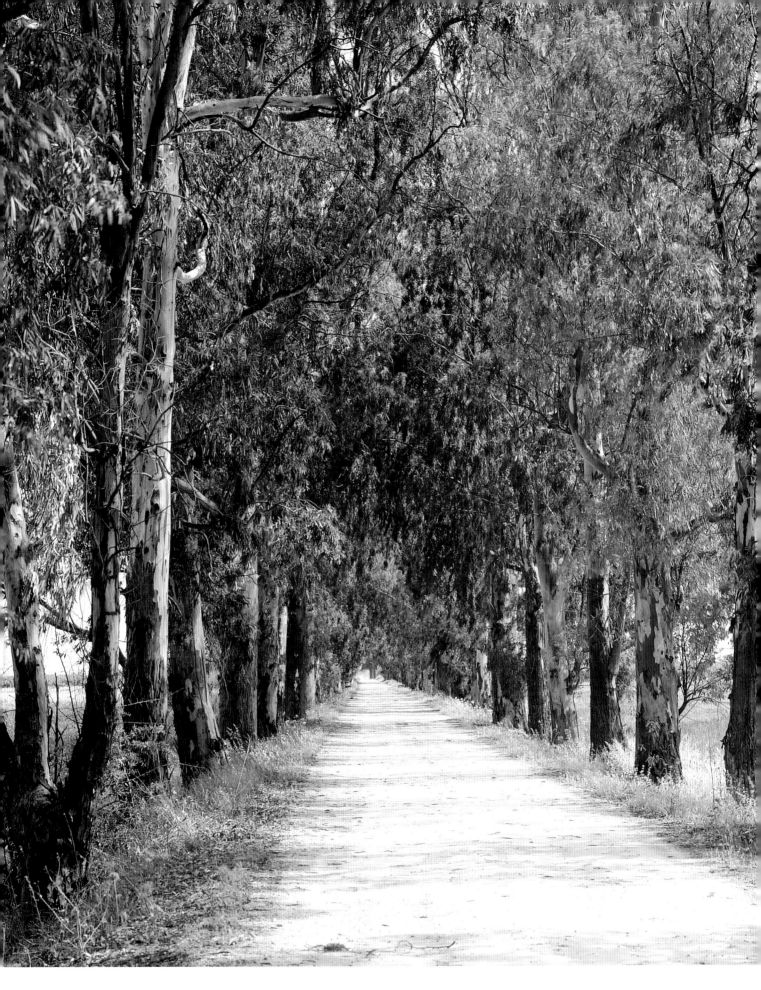

Wide-angle Lenses

Wide-angle lenses have a field of view greater than the human eye. They range from relatively modest lenses with a focal length of 35mm through to fish-eye lenses, which have an angle of view of 180°.

In addition to having a greater angle of view than normal or telephoto lenses, wide-angle lenses also have a greater depth of field; this means that you can photograph objects that are extremely close to the lens while retaining the sharpness of detail in the background. In landscape photography this can be put to good effect by having some natural phenomenon, such as a plant or a rock formation in the foreground, which might fill as much as half the frame, while the rest of the picture stretches to the horizon and retains its sharpness. When composing this type of picture, it may be necessary to take a low viewpoint by either kneeling or lying on the ground – such a position can alter the impact of the final shot dramatically.

The most important point to remember when shooting with wide-angle lenses is not to let their ability to record a wide view diminish the main subject's importance. This is an easy mistake to make. Often, when looking at the final image, you can hardly distinguish the most important details because so much has been included in the shot: backgrounds can appear to get pushed further away, perspective can look stretched and foreground detail, especially people, can easily become distorted, so careful framing is essential.

Another point to consider with this type of lens is vignetting, where the corners of the final image are cut out and appear black. This occurs when accessories, such as a lens hood of the incorrect size, or filters, are doubled up and attached to the front of the lens. When shooting landscapes with an ultra-wide-angle lens, flare can easily ruin the shot, so it may be necessary to shade the lens with something other than a standard lens hood. When using a polarizing filter with ultra-wide-angle lenses to intensify blue skies, the effect can often be uneven, so careful selection of focal length and viewpoint is an important consideration.

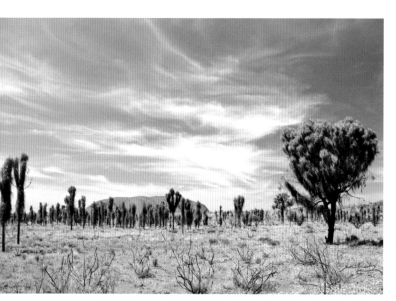

Below: Because the angle of view is so far greater than what we see with our own eyes, take care that the picture does not become distorted, particularly when the camera is not completely level. If the camera is pointed upwards, the subject can appear to taper towards the top (converging verticals). Wide-angle lenses can also give increased depth of field, for example when you want the foreground to dominate the picture. Because the depth of field is so great, even at wide apertures, the background can end up just as sharp and diminish the impact of the shot.

Opposite: Wide-angle lenses have several advantages over other lenses of different focal lengths. The main one is that they have a greater depth of field than normal or telephoto lenses, even when using wide apertures such as f2.8; this means that so much more of the picture can be kept in focus. This is excellent when creating foreground interest in landscape photography, as shown here, where a low viewpoint was chosen; the foreground grasses are as sharp as the hills in the background.

Above: With a wide-angle lens you can get more into the frame than with normal or telephoto lenses. However, this can cause problems, such as making the background appear to recede far too much into the distance so that important detail is lost. In this shot – taken with 24mm focal length – the trees frame the edges of the picture and give a good feeling of depth; the eye then focuses on Australia's Ayers Rock in the background. Had a wider angle lens been used, Ayers Rock would have faded so far into the background as to not be immediately visible.

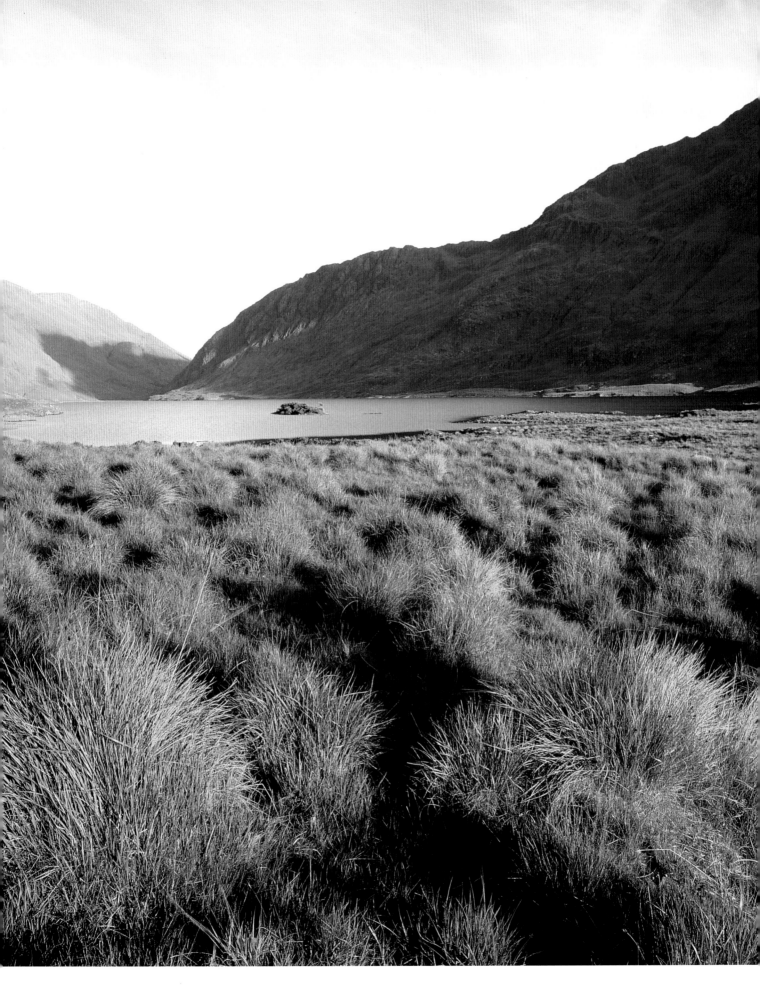

Telephoto Lenses

As opposed to wide-angle lenses, which include a lot of information, telephoto lenses can be used to cut out, or at least cut down on, the amount of the subject that gets included in the frame.

In addition to bringing distant objects closer, telephoto lenses are excellent for isolating detail. One of the ways that this can be done is to use the limited depth of field of these lenses, especially when using wide apertures such as f2.8. This puts the background out of focus, so that unwanted detail in that area becomes a blur of indistinguishable colour that can look very attractive.

An additional benefit of telephoto lenses is their ability to compress a picture. For example, imagine a shot of a road that has a line of trees or telegraph poles along it. When this scene is shot with a telephoto lens, the space between each tree or pole appears to be less than it actually is – the greater the focal length of the lens and the further it is from the camera, the greater the effect.

With this type of shot, you probably need to use a small aperture to obtain the greatest depth of field. This in turn may mean using a slow shutter speed, so keeping the camera steady can be a problem. If this is the case, a tripod, or at least a monopod, is essential. When using telephoto lenses, light has further to travel from the front of the lens to the film or the sensor in the camera than it does when using normal or wide-angle lenses; this necessitates an increase in exposure, so again a tripod can prove invaluable.

Telephoto lenses can help with composition by allowing you to tightly frame your subject and crop out unwanted detail. In landscape photography, this enables you to get in close to a waterfall or fast-flowing river, for example, when it might be too dangerous to physically be that close.

One problem with ultra-telephoto lenses can be atmospheric haze. Although this is most apparent with man-made smog caused by traffic emissions, it can also occur in rural settings after a period of sustained heat and lack of rain.

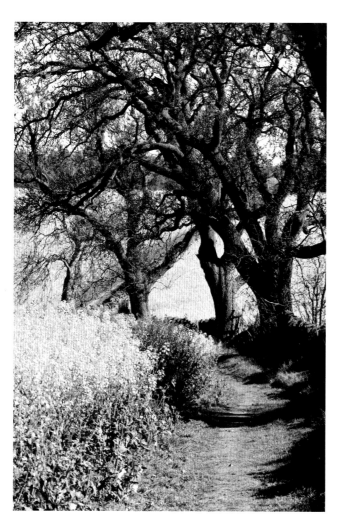

Left: This shot was taken with a 200mm telephoto lens on a full-frame digital camera. This gives the appearance that the detail in the shot has been slightly compressed, with the background brought forward, making for a tight composition, where the branches of the trees help disguise a featureless sky. The path leads the eye into the picture but then disappears, lending a feeling of mystery.

Below and right: In comparison to normal or wide-angle lenses, a telephoto lens has an extremely narrow field of view. On a full-frame 35mm camera, the angle of view is roughly 40° across the horizontal plane when using a 50mm lens. However, when using a 300mm lens, the angle of view is reduced to just 6.5° on the horizontal plane.

Opposite: The most obvious advantage of telephoto lenses is their ability to bring your subject closer without the need to move nearer. In some circumstances moving closer might not be practical, for instance, if your subject is surrounded by deep water, a ravine or swampy ground. Another asset is that you can isolate one aspect of the landscape and make it stand out from its surroundings, as is the case here, in this shot of grasses growing on a sand dune.

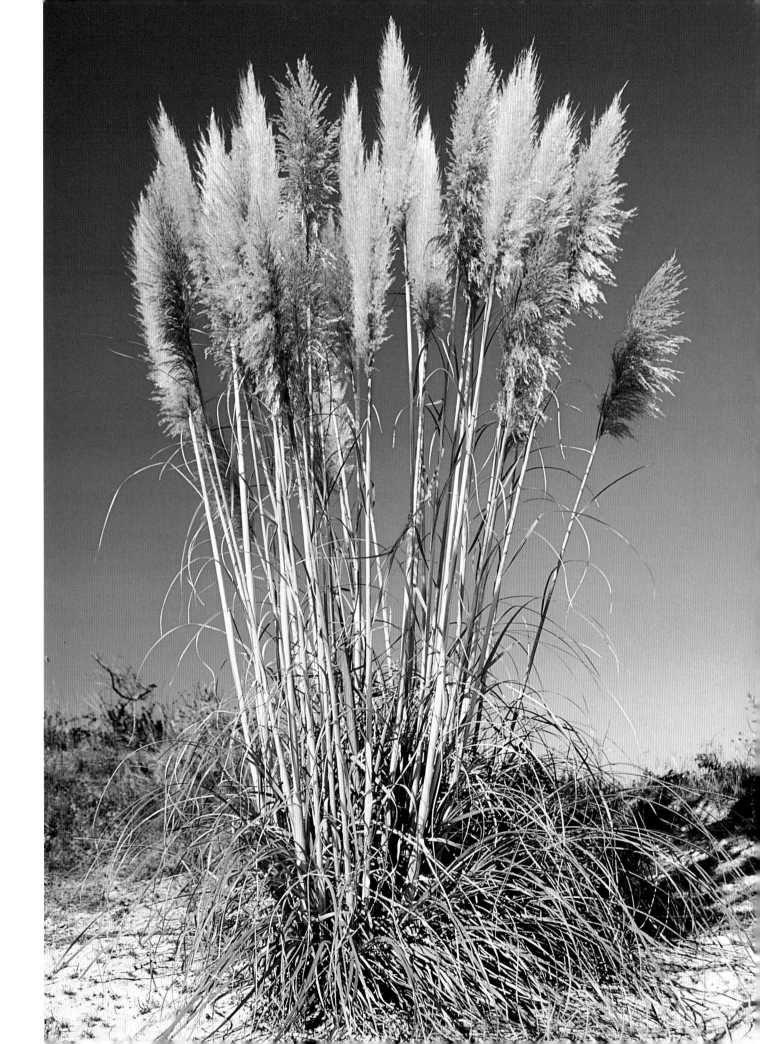

Understanding Depth of Field

Depth of field is the distance that is in sharp focus in front of and behind the point on which the camera's lens is focused: wide-angle lenses have the greatest depth of field, while ultra-telephoto lenses have the least. However, it is not just the length of the lens that determines depth of field; it is also the aperture with which the shot is taken.

Imagine that you are shooting a subject 10ft (3m) away. If you use a normal lens set to its maximum aperture, say f2.8, very little in front of or behind the subject is in focus. If you stop the lens down to, say, f8, the area of sharp focus increases and more of the foreground and a greater area of the background is in sharp focus. If an even smaller aperture, such as f22, is selected, a greater area in front of the subject is in focus, and perhaps all of the background. Understanding this correlation between aperture and depth of field is a vital step in composing and creating striking pictures.

The more you stop the lens down by using a smaller aperture, the more you have to increase the time of the exposure. For example, if an exposure of f8 at 1/125th second is correct, the shutter speed for an aperture of f22 is 1/15th second. At this speed it is essential to use a tripod or other means of support to keep the camera steady and eliminate camera shake.

When using wide-angle lenses, the depth of field is greater at all apertures than with a standard lens. Using an aperture of f8 with a 28mm wide-angle lens results in more of the shot being in sharp focus than using the same aperture with a normal lens. This means that you can place a subject close to the lens and still keep the background in focus.

On SLR cameras you can see how much depth of field is possible by pressing the preview button. This closes the lens down to the chosen aperture so that the total area of sharp focus is visible in the viewfinder. Many cameras with built-in metering systems use a variety of methods to read the light and set the exposure. One of these, aperture priority, enables you to select the aperture, and the camera then selects the speed.

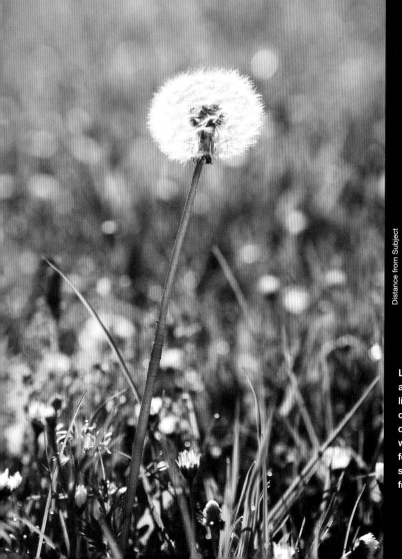

Area of sharp focus

Aperture of f2.8 Aperture of f8 Aperture of f22

Distance from Subject

1
2
3
4
5
6
7
8
9
10
11
12
13
14
15
∞

Left: Adjusting the aperture is about more than just letting in light. By choosing your aperture carefully, you can control the depth of field. Here, by using a wide aperture the area of sharp focus has been kept to a minimum so that the dandelion stands out from the blurred background.

Above: This illustration shows the scale of sharp focus when the aperture is adjusted: at its widest very little of the picture is sharp, whereas the smaller the aperture, the greater the area of sharp focus. This is shown in the series opposite, where the area of sharp focus can be seen clearly.

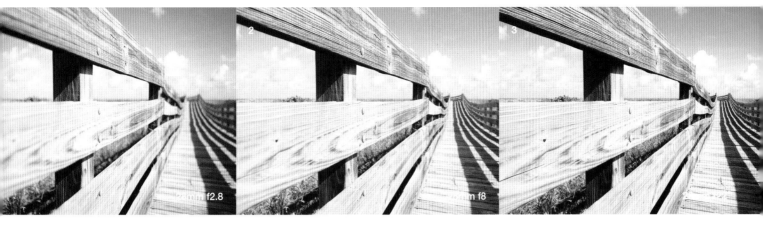

Above: In (1) a 28mm wide-angle lens was used with an aperture of f2.8. A great deal of the picture is in focus, with only a slight fall-off in the very front and in the far distance. When the lens is stopped down to f8 (2), more of the picture is in focus, or sharper. When the lens is stopped down to f22 (3), all the background and virtually all of the foreground are in focus.

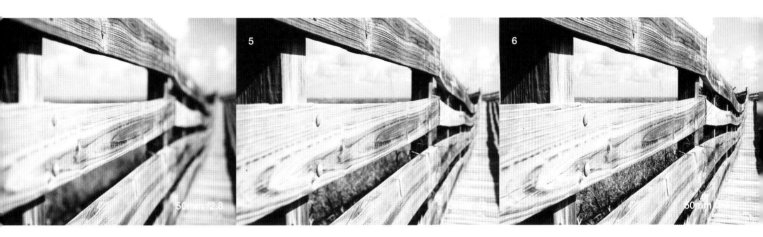

Above: When the lens is changed to a 50mm standard lens and an aperture of f2.8 is used (4), it can be seen that far less of the picture is sharp than with the equivalent aperture used in (1). As the lens is progressively stopped down, first to f8 (5) and then to f22 (6), more of the picture becomes sharp but still does not compare to the sharpness of the wide-angle lens.

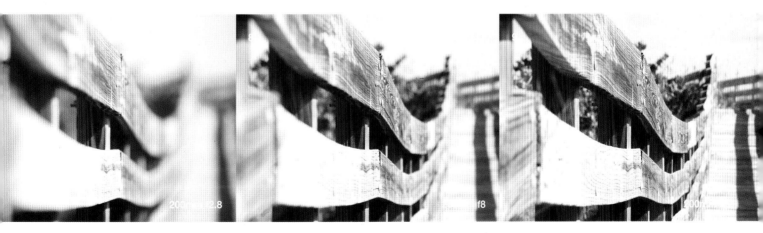

Above: When the lens is changed to a telephoto lens such as a 200mm, using an aperture of f2.8, very little is sharp either side of the point that the lens was focused on (7). When stopped down to f8 (8), little more is in focus, and when the aperture is adjusted to f22 (9), only a small amount more in front of and behind the point of focus is sharp.

Understanding the Shutter

On many cameras, especially those at the cheaper end of the market, it is not possible to change the shutter speed. On more expensive models, however, especially SLR cameras, the ability to change the shutter speed can greatly enhance your ability to shoot effective landscape pictures.

On most cameras with this facility, the shutter ranges from about 1 second up to 1/1000th second; at the very top of the range, shutter speeds can range from 30 seconds up to 1/8000th second.

On the camera there may be another setting, B, which stands for "bulb". If you set the shutter dial to this, the shutter remains open for as long as the shutter release button is depressed. Very long exposures can thus be taken, although when shooting digitally, you need to be careful with any areas of bright light, as these could do permanent damage to the sensor.

There are many reasons why a camera with an adjustable shutter is desirable. Imagine you are photographing some flowers in the foreground of your landscape picture, or that you are isolating them so that they are the central focus of your shot. If it is a windy day and the flowers are blowing from side to side and you take your shot with a shutter speed of 1/60th second, the chances are that they will come out blurred. Although in certain situations this could look attractive, in others, where you might want to see the detail, the shot would be ruined. Using a shutter speed of 1/500th second or faster, you can "freeze" the flowers so that they are sharp and appear stationary. On the other hand, you might want to use a fast shutter speed so that you can use a wide aperture. This results in minimum depth of field, isolating the subject, say a single flower, on which you have focused the lens, from the background which is now out of focus.

If you are photographing a fast-flowing river and use a slow shutter speed such as 1/8th second, the water will come out blurred. However, this gives a greater sense of movement than if you used a fast shutter speed, but the camera should be supported on a tripod or some other means of rigid support.

Shutter Speeds

These three pictures below show the difference the choice of shutter speed makes. In (1) a speed of 1/500th second was chosen, and the oil-seed rape, which was blowing in the wind, has been virtually "frozen" and appears quite sharp. When a shutter speed of 1/125th second was chosen (2), the oil-seed rape is less sharp and there is a certain amount of movement. However, when the shutter speed was set at 1/30th second (3), the oil-seed rape is quite blurred and little of the movement is sharp.

Opposite: Sometimes it is better to use a slow shutter speed to give a deliberate feeling of movement in your photographs. In this picture of a fast-flowing river I used a shutter speed of 1/2 second, which has made the water quite blurred but gives a sense of motion. It was essential to have the camera mounted on a tripod to keep the other areas of the shot sharp. In cases like this, it is a good idea to have a neutral density filter handy in case you cannot stop down far enough for such a slow speed.

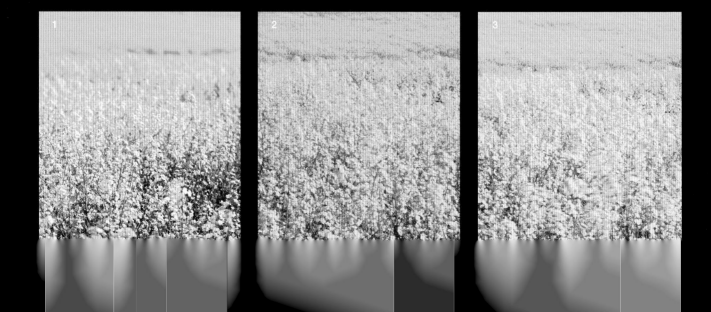

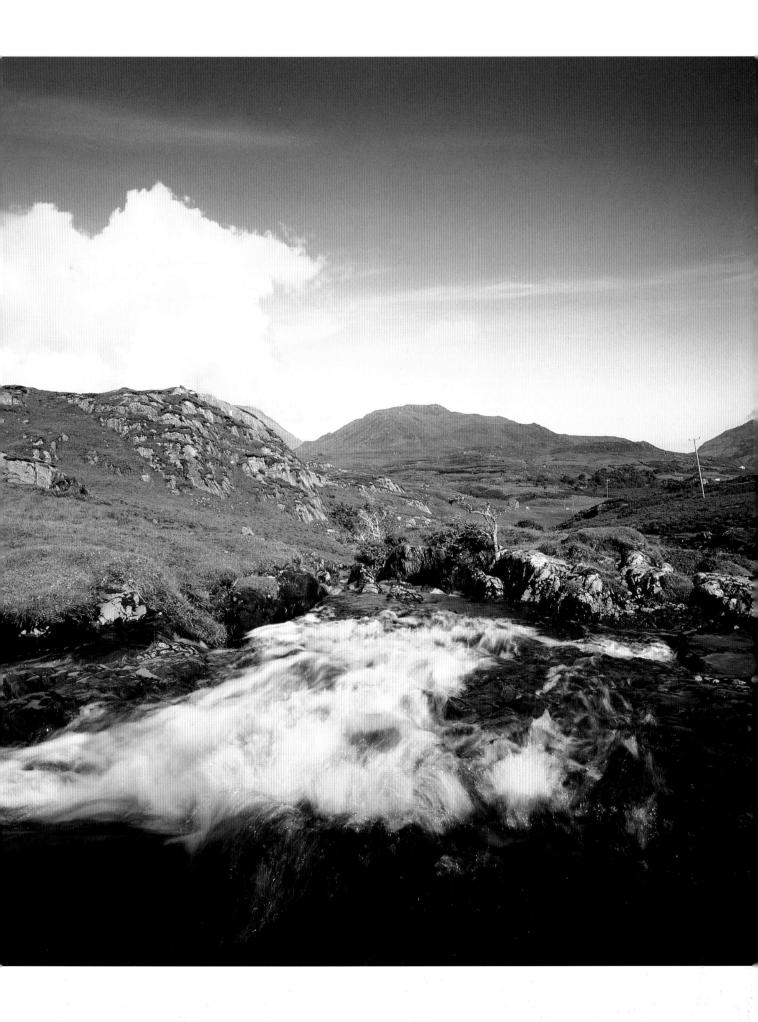

Understanding ISO

All film comes with an ISO rating. The acronym stands for International Standards Organization, and the system has superseded the old ratings, known as ASA (American Standards Association) or DIN (Deutsche Industrie Norm). ISO rating is also applicable to digital photography, and many of the models at the higher end of the range have a facility that enables you to adjust the ISO setting.

The ISO number on a film indicates its speed, and ranges from 12 ISO up beyond 3,200 ISO. The lower the number, the finer the grain; the higher the ISO number, the larger the grain. Films are often divided into three speed categories: slow, medium and fast – slow films range from 12 to 64 ISO, medium-speed films range from 100 to 200 ISO, and fast films start at 400 ISO. If you want to make large prints, say A3 or bigger, from your landscape pictures, you need to use a low ISO setting to minimise the grain, known as "noise" when shooting digitally. However, both grain and noise can be used creatively in some aspects of landscape photography.

Most 35mm and APS films are DX-coded. This is seen as a strip on the cassette, similar to a bar code. DX coding means that when the film is loaded into your camera, the camera's metering system reads the code and sets itself automatically to the correct ISO setting. It is possible to override this setting and rate the film at a higher speed than stated on the packet. You then need to "push-process" the film when you have it developed. The drawback with using fast film is that the size of the grain increases with the ISO number. In digital photography, noise can become unacceptable in the shadow areas of the image, together with a loss of image sharpness.

Most films manufactured today have very fine grain, even at the higher end of the ISO range; this is a pity, as many photographers think that the correct use of grain can add greatly to their photographs. One of the benefits of using a computer and a program such as Photoshop is that you can add noise for creative effect. This can be done to an image shot digitally, or to one that has been shot on film and then scanned.

Fine grain
When the chosen ISO is 100, photographs have a fine grain or noise (1), and even when the shot is enlarged (2) and the grain or noise increases and the sharpness begins to suffer, the result is still acceptable.

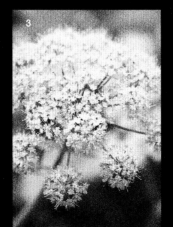
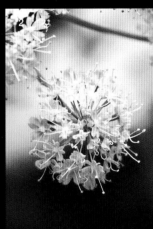

Coarse grain
With the ISO at 1250, the grain or noise increase dramatically and the overall sharpness of the shot begins to diminish (3). When the shot is enlarged (4) this becomes even more apparent, and in certain situations this would be unacceptable

Opposite: Grain can add a dimension to the image that makes it particularly attractive.

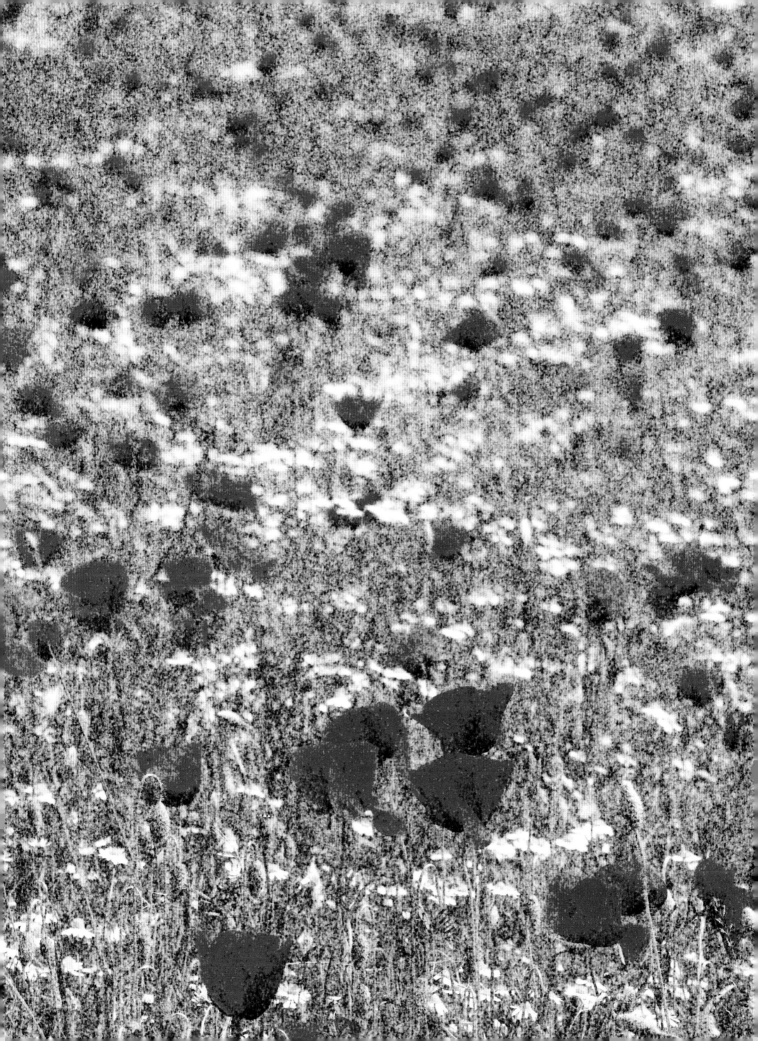

Understanding Exposure

Accurate exposure is essential in landscape photography. This might seem to be stating the obvious, but it is all too easy for "automatic" cameras to be fooled into under- or overexposing your shots.

If your shot has a large area of bright sky, the camera's meter may read for this and underexpose the foreground; on the other hand, if the camera's meter reads for the foreground, this may be at the expense of the sky, which can mean that all detail is lost and the clouds, which looked so billowing and dramatic and attracted you in the first place, get completely burnt out and all detail is lost. Other situations where the camera's metering system can have problems is with the sea or snow scenes, in both of which there may be vast areas of reflective surfaces.

Many cameras have centre-weighted metering systems. This means that the meter reads all the light being reflected from the total scene that you see in your viewfinder. However, this is biased towards the central part of the scene. Another exposure mode is where the camera uses the partial metering method.

This records a central area of the frame that is probably in the region of 8–10 per cent of the total frame.

Whichever of these methods you use, the one thing they all have in common is that they read the light being reflected off your subject. While this is acceptable in most shooting situations, a far more accurate method is incident light reading, in which the meter reads the light falling on the subject, not that reflected from it. To use this method, you need a separate handheld meter. Unlike the reflected light method, where you point the meter at the subject, the incident light method means that you point the meter at the light source. Most meters are quite compact, and offer both the incident light and the reflected light methods in a variety of different modes, such as spot metering.

With digital photography you have the advantage of seeing your shot on the LCD and being able to study the histogram. If the shot is incorrectly exposed, you can dump it and make adjustments to get the correct exposure.

Overexposure, normal exposure and underexposure

Right: The exposure data of a digital image is displayed as a histogram on the camera's LCD. The levels in (1) are bunched towards the upper end of the histogram, or to the right on the camera's LCD. This indicates that the brighter parts of the image are burning out and overexposing. In (2) the levels are spread through the histogram, showing an even distribution of tones. The levels bunched in the middle shows a good exposure for an average subject. In (3) the levels are bunched to the left and blocking in, showing underexposure.

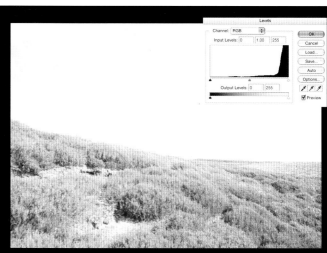

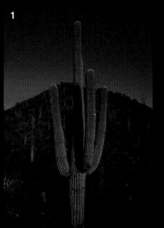
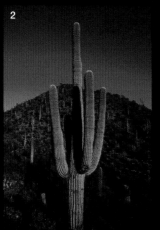
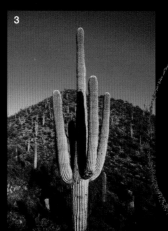
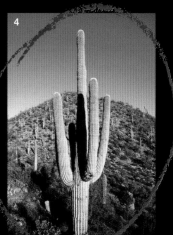

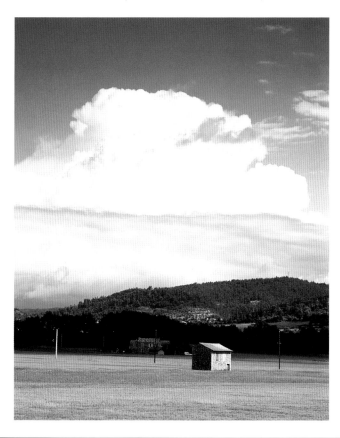

Above and left: It is often necessary to even up the exposure required for two different parts of the picture. In the shot above, the foreground is underexposed while the sky is correctly exposed. Using a graduated neutral density filter, shown left, more exposure can be given to the foreground while still retaining detail in the sky.

Overleaf: This shot has all the potential pitfalls associated with getting the right exposure, as the bright setting sun is shining directly on the rock form. I decided to expose for the rock at the expense of the foreground and the sky, dramatically enhancing the sky, and making the rock look even more monumental.

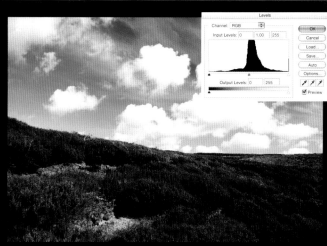

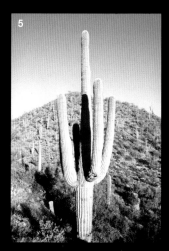

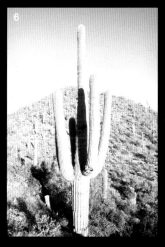

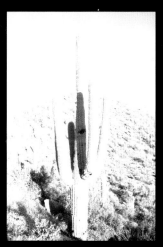

Left: In this series of pictures you can see the effect of bracketing the exposure. In (1) the shot is too dark and is underexposed. By gradually increasing the exposure, the shot becomes lighter, and the correct exposure can be seen in (4). Increasing the exposure further results in overexposure (7). Although an acceptable print might be possible with images 3 and 5 the others will result in a loss of detail.

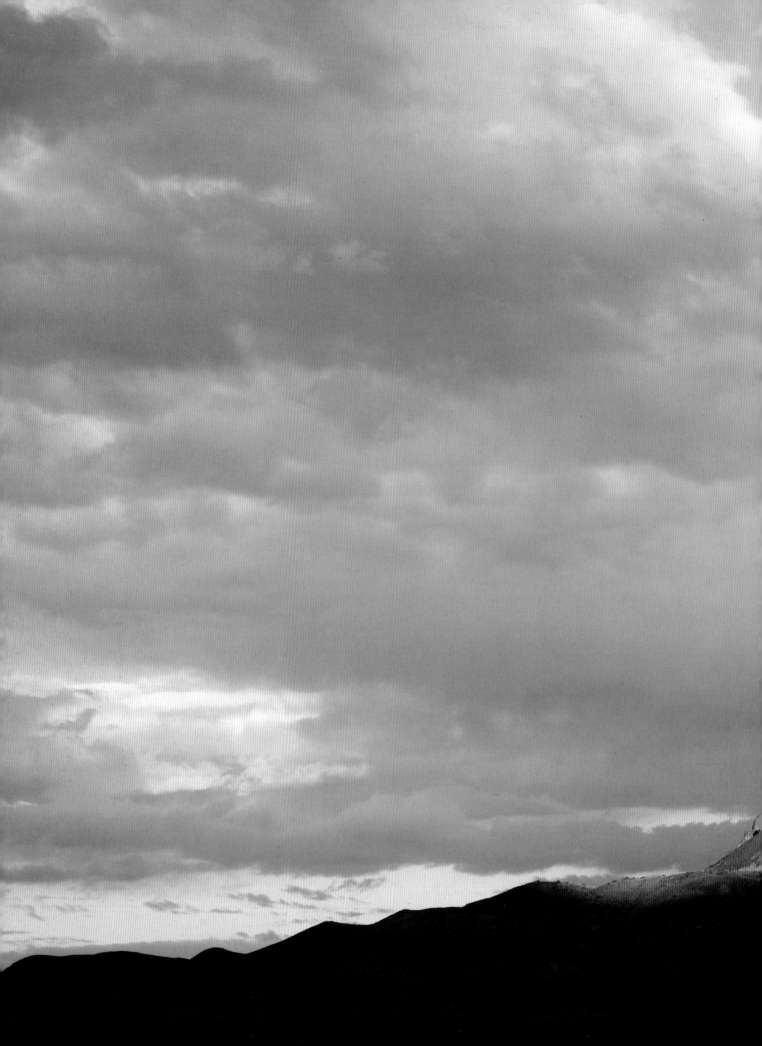

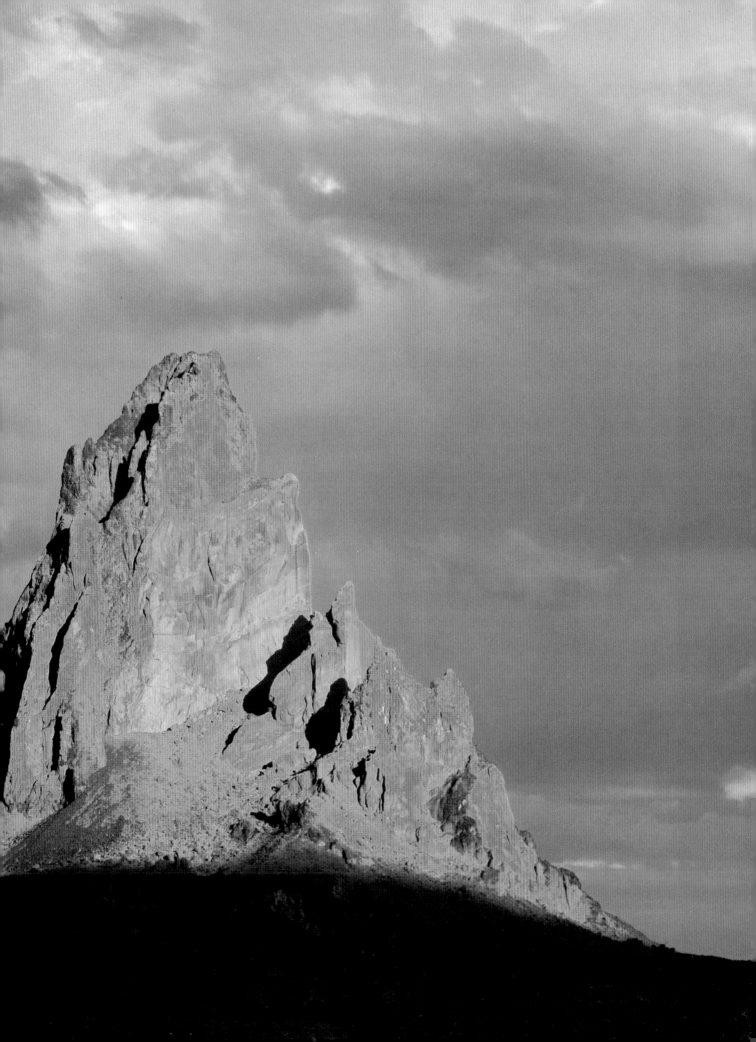

Basic Composition

Composition – or the lack of it – is probably the reason why so many pictures fail. Whether the final shot is a grand vista or a close-up of an area of detail, composition plays a crucial part in its success or failure.

The interesting aspect of composition is that, generally speaking, it doesn't require any additional equipment, so if anyone ever says to you, "But you have a much better camera than me", you will know that they did not take the time to really look at what was in front of them – what made them decide to take a shot in the first place.

The first compositional aspect to consider is whether the shot would look better if it were taken with the camera in either the landscape (horizontal) or portrait (vertical) mode; it is amazing how many people appear to only take their shots while holding the camera in the former position.

Once you have decided on your format, consider how the various ingredients that you want in your shot are distributed in the frame. There is a rule that artists have used for centuries, known as the "golden section" (also known as the rule of thirds). Using this, your subject should be placed at the intersection of imaginary lines drawn vertically and horizontally a third of the way along each side of your picture.

On some cameras it is possible to change the focusing screen to an alternative type, known as a grid screen. This is etched with lines that run horizontally and vertically so that when you look through the viewfinder it makes the positioning of your subject easier. Grid screens are an invaluable asset when it comes to composing multi-exposure shots, and of course the lines do not come out in your finished picture.

Filling the frame is also important. Many people fall into the trap of trying to get as much into their shots as possible, but when they then look at their finished images, the horizon can be so far away that it is impossible to see any detail. This usually goes hand in hand with large areas of uninteresting sky and great swathes of foreground that have no point of focus – certainly nothing that helps to draw the eye into the shot.

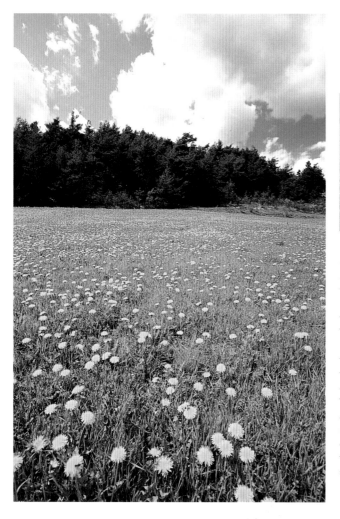

Left and above: The composition of your photographs can be altered significantly just by turning the camera from the horizontal, or landscape, position to a vertical, or portrait, position. These two pictures illustrate the point clearly. In the picture above the eye is drawn to the trees in the background, which on their own have little pictorial interest. The flowers have little presence, and the overall picture is very mundane. The picture on the left concentrates the eye on the wild flowers in the foreground that sweep away to the background.

Opposite: This shot of grazing sheep is a tight composition made possible by the use of a 200mm lens. In addition to cropping out unwanted detail, the lens has the effect of slightly compressing the picture, keeping the spaces between the sheep appearing to be less than they actually are. The ewe and her lamb in the foreground give a point of focus that enhances the overall composition.

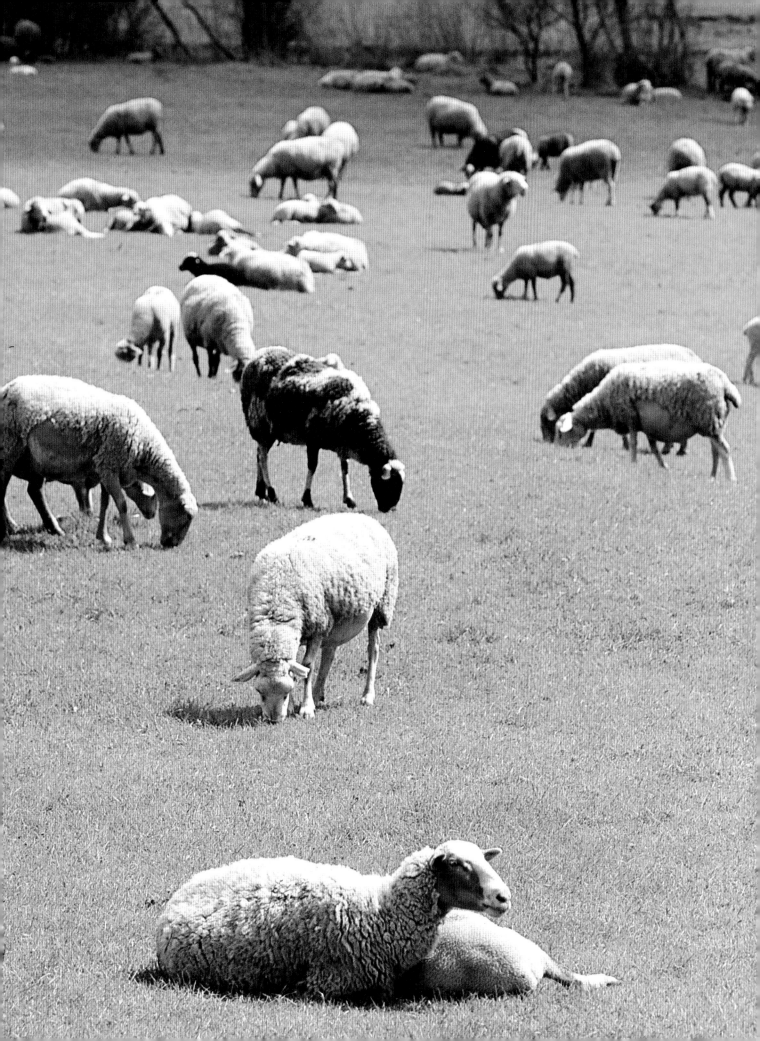

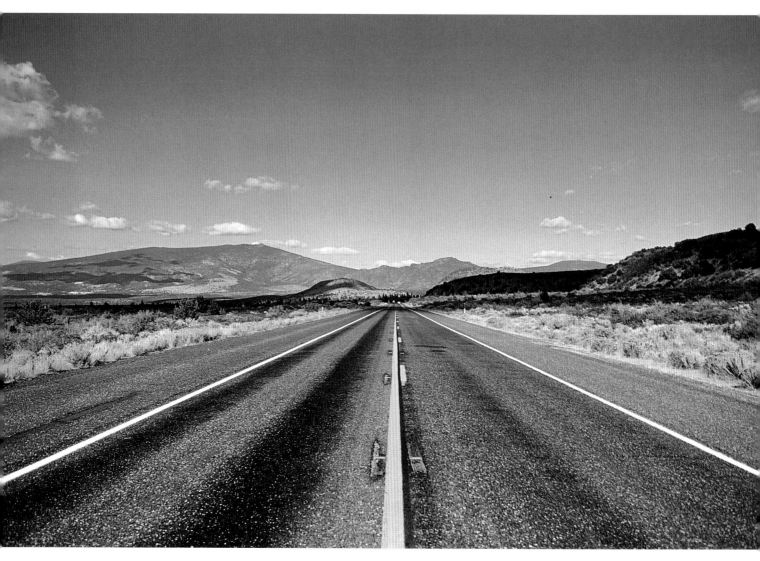

Above: A low viewpoint together with a 28mm wide angle lens gives a feeling of depth in this picture. The road adds a great sense of perspective and appears to go on forever, taking the viewer straight to the mountains in the background and adding a sense of curiosity as to what lies beyond. The deep blue of the sky gives a sense of light, and the overall composition conveys a great feeling of space.

Opposite: Many people think that it is bad compositionally to place your subject in the middle of the frame. However, all rules are there to be broken, and in this shot I deliberately placed the cactus in the centre of the shot, so that it takes on a very powerful and imposing presence within the composition. This is enhanced by the setting sun, bathing it in a warm glow, and the drama of the evening sky.

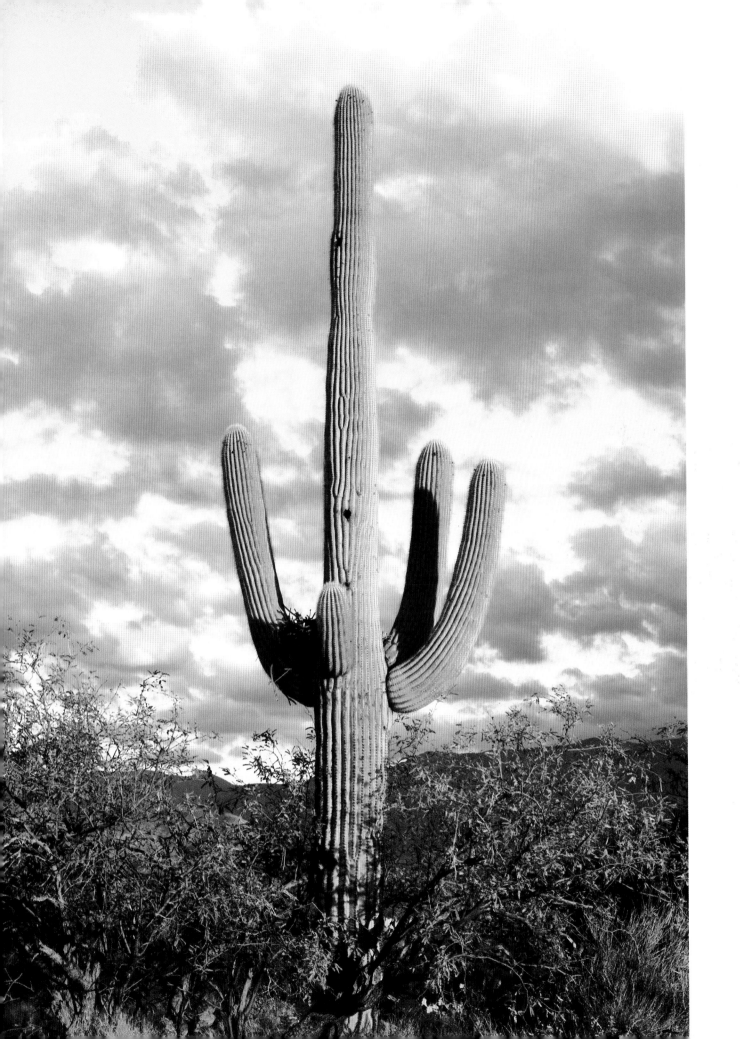

Creating Foreground Interest

When taking landscape photographs, one of the most important aspects is the attention given to the foreground. Seeing a great landscape view and transferring it onto film or the camera's sensor as the eye saw it needs a little more thought than just pointing the camera at the horizon.

What you place in the foreground of your photographs can frame the overall picture, or can be used as a device to draw the eye into the middle ground. On the other hand, if what you place in the foreground is badly positioned or cluttered, then it detracts from the overall composition and the eye is confused as to where the centre of interest is.

Many devices can be used in the foreground of landscape photographs, both to frame the picture and to hide unwanted details that could ruin the composition. For instance, in the case of a bland-looking, overcast sky without clouds or colour, you could use the trunk of a tree to act as a framing device on one side of the shot, with the branches framing the top – both would cover the bland sky and add interest to the overall shot. If you adjust the viewpoint and make it higher or lower, the branches can cover more or less of the sky until they are in just the right position.

If there are no trees, are there other devices that can be used to create foreground interest? These can be as simple as a farm gate or a weathered wall that you can use to run across the foreground of the shot. Colour and contrast can also be used to create foregrounds for landscapes – flowers add a welcome splash of colour to the foreground, especially in spring.

Other devices that can be used to good effect are rock formations, soil erosion or fallen trees. You can choose a low viewpoint and point the camera slightly downwards to make a real feature of details that lead the eye into the picture, particularly using a wide-angle lens with a small aperture, which results in maximum depth of field so that every detail of your shot is sharp. This type of angle can also be used to cut out dull skies or at least minimize their presence.

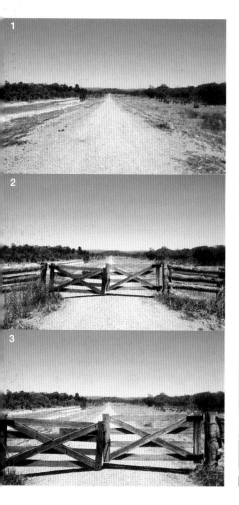

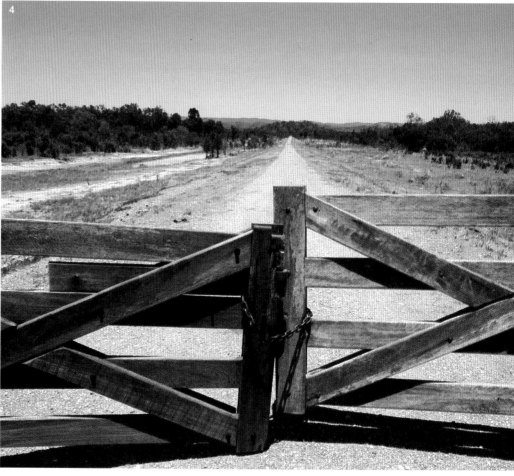

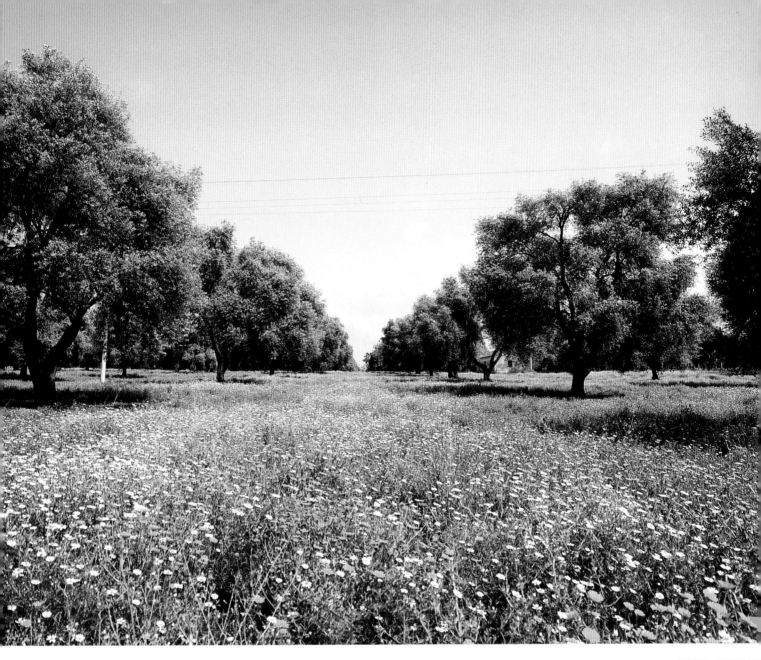

Opposite: Changing your viewpoint, even slightly, can radically alter the foreground interest. In (1) I took the shot from above the gate, cutting it out of the shot. This created a tedious view of a long country track. By moving backwards (2) I included the gate, but this obscures too much of the track. Even moving slightly forward (3) does not enhance the overall composition. In (4) I cropped out some of the gate and took a slightly higher viewpoint, creating just the right amount of foreground interest and tightening up the overall composition.

Above and right: This is another example of how careful choice of foreground interest can totally alter the feel of your shot. In the picture at right, the uninteresting earth and lack of wild flowers in the foreground do nothing to make the picture work. By contrast, walking just a short distance forward, as shown above, the uninteresting earth has been cropped out and the foreground is now filled with flowers, giving the orchard a true sense of late spring.

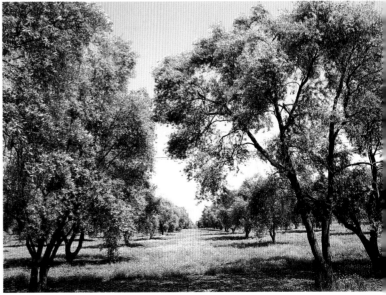

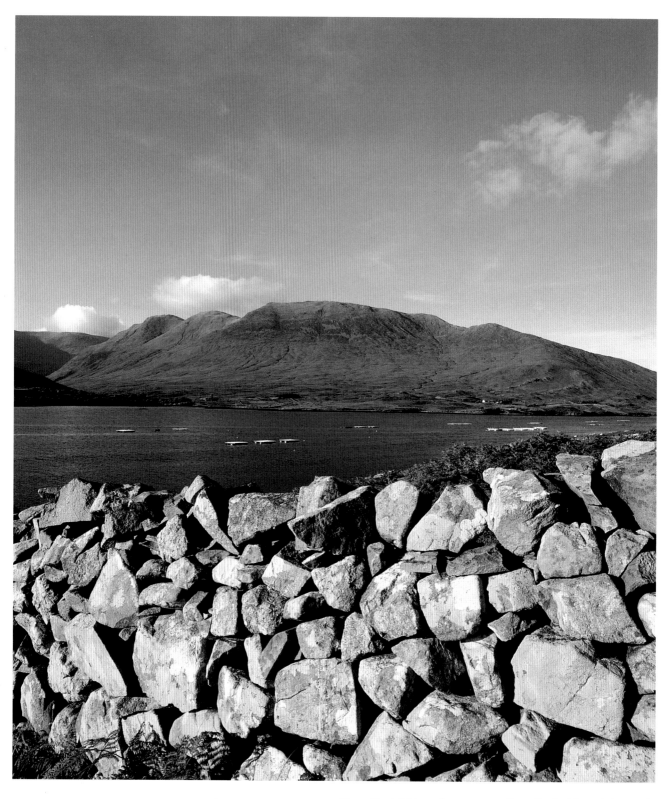

Above: The bright evening sun was shining directly on this dry stone wall, highlighting its construction. By placing it in the foreground and choosing the viewpoint carefully, I was able to obscure a great deal of uninteresting grassland.

Opposite: A wide-angle lens and a low viewpoint helped to make the dandelion the centre of foreground interest. To keep as much of the picture as sharp as possible, I stopped down to f22 and mounted the camera on a tripod.

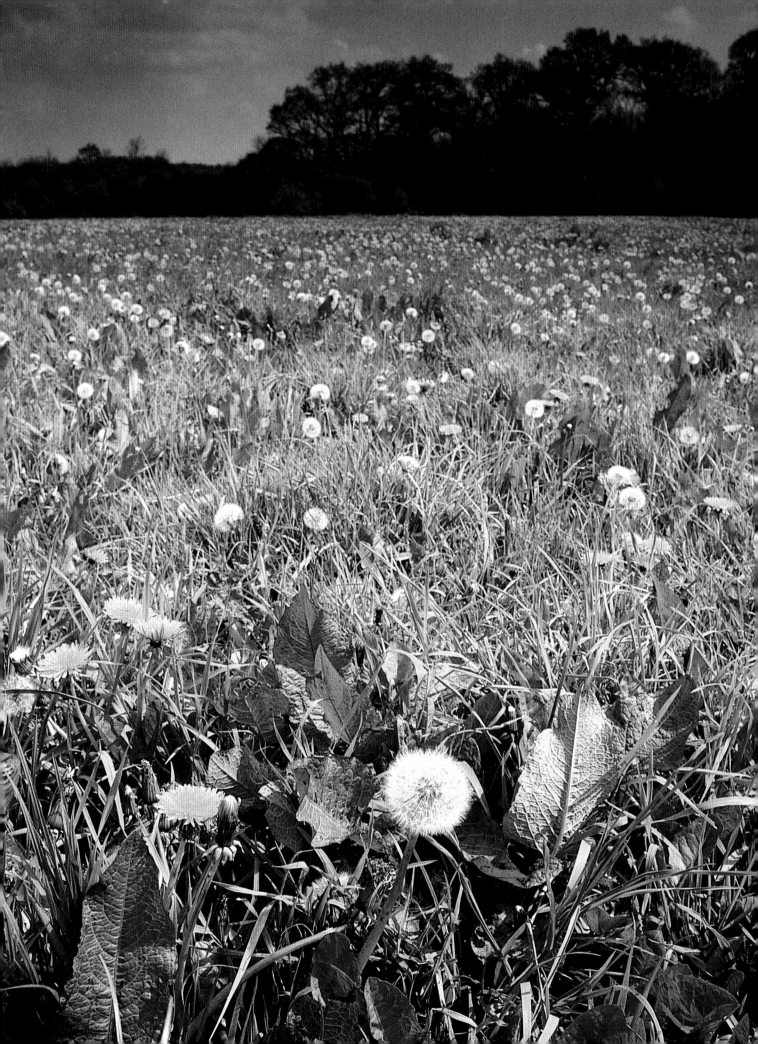

Backgrounds

Many people believe they have no control over the background when photographing landscapes. Of course you cannot move mountains or uproot trees, but you can move yourself, and often shifting a few inches either way can help to eliminate unwanted background detail.

Alternatively, you can change the focal length of your lens. A telephoto lens enables you to crop out unwanted areas of background detail and give the impression of compressing the picture and appearing to bring the background closer. It can also be used to cut out, or at least cut down on, unwanted sky. A wide-angle lens, with its greater depth of field, used with a low viewpoint, can keep both the foreground and background sharp. Take care with wide-angle lenses, as it is possible to include so much in the shot that the background literally gets lost in the background.

Weather and the time of day can also create interesting backgrounds – think of how a storm can suddenly blow up, with dark thunderclouds filling the sky and forming a dramatic backdrop. This can look particularly effective if the foreground is still lit by bright sunshine highlighting trees or a building. In such situations you need to be prepared and have your camera to hand – it is surprising how quickly the light can change, and once the moment has gone, it never comes back.

Another way to create interesting backgrounds is to use the contours of mountains and hills, which can form valleys that frame the sides of the picture and lead the eye into the distance. Again, the sky plays an important part in the finished shot, especially if the sun is low on the horizon.

A graduated neutral density filter (see pages 122–125) is an essential tool. It can help you to balance the differences required in the exposure of the foreground and the sky in the background so that all the details of both areas are recorded.

When shooting digitally, if the sky that forms the background to your shot is bland and without detail, and there are no available framing devices to crop out the sky, you can add another sky on your computer (see pages 118–121).

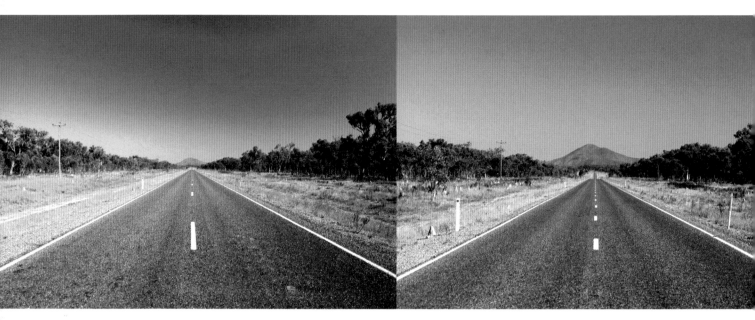

Above: These two pictures show how you can alter the effectiveness of the background. In the one on the left, a wide-angle lens was used and a low viewpoint was chosen. The background looks very far away and has lost all of its detail. In contrast, the picture on the right was taken with a 200mm lens and a slightly higher viewpoint. Here, the background has been brought forward and the contours of the mountain make a far more interesting background. Both shots were taken from the same position.

Opposite: I noticed two pine trees that were leaning diagonally in a forest and chose a viewpoint that would frame them with two vertically-standing trees. The leaning trees make an effective background and add to the geometrical composition.

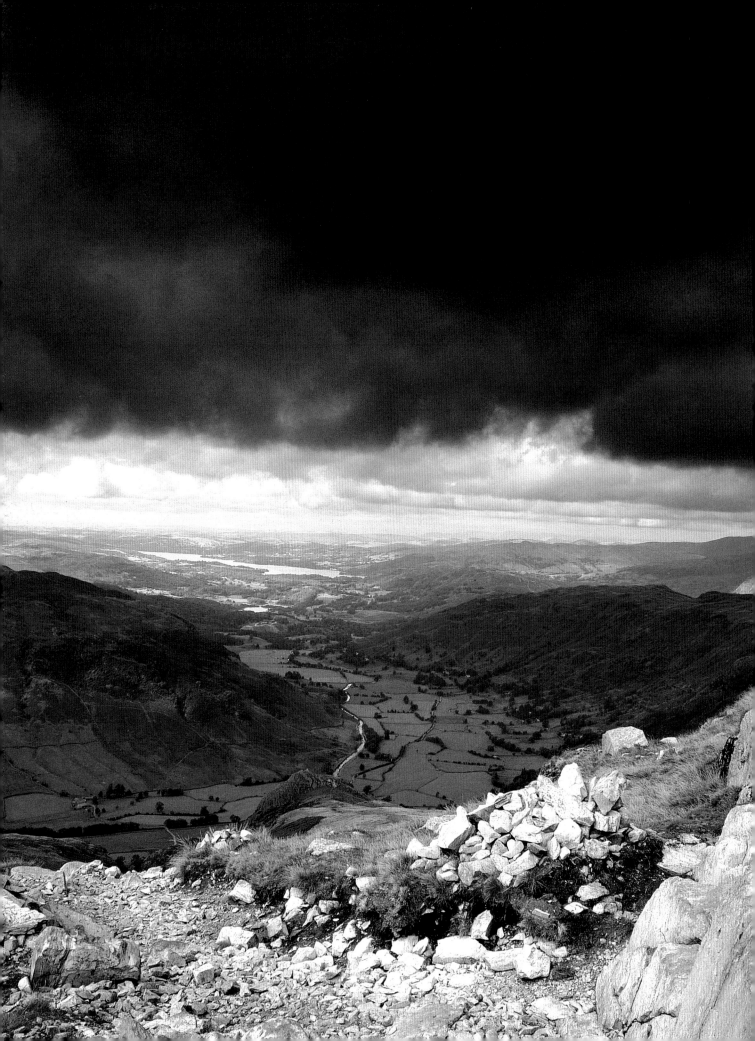

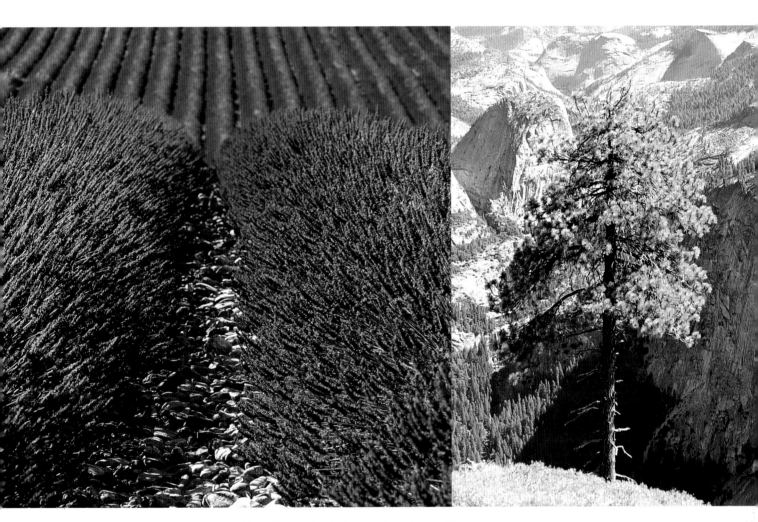

Opposite: In landscape photography there are endless possibilities for creating interesting backgrounds. I had climbed several thousand feet to get this stunning view. A storm was closing in, and I used the foreboding clouds as the background to the shot. Their presence is enhanced by the contrast of the light falling on the foreground and the enormity of the valley, stretching miles away into the background.

Above: By cutting out the sky in this picture of a lavender field in the south of France, all the accent is on the vibrant colour. A telephoto lens was used to compress the shot, bringing the background nearer. A wide aperture kept the depth of field to a minimum.

Above right: In this example, using a telephoto lens isolated the tree from the background, making it stand out against the mountains behind. The way the sun is falling on the background has formed strong shadow patterns, which add interest without being overpowering.

Black and White

After years of being thought of as second best to colour, black and white photography is now a very fashionable medium when it comes to displaying your prints, particularly in landscape photography. Unlike colour photographs of landscapes, which can be easy on the eye and therefore possibly hiding faults in their technical quality, black and white landscape photographs stand or fall on their merits of composition, tone and print quality.

Good black and white landscape prints have a timeless quality, and with the technical innovation of digital printing and the wealth of different papers available, everyone can now produce exhibition-quality prints for display, either in albums or hanging on the wall. In addition to photo-quality papers, there are rag papers with different surfaces; some of these have archival permanence and can reproduce images with a quality that many think surpasses traditional bromide printing.

When shooting on film, choose a fine-grain one: 100 ISO is ideal, as it allows you to enlarge the image to beyond A3 without pronounced grain and gives a wide range of tones. Filters also play an important part in enhancing the detail of your shots (see pages 122–125): a yellow filter helps to retain the detail in a sky and brings out clouds so that they appear with greater clarity. If you want to make the sky look really moody, a red filter can darken it and give your shot a stormy appearance. Graduated neutral density filters help retain the detail in skies while allowing correct exposure of the foreground.

When shooting digitally, you can convert your images to black and white when you have downloaded them into your computer. Once this has been done there are a wealth of postproduction techniques that you can employ, especially if you have a program such as Adobe Photoshop; for example, you can tone your shot (see pages 146–149). Used subtly, this type of enhancement can give a real exhibition quality to your prints. Toning techniques can also be applied to landscapes shot on film, as you can scan your negatives or transparencies onto the computer and then work on them.

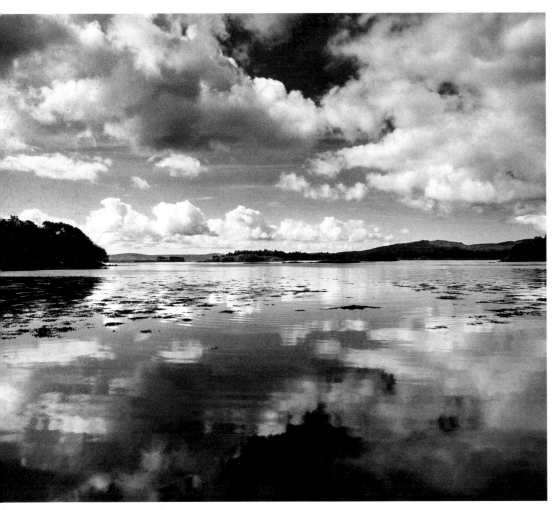

Left: Because the detail of the reflection in the water could have been lost with a polarizing filter, I used a graduated neutral density filter instead. This retained the detail in the sky and enhanced the clouds, which make a perfect mirror reflection in the lake.

Opposite: In contrast, I used a yellow filter to enhance the cloud detail in this shot. It also slightly darkened the blue areas of the sky, which help to define the clouds further. The yellow filter is an essential piece of kit, especially if you are going to do a lot of landscape photography.

Overleaf: This is a strong graphic image that works well in black and white. By cutting out any other detail, including the sky, the emphasis is placed firmly on the gullies of the hills, and the low afternoon sun creates good shadow detail that heightens the contrast of the overall image.

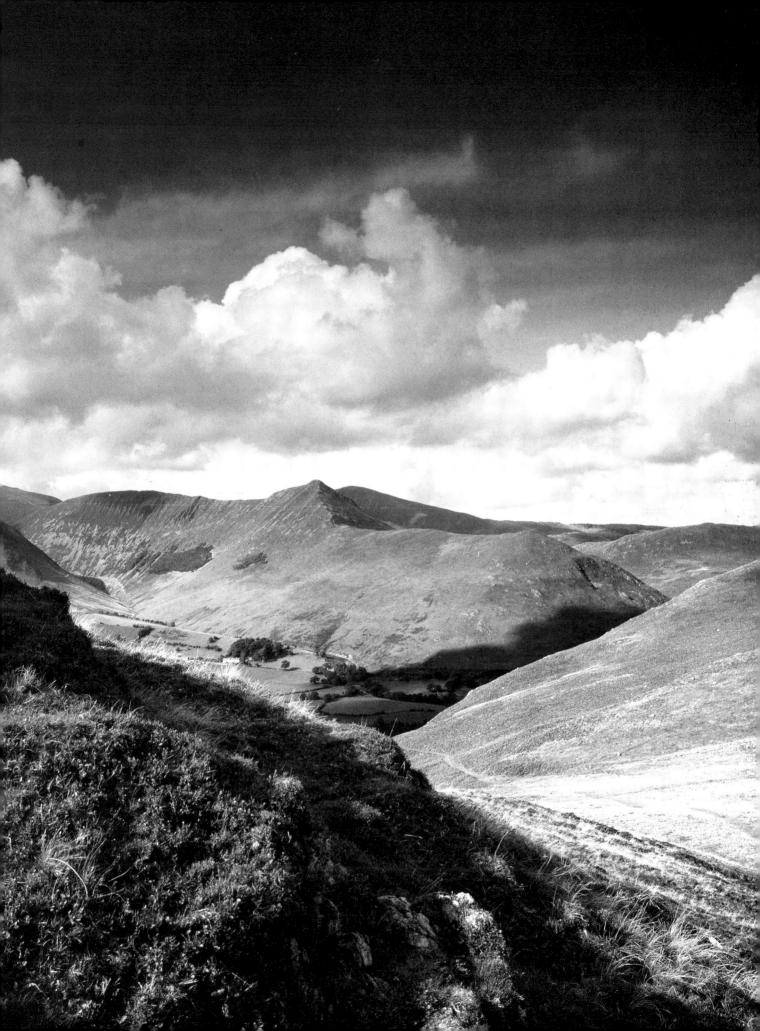

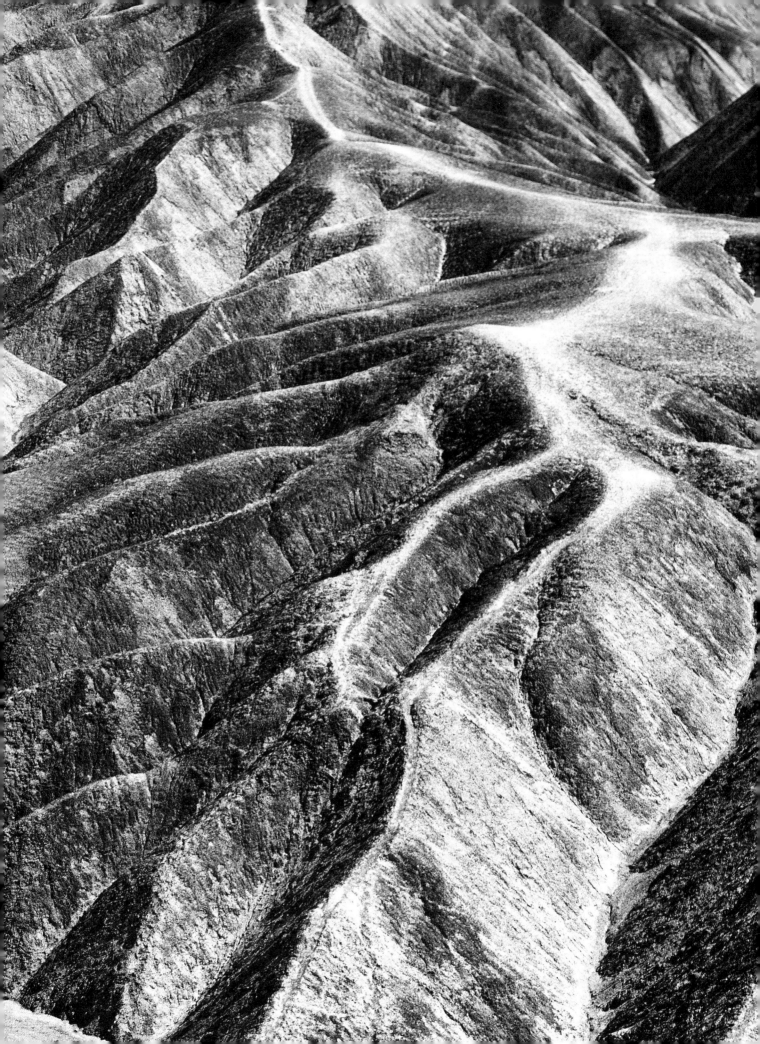

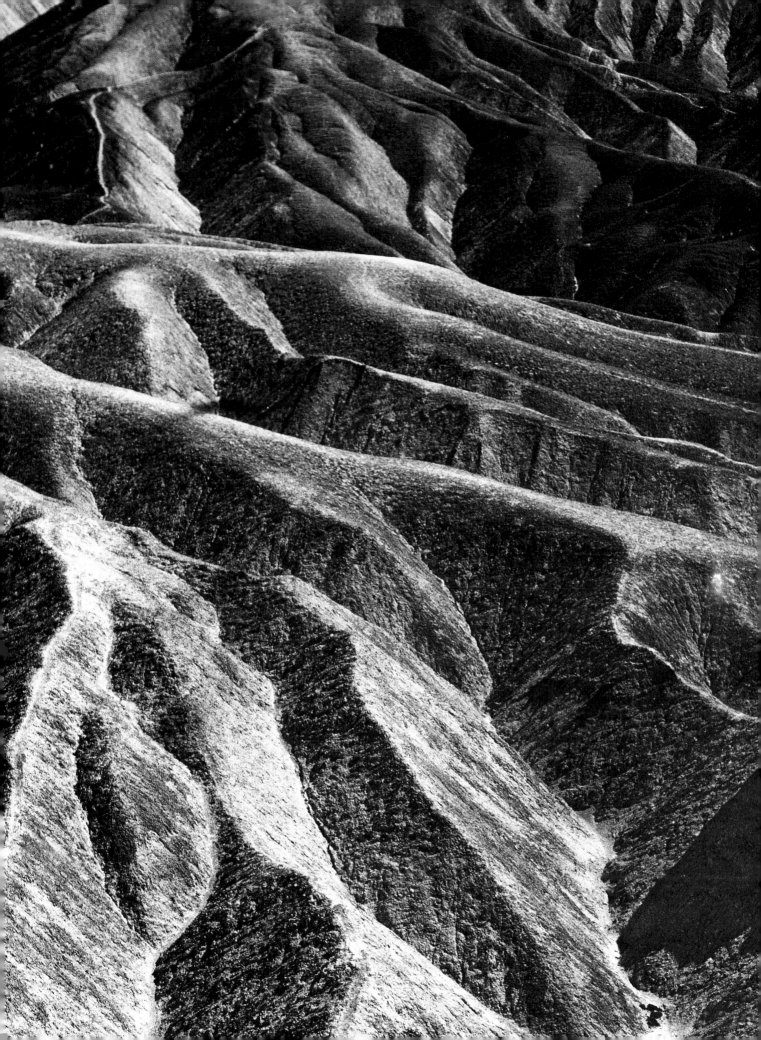

Perspective

One basic fact about all photographs, whether prints or transparencies, is that they are two-dimensional. To create a feeling of depth, a three-dimensional sense needs to be added via perspective, which helps to provide a feeling of depth in a picture. Without this, the results can look flat and uninteresting.

You can create perspective photographically by using naturally formed lines. To make "linear" perspective, imagine standing in the middle of a road, looking along it into the distance. The sides of the road appear to meet at a distant point, as though they are converging. This is basic linear perspective, and the effect is apparent even when viewed with the naked eye. Although you know that the road is straight, because it appears to taper, the perspective is exaggerated giving the impression that the road has no end. Again, by focusing on something close, such as the centre lines of the road, you can enhance perspective by seeing these lines change from being one large strip to one continuous band.

This effect is greater the lower your viewpoint. Trees at the side of the road can also be used to produce a similar result.

With their great depth of field, wide-angle lenses help you get in close to your subject while keeping the background sharp. They also give the illusion of greater space between objects, such as road markings or trees, as they recede from the camera. The opposite is true with telephoto lenses, where the sense of depth is compressed and the distance between near and far objects diminishes. The space between foreground, middle ground and background is vital if a picture is to have life.

Foreground composition (see pages 38–41) is essential when creating a sense of perspective: a strategically placed tree, rock formation or gate can add a great sense of depth and give shots a feeling of perspective. Natural elements, such as wispy or cotton-wool clouds, can add perspective to landscape photographs as they recede into the distance. Viewpoint is essential to creating a sense of perspective, and exploring all the various angles is vital to creating an eye-catching shot.

Creating perspective

There are many ways that you can create a strong sense of perspective. In (1) the shot was taken looking across the vines to the hills beyond. This has created a cluttered foreground that does nothing for the overall composition of the picture and gives little sense of perspective. By moving the viewpoint slightly, the whole feel of the shot has been changed (2): the rows of vines now look well-defined and form a strong sense of perspective. They lead the eye into the shot, and the hills, which have now become an essential part of the composition, form a much more distinct backdrop.

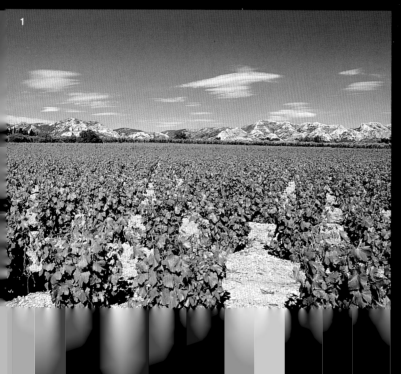

1

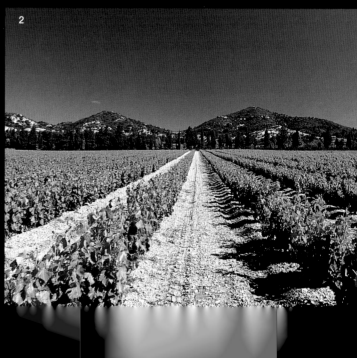

2

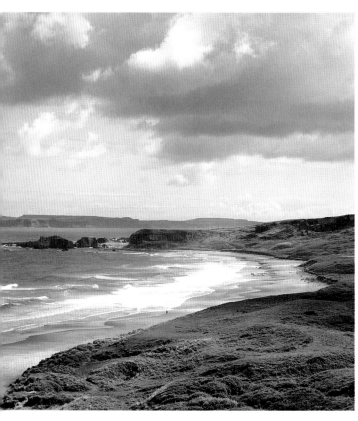

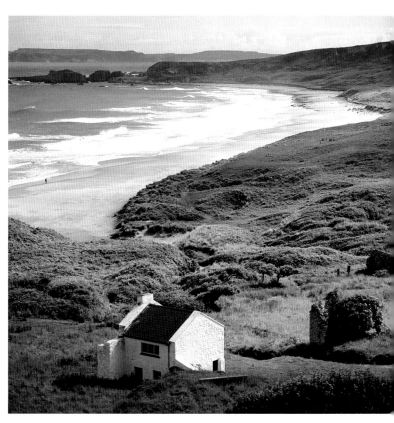

Above: These two shots show how important it is to choose the correct viewpoint when trying to create a sense of perspective. Although at first glance the shot on the left looks pleasing enough, it lacks the perspective and depth when compared to the shot on the right, which was achieved by walking just a little way up the hill behind and including the whitewashed cottage in the foreground. This created a much stronger sense of composition and enhanced the perspective of the shot.

Right: In this shot I used the wall and the gate as a means to create a sense of perspective: by placing them in the bottom third of the picture, I could separate the foreground, creating a sense of depth and increasing the overall perspective effect.

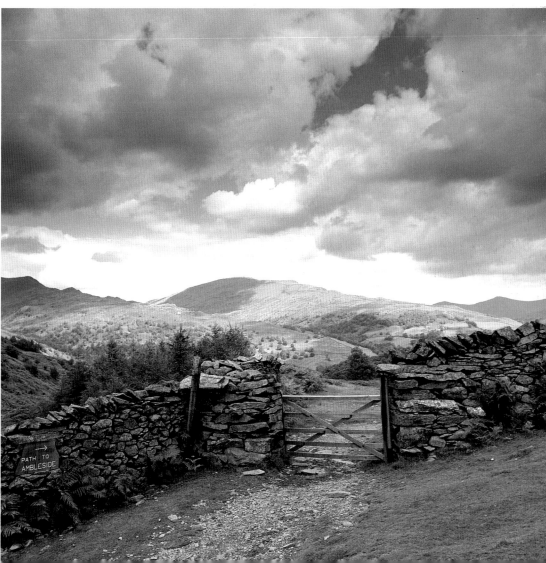

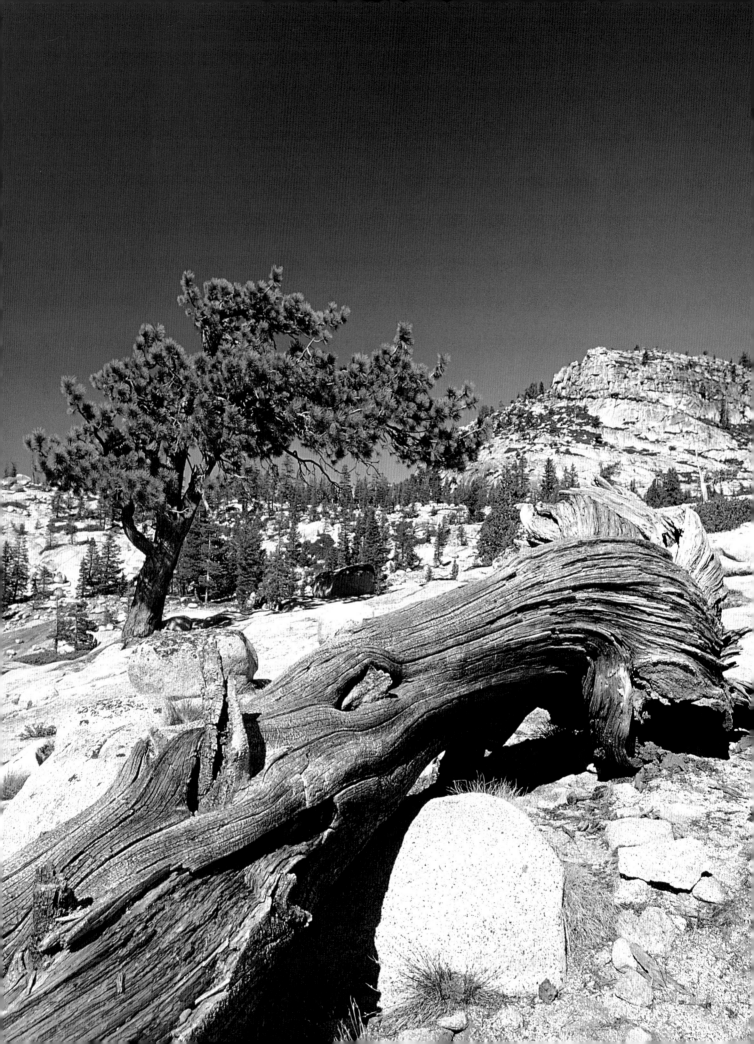

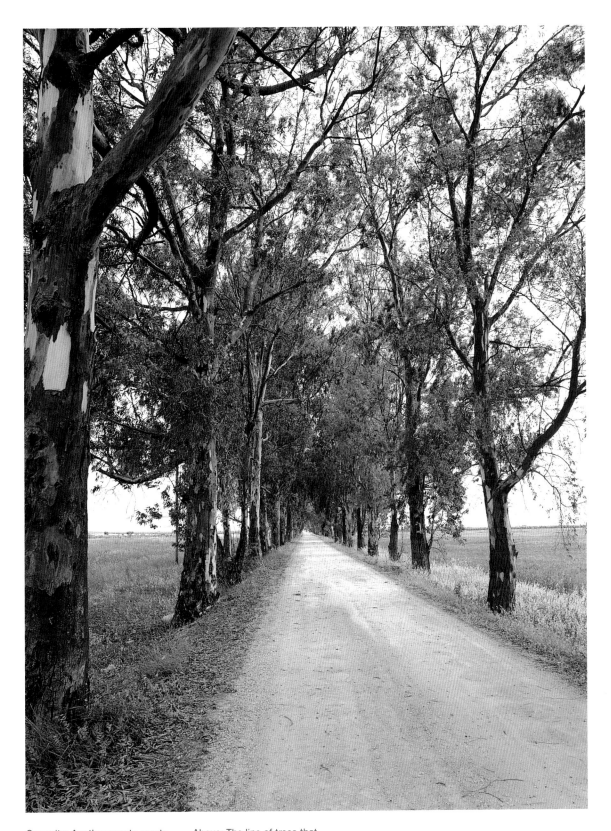

Opposite: Another way to create perspective in your landscape pictures is to look for an item that can be placed in the foreground. This dead tree does the job perfectly and forms a strong foreground composition.

Above: The line of trees that borders this country road in Italy, has created a vanishing point that enhances the perspective of the shot. Using a wide-angle lens helped to create even greater depth.

2 The Subjects

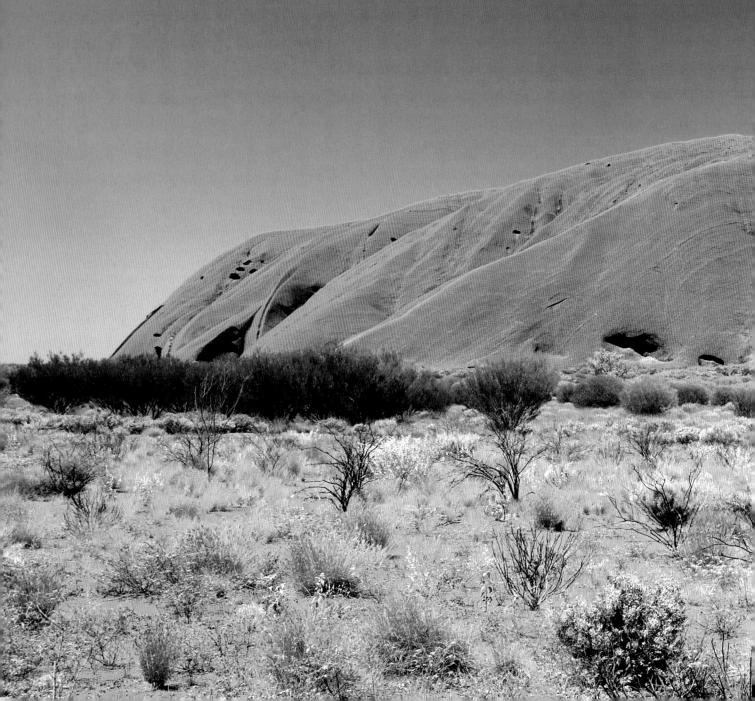

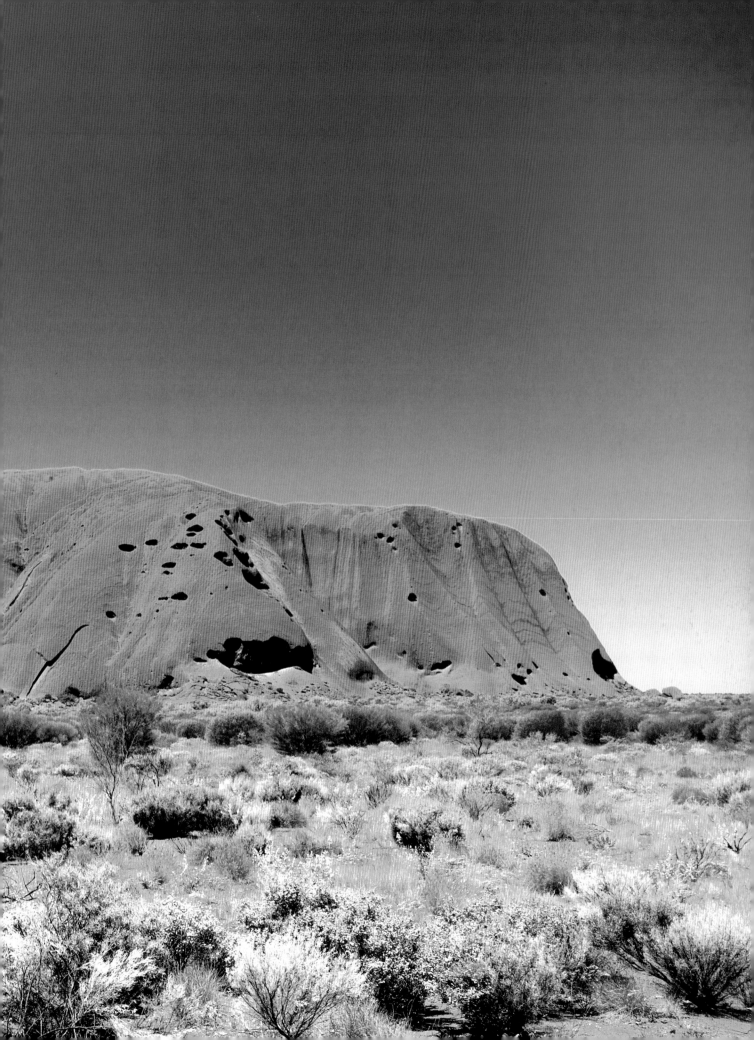

Spring

One of the aspects of landscape photography that puts a lot of people off is the need to get up early. In spring, it's good to try to be in position before the sun is actually up. The reason is that apart from the fact that there will be few, if any, people around to ruin your shots, at that hour the low morning sun filters through trees, creating dappled light or casting long shadows.

You need to be in position to take advantage of every drop of early morning light. The sun often appears to rise rapidly, and in 20 minutes the quality and feel of the light can alter dramatically, and the scene that first attracted you can suddenly appear flat and uninteresting. Because shadows cast by a low sun are long, pay attention to where you choose your viewpoint: it is very easy for your own shadow to creep into your shot at this time of day. If your shot has water in it, such as a lake, the mirror-like reflection will disappear soon after the sun has risen – once the water starts to ripple, what was reflected into it will be indistinct and the tranquillity of the scene can be lost completely.

Another reason for an early start is detail. Flowers covered in dew or a spider's web spun from one flower to another can make excellent shots. A macro lens is useful, as it enables you to go in closer than would be the case with a normal lens. An alternative is to use extension tubes or bellows, which fit between the camera and the lens, allowing you to take extreme close-ups.

Because you are likely to stop the lens down to a small aperture to get maximum depth of field, it is also likely that you need to use a slow shutter speed. If this is the case, a good tripod is a real asset. When buying a tripod for landscape photography, try to get one that will enable you to alter the legs in such a way that you can get down to ground level.

Pictures of spring need to be planned carefully, as what looks photogenic one day can wilt and fade by the next. If you are familiar with an area and know when the first flowers bloom, plan to photograph them as early as possible, or ask someone in the area to keep you posted on the progress of the scene.

Opposite: Spring sees a profusion of new growth, with blossom on trees and plenty of wildflowers in fields and hedgerows. In addition to individual shots of this growth, a series of pictures mounted together can make an interesting and effective collage.

Below: In this valley in northern Spain, the mountains on either side of the frame create a natural perspective. I particularly liked the way the new growth, which can be seen in the foreground, contrasts with the melting mountain snow. The track that leads into the picture also helps with the overall composition.

Right: This abandoned, isolated building in Italy provided a good photographic opportunity. The spring flowers growing in the foreground provide a splash of colour and represent new life, while the building represents the old and the decayed.

Overleaf: I filled the frame with these trees, fresh with new leaf growth. The sun filtering through the trees creates a dappled effect, which enhances the feeling of spring. A shot like this works particularly well when enlarged and printed.

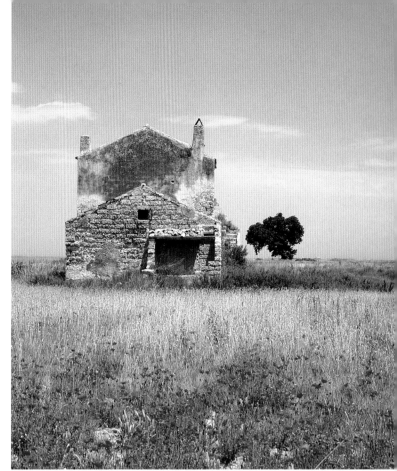

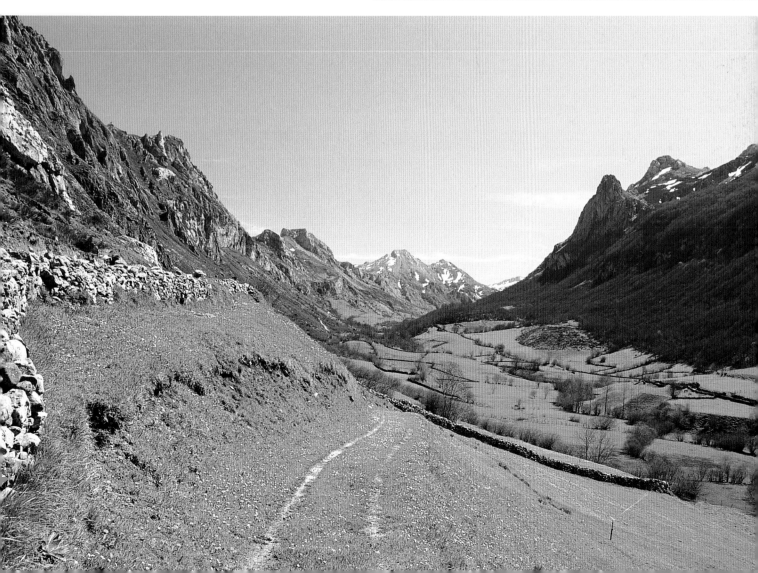

Summer

There are many photographic opportunities that occur in midsummer that you do not find in other seasons. For example, lavender is at its peak from June through to mid-August, and these cultivated plants stretch in great swathes through the landscape.

Lavender fields can be shot either from a low viewpoint, so that the delicate detail of the flower's petals can be seen in close-up with the rest of the field sweeping into the background (see pages 6-7), or from a higher viewpoint so that the furrows of earth enhance the photographic perspective and the vivid lavender colour can be seen against a radiant blue sky.

If the weather is clear, a polarizing filter (see pages 122–125) can be used to darken a blue sky and help white clouds to stand out with greater clarity from it. To get the most from this filter, it is best to shoot in either mid-morning or mid-afternoon. At midday, when the sun is at its highest, the effect of the polarizing filter is minimal or nonexistent. This filter also helps to give a vivid blue hue to seas. Look out for changes in the sky when storms occur, as these can often act as a dramatic backdrop, dark and foreboding, when set against a brilliantly sunlit foreground.

The main problem when taking shots in high summer is when the temperature becomes so hot that a heat haze builds up, making photographs of landscapes look dull and flat. If the weather has been like this for some time, even in the very early morning, there can be an annoying haze that often does not disperse until a thunderstorm or downpour clears the air.

If haze persists and is still a problem, look at the scene in a different way; for example, can you go in close and make a feature of detail? Crop tightly and don't be afraid to use the telephoto or zoom lens. If the area you are photographing is in your locality, can you photograph it in all four seasons to show the differences that take place throughout the year? The summer is a time of year when there is a lot of rural activity. Be on the lookout for this – if you don't act quickly, a field of golden wheat can soon become a field of stubble.

Left: There is a great deal of agricultural activity in the summer months, much of which provides good photographic opportunities. I placed this farmer, who was working on a Greek hillside, towards the foreground of the shot. His old fashioned farming methods make an interesting focal point.

Opposite: I used a 100mm medium telephoto lens to photograph this rural town in Ireland. The lens helped to keep the mountains in the background very much part of the shot. Using a graduated neutral density filter means that the detail in the sky has not been lost.

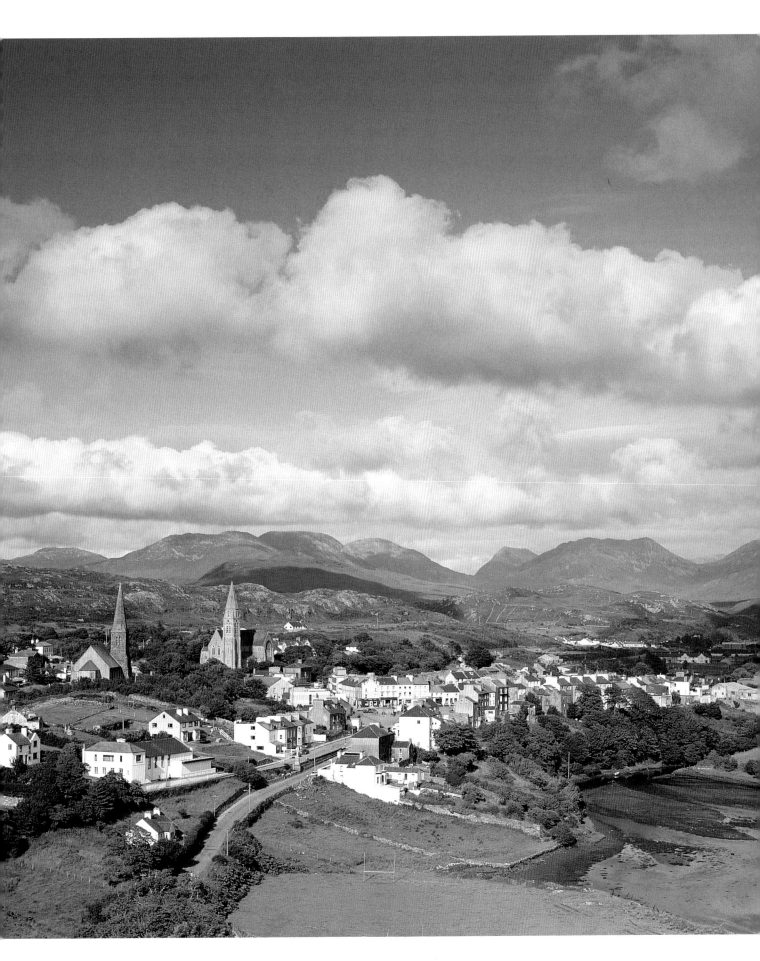

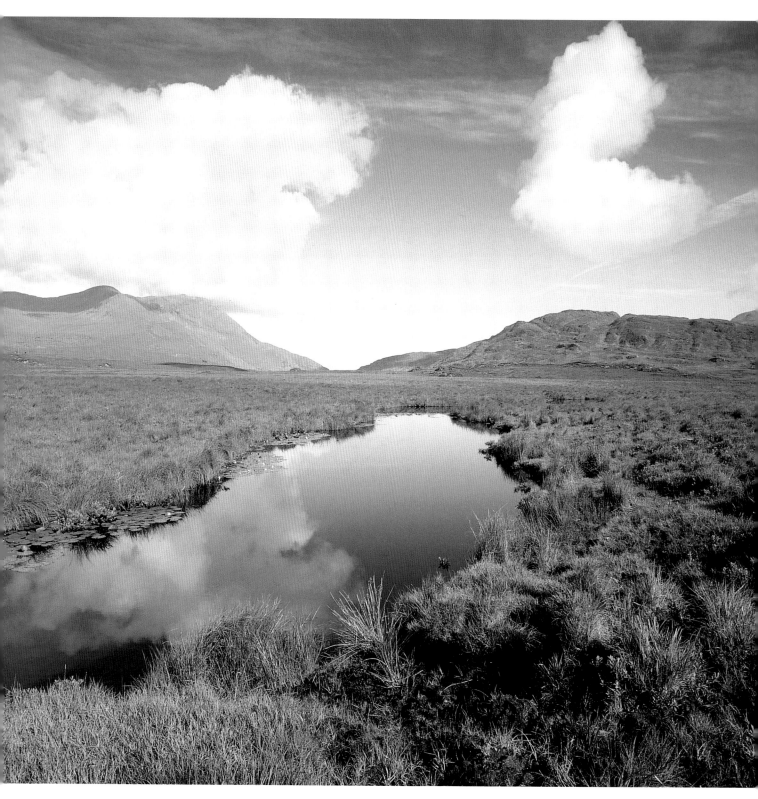

Above: Summer can create difficulties when photographing landscapes, because heat hazes can build up quickly. One of the best times to get good shots is first thing in the morning, when the sun has just risen, and everything is crisp and clear.

Opposite: Haze was a problem with this shot, and although it was hot and sunny the sky looked flat and grey. Because of this I deliberately cropped the sky out of the shot, enhancing the sunflowers.

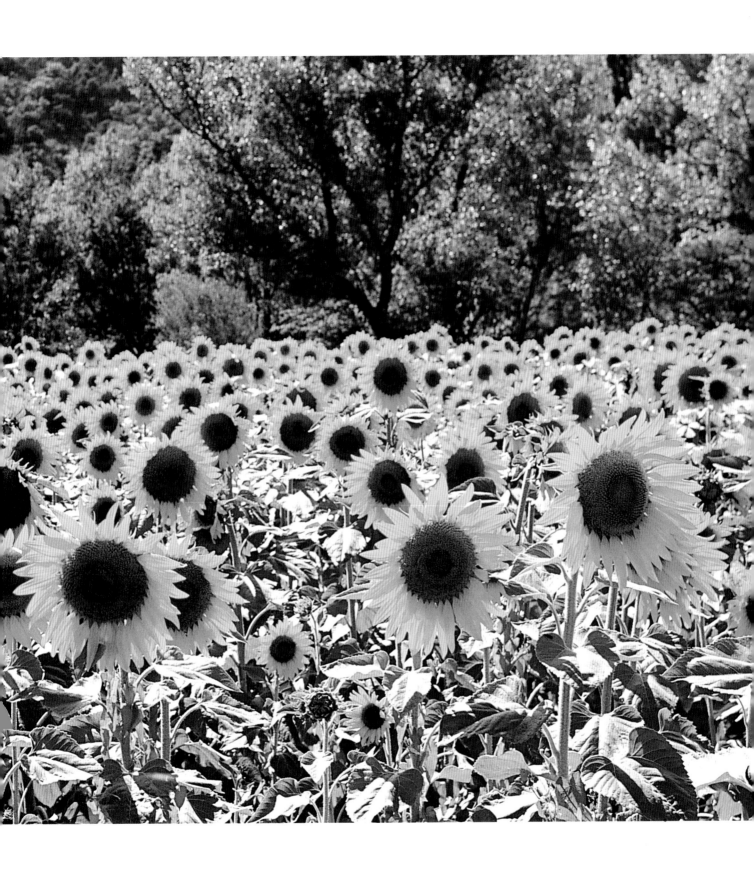

Autumn

Autumn is a season that is rich in colour; however, it is probably the shortest of the seasons in photographic terms. It can be made shorter still by the weather: if the summer has been very wet, the leaves may not change colour to their full extent until they are actually about to drop, and a couple of days of high winds can quickly strip a tree of all but the most tenacious foliage.

It is for reasons such as these that the photographer needs to be alert and take shots as soon as the possibilities present themselves. If the weather gets better, you can always take more and perhaps improve on what you have already shot. However, if it doesn't you could end up without any shots at all, and then you will have to wait until the next season.

The colours of autumnal trees look brilliant, especially if you can contrast them against one another. For instance, a tree whose leaves have turned gold can look beautiful when photographed against a background of evergreens. You might want to consider using a telephoto lens in this situation; if there is sufficient distance between the main tree and the background and you use a wide aperture, it may be possible to throw the background out of focus. This can result in a blurred but muted backdrop that makes the main tree stand out in glorious clarity. Another opportunity to keep an eye open for is a group of trees that have changed to provide contrasting leaf colours such as copper against gold or brown against red.

Be on the lookout for details. As well as looking at leaves on branches, you can find potential shots at your feet, and these can often make great close-up pictures. Not only can you shoot leaves where you find them, you can also gather them up and take them indoors to photograph as a still life, arranging them without worrying that they may blow away.

You can consider backlighting them to reveal the skeleton of the veins and membranes running through the leaves, particularly when they are slightly weathered. You can even spray leaves with water to give the impression of early morning dew or rain.

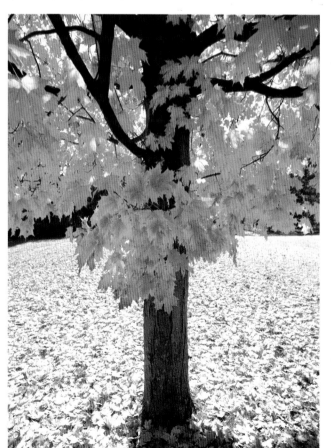

Left: I moved in very close to this tree and used a 24mm wide angle lens. Although this gives a false sense of perspective, I like the way that the leaves on the tree fill the top half of the frame, while the leaves on the ground form an interesting backdrop.

Below: It's not just leaves on trees that provide autumn colour. Here, the ferns on this heath have also turned a rich and vibrant range of hues. The late afternoon light helped intensify the foliage, and the low sun created interesting shadow detail.

Opposite: To get this shot I placed the camera, fitted with a 400mm telephoto lens, on a tripod and chose a low angle so that the camera was looking up into the trees. This filled the frame with the tree's branches, which are heavy with autumn leaves. Because the light was quite low I had to use a slow shutter speed, which meant that it would have been impossible to hold the camera steady when using this lens without a tripod.

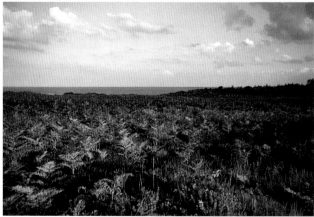

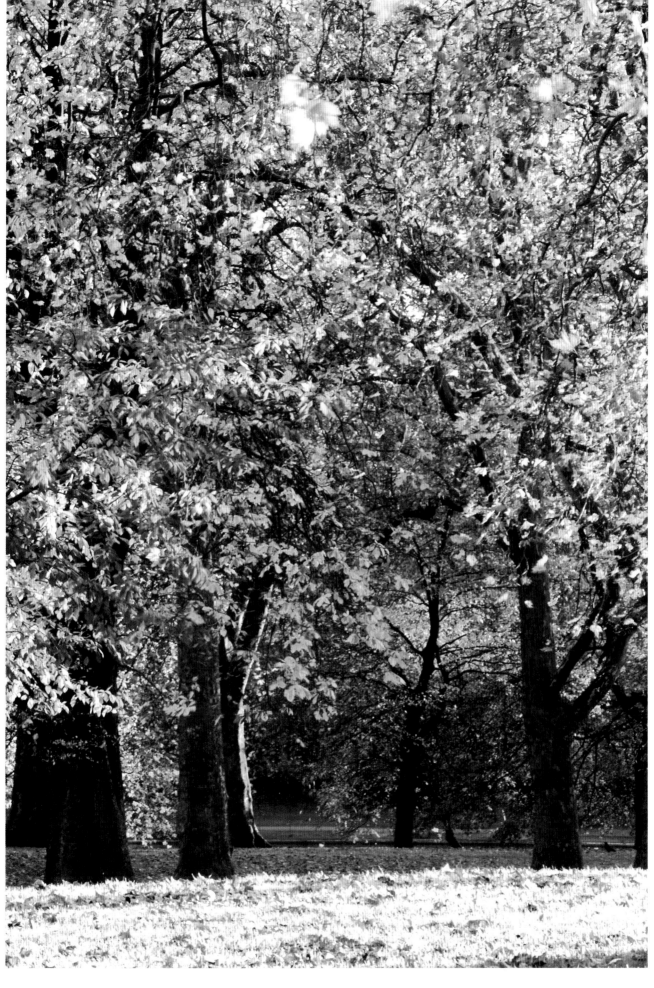

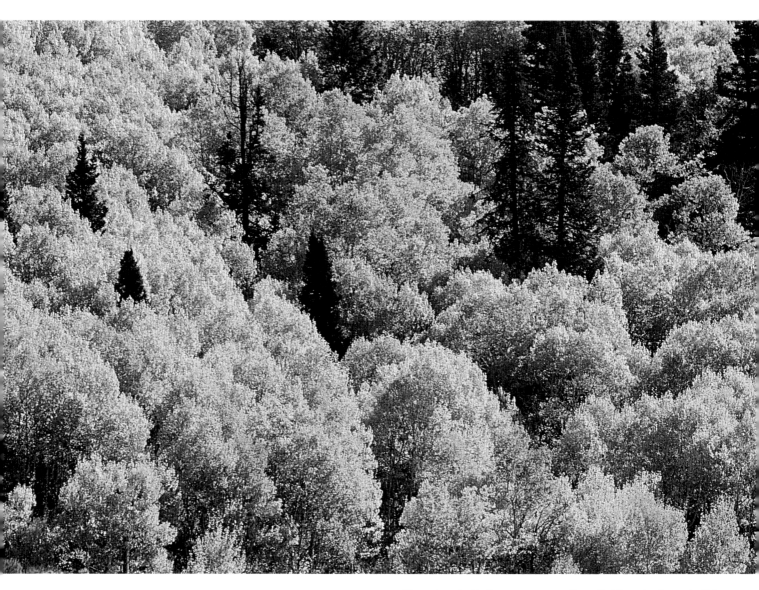

Above: I wanted to focus on these vivid autumn leaves so I used a 200mm telephoto lens to get to the heart of the scene. Because I could not use a tripod, I turned on the image stabilizer mode on my Canon lens. This is a great asset when you have to use slow shutter speeds.

Opposite: There is often potential at your feet. I got down low for this picture and fitted a No. 1 extension tube to my 70mm lens. I pointed the camera into the light and backlit these leaves. This showed up all the veins, and a wide aperture kept the depth of field to a minimum, placing the focus fully on the foreground.

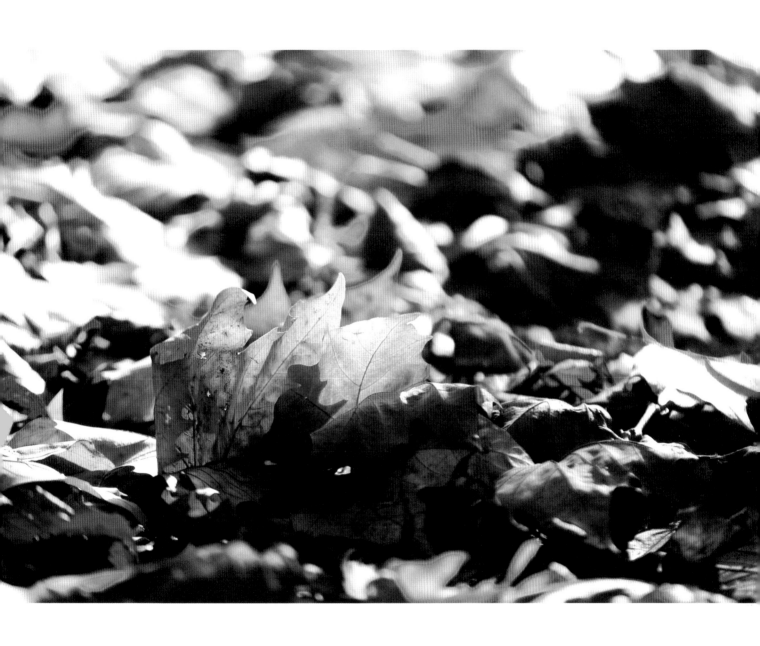

Winter

Snow and sun are perfect ingredients for great landscape pictures. While you can take shots in snow without sun, its presence makes all the difference, creating shadows and giving interest to otherwise bland and lifeless shots.

Although winter can provide great photographic opportunities, it does come with several problems. The most common of which is exposure: a large area of freshly fallen snow reflects a lot of light and can fool the camera's metering system into thinking that the scene needs less exposure than it does. This means that some shadow areas can come out totally underexposed, with little, if any, detail at all. If you are taking a shot of a snow-covered landscape with trees to one side of the frame, the trees can come out underexposed because the camera's meter takes its reading from the highly reflective snow. A more accurate reading can be taken using the incident light reading method (see pages 30–33).

Another method is to look for an area of mid tone and take your reading from that. If this is only a small area, be careful that you do not cast your own shadow over it when taking your reading, as this could result in the meter underexposing your shot. An alternative method is to bracket your shots so that you can choose the best one when the film has been processed. When shooting digitally, you can review your shots on the camera's LCD and study the histogram.

Another problem with winter snow scenes can arise from the camera's auto-focusing system. When you point the camera towards the horizon, the auto-focus cannot work if the sensor or focusing point, which is visible in the viewfinder, is on the sky. It cannot focus because of the lack of detail, and if the focusing point is aimed at the snow it cannot focus there either, for the same reason. In this case you have two options: one is to switch off the camera's auto-focus mode and focus manually, and the other is to find an area of detail in your shot and move the focusing sensor over it so that the camera can focus on this detail. Then recompose your picture using the camera's auto-focus lock (AFL) and take your shot.

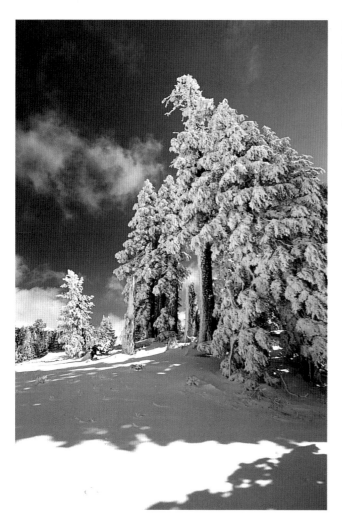

Left: The most important feature of snow pictures is sunshine. Although it is possible to get effective snow pictures in overcast conditions, there is nothing quite like a backdrop of deep blue sky and strong shadows on freshly fallen snow.

Opposite: The road sign provided a splash of colour in this snow scene. Always be on the lookout for what might seem mundane but can take on a different dimension when photographed.

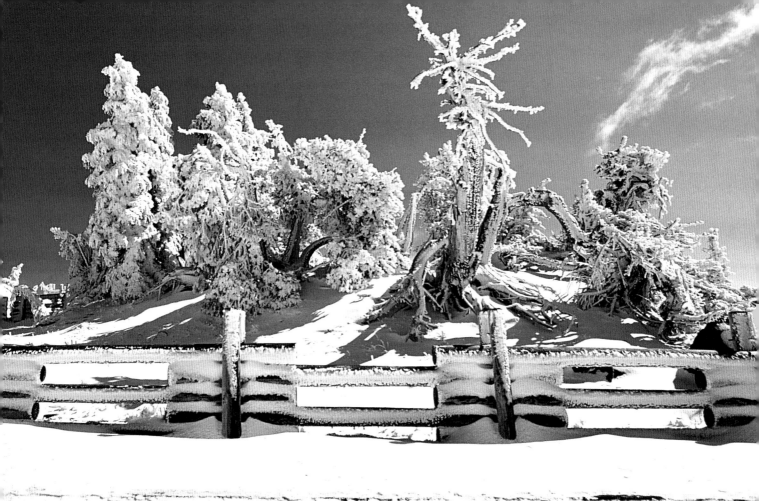

Above: I took care with my viewpoint when taking this shot, as I was looking directly into the sun, which can be seen from the shadows of the trees coming towards the camera. A lens hood is essential in situations such as this, but should be fitted as a matter of course.

Opposite top: I deliberately placed the tree on the right-hand side of the frame to fill the empty area of sky. It towers majestically over Meteor Lake in Oregon, USA, and lifts an otherwise bleak winter landscape.

Opposite bottom: It was so cold when I took this shot that the sea had frozen. In conditions such as this, it is quite easy for the camera to malfunction and the shutter to fail because of battery failure, so you need to keep your equipment protected.

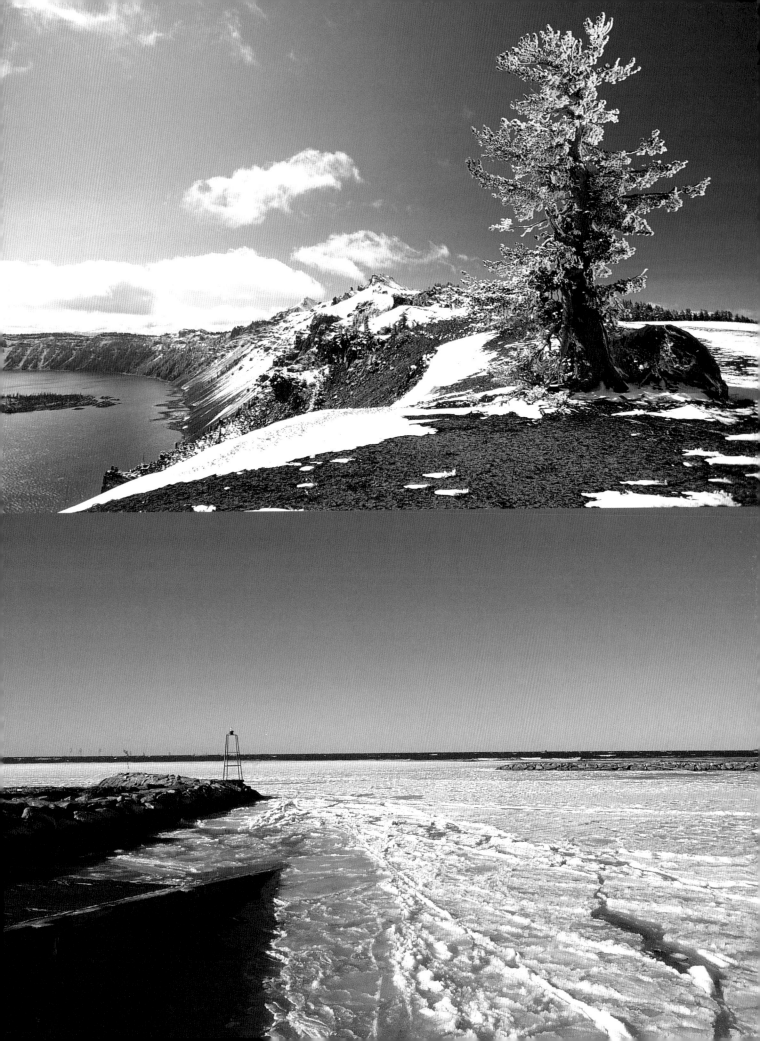

Rivers and Canals

Fast-flowing rivers make great subjects for landscape photography, but a little forethought is required to get the best out of them. The most effective way to photograph such a river is to use a slow shutter speed, probably in the region of 1/8th or 1/4 second, which means that the camera should be supported on a tripod or some other means of steady support.

The reason for using a slow shutter speed is to get a sense of movement in your shot; if you use a fast shutter speed, 1/250th second or faster, water looks static and it is difficult to see whether it is moving at all. You may find it best to focus manually in situations like this, as the camera's auto-focus sensor may have difficulty in focusing on the moving water and all your shots may end up out of focus.

Another area to consider in these situations is foreground interest (see pages 38–41). River water can be dark and murky, and may not look very effective if it is a prominent feature in the foreground of your shot. Try to choose a viewpoint so that the

riverbank or rocks break up this area. Dark river water can also give you problems with getting the correct exposure. Because it is so dark, the camera's metering system can overcompensate, putting your shot in danger of being overexposed.

In addition to idyllic stretches of water, canals also provide the photographer with opportunities such as boats and locks, which can either be used as compositional tools or as subjects in their own right. Many canal boats are extremely decorative, while the texture of weathered wood and metal of an older boat makes great close-up detail shots. Other subjects in situations like this are the characters who sail or work on these vessels; be on the lookout for the opportunity to shoot a strong portrait.

Rivers and canals are usually great areas to find wildlife – even in urban areas these stretches of water can provide the habitat for colourful birds and varieties of plant life. A 200 or 300mm telephoto lens is ideal in these situations, together with a great deal of patience.

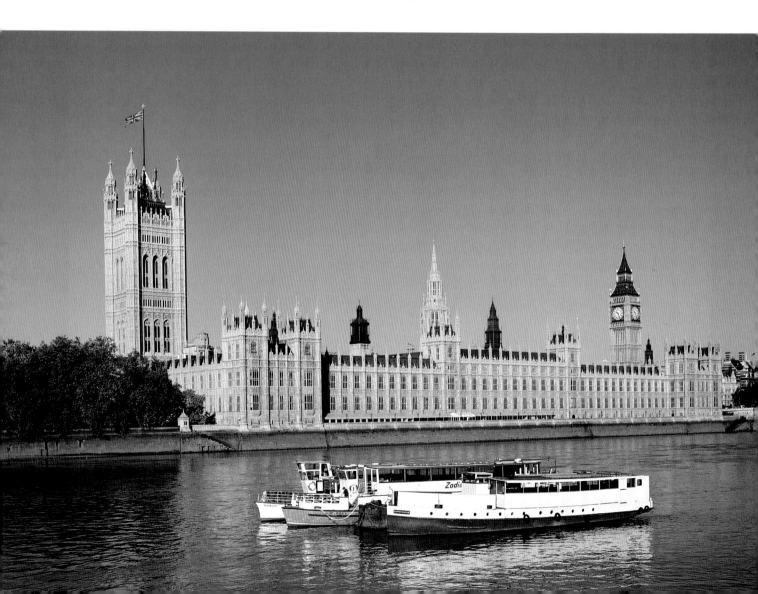

Right: In this shot, the river comes in diagonally from the left-hand corner of the frame while the hills, on either side, come in diagonally from above. These elements, shot like this, resemble the extremities of the letter X and make an effective composition.

Opposite and below: London's Houses of Parliament are one of the world's most familiar sites. In contrast, the canal in Thailand is less grand and less well known. However, when displayed together they form an interesting juxtaposition of cultures, of equal importance to those whose lives are shaped by them.

Overleaf: I got as close as I safely could to this fast-flowing river. To give a sense of the water's speed, I placed the camera on a tripod and used a shutter speed of 1/2 second, recording the water with a degree of blur that gives a sense of movement.

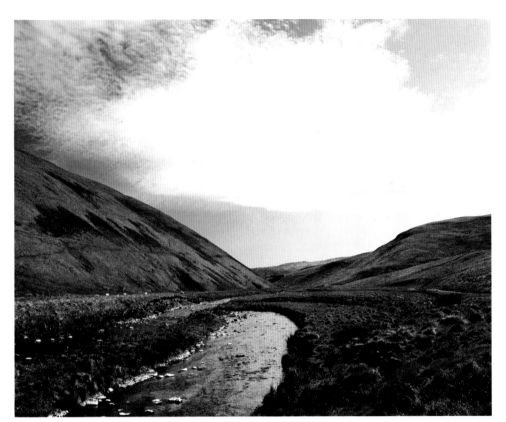

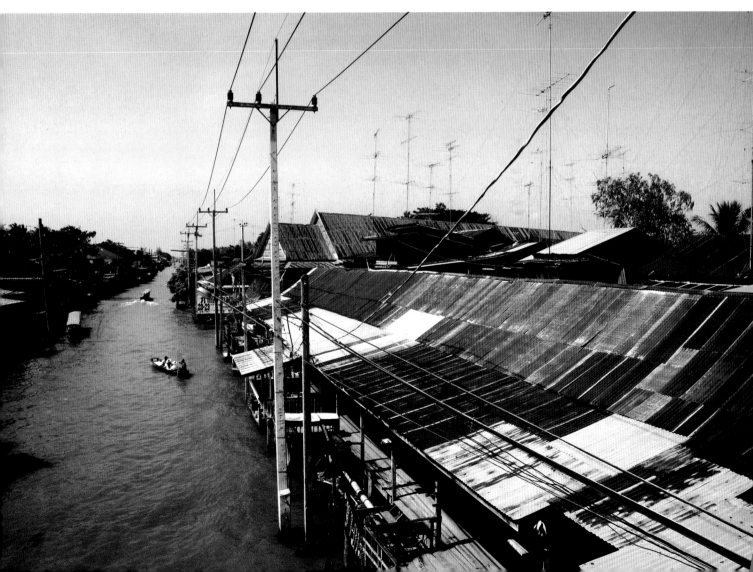

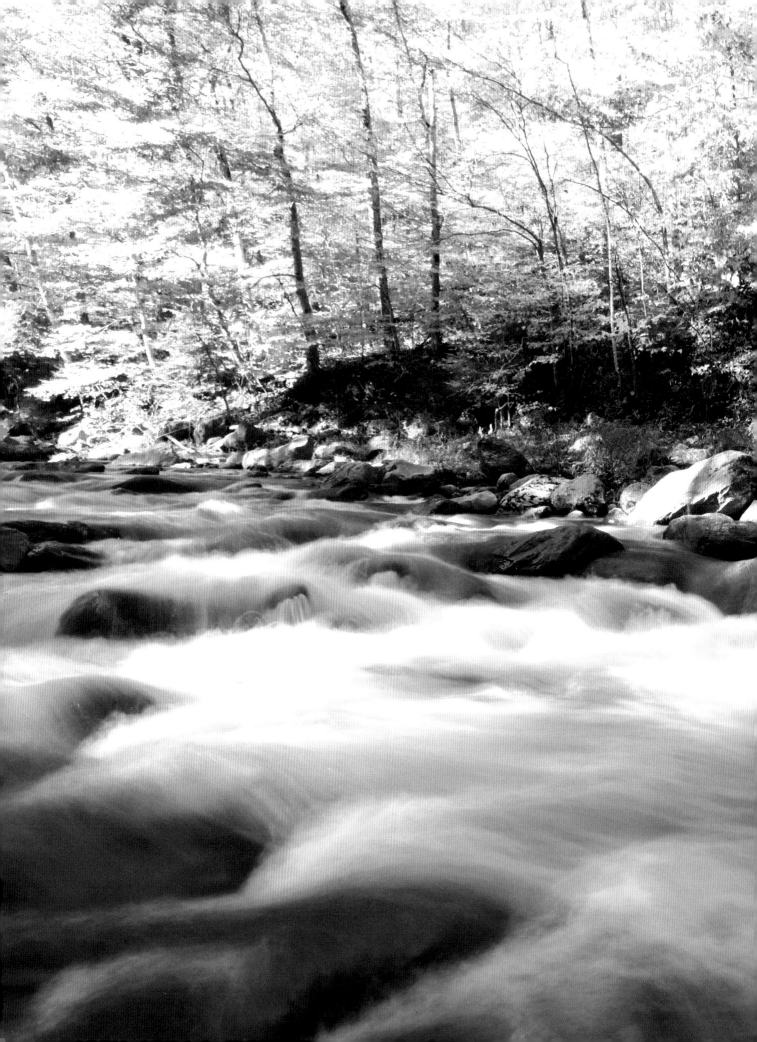

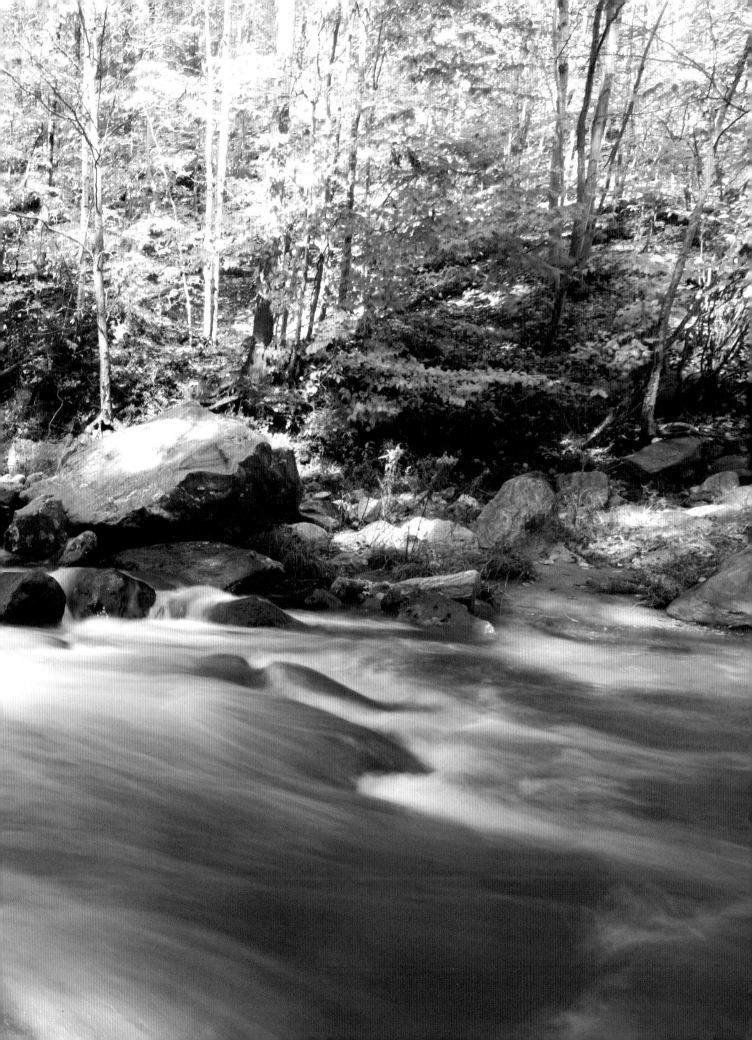

Seas and Lakes

With water covering the majority of the world's surface, artists and photographers have been using it in their imagery for centuries.

As with photographs of rivers and canals, there are many potential pitfalls for the photographer, and the greatest is probably exposure, as the combination of vast skies and highly reflective surfaces of sand and sea can mislead your exposure metering system into thinking that your shots need less exposure than they do, with underexposed results.

Another problem that occurs time and time again is that many photographers use a wide-angle lens to shoot this type of subject. In itself there is nothing wrong with this choice, but unless you frame your shot carefully it is all to easy to end up with vast areas of foreground without any visual interest whatsoever, and with the background appearing so far away that very little detail can be seen. In addition, skies that are overcast and without any cloud detail can look bland and result in a bad shot (see pages 34–37).

When composing pictures of seas and lakes, think carefully about foreground detail (see pages 38–41). On a beach of endless sand, is there anything that you can place near the camera? If the beach is fringed with trees, can you use them to frame one side of your picture?

To capture the mirror-like surface of a lake, you need to be in position before the sun rises on the horizon. The reason for this is that shortly after the sun rises, ripples in the waters surface usually begin to appear, and the wonderful reflections of bordering hills or mountains disappear, leaving you with a large uninteresting area of dark water in the foreground.

When using a polarizing filter to enhance clouds in a blue sky, be careful that you do not eradicate their reflection in the water at the same time. If you are shooting the sun setting over water, your camera's meter may take its reading from the sun, which can then come out as a white spot with little detail in the surrounding areas. If the meter reads for these areas, the sun and sky can come out overexposed, losing any atmosphere.

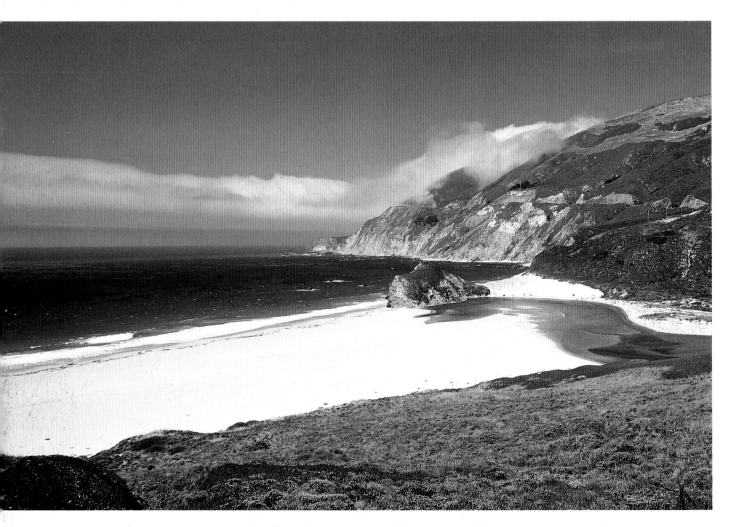

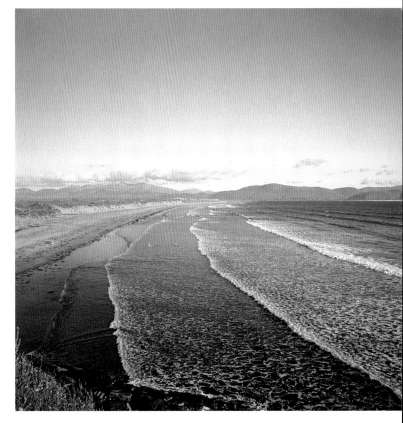

Opposite: A polarizing filter vividly enhances the colour of the sea in this shot of California's Big Sur coast. The radiant blue sky also contrasts well with the pristine white sand of the beach.

Right: These gentle waves stretch far away from the camera's viewpoint, forming strong compositional lines. The late afternoon sun enhances the colour and adds to the tranquillity of the scene.

Framing

Sometimes it is worth taking two shots of a landscape scene: one vertical or "portrait", and the other horizontal or "landscape". It is surprising how just this small adjustment can make all the difference. In the shots here, I feel the portrait version works so much better, as it has cropped out a lot of unwanted detail on the left-hand side of the landscape shot, and the inclusion of more foreground and sky add depth. This exercise is always worth doing, whether you are shooting on film or digital.

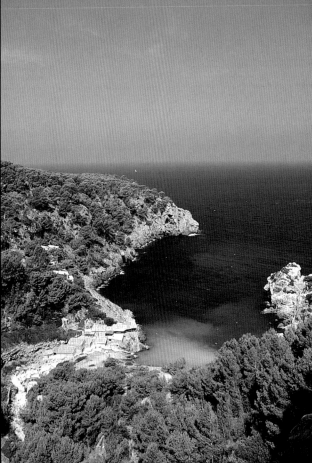

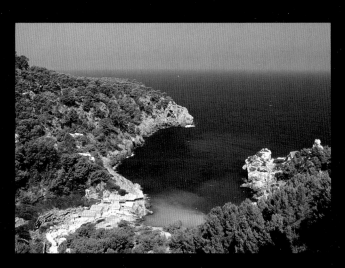

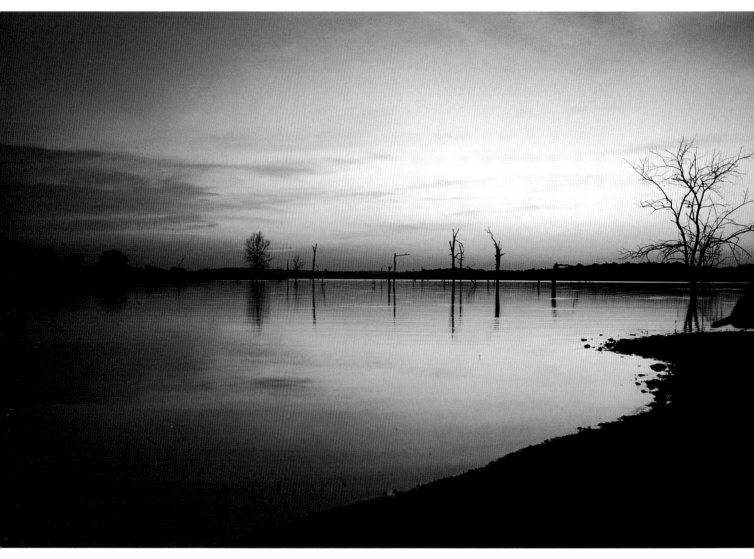

Above: I took this shot before the sun had actually risen – the rich colours of the sky made it worthwhile getting up early. It can't be emphasized enough that most good landscape pictures are taken early in the morning, either before the sun has risen or very shortly after.

Opposite: In contrast, this shot was taken just before the sun set. It was shining directly on the strange formations that appeared to be ascending from the water. I used a small aperture to give as much depth of field as possible, and positioned the formations close to the camera so that they dominated the scene.

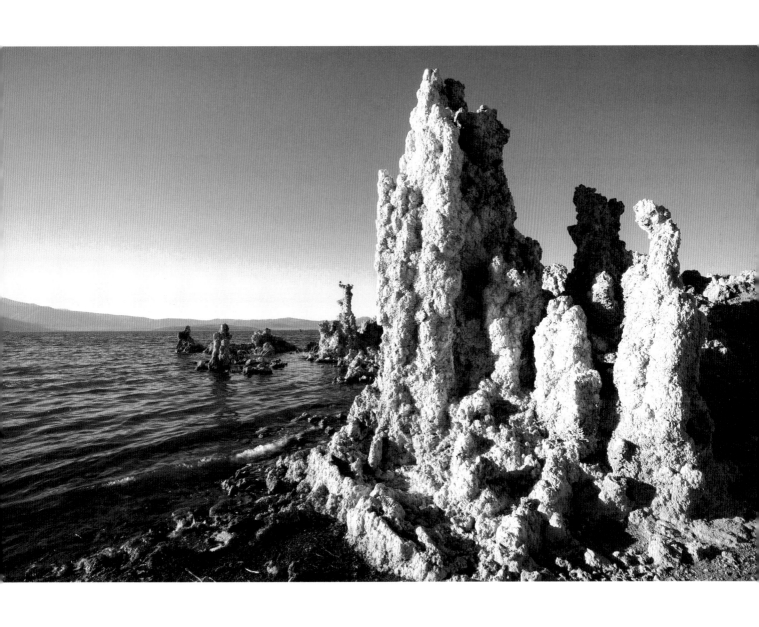

The Weather

In landscape photography the weather plays probably the most important part in determining whether a shot is a success or failure, because it is the one area over which you have no control.

A stunning view can be ruined when the sky is overcast and has little cloud detail, or when an atmospheric mist turns into a thick fog. However, even in what might appear to be a desperate situation an innovative photographer can turn what to others is terrible weather into the basic ingredient for a dramatic and effective shot.

Although it is difficult to take effective pictures in pouring rain, there are other aspects of wet weather that you can use to advantage – distant clouds, for example, from which you can clearly see rain falling can look dramatic when caught in the right light. If the rainclouds are some way in the distance, you may need a telephoto lens for this type of shot; if the rainstorm is nearer, a wide-angle lens can be used from a low viewpoint to make the sky more prominent and equally dramatic.

When the rain has stopped, look for puddles or flooded areas that might contain interesting reflections. Look at these carefully – just a step backwards or forwards can make all the difference to the reflection and how much you see of it. The same is true with the height from which you look at it: with pictures of reflections you need to focus on the reflection and not on the top of the water – with the latter, the main point of interest in your shot can be out of focus; with auto-focus cameras, the sensor can focus on something floating on the top of the water.

Unless mist and fog are particularly thick, you can get some very atmospheric pictures in these conditions. Again, auto-focus cameras may have trouble focusing in these conditions, and you may be better off using the manual focusing setting. Snow is obviously photogenic, but frost is an equally good subject. Depending on the severity of the weather, it will probably be essential to shoot early in the morning before frost starts to melt, which can happen quite quickly if the sky is clear.

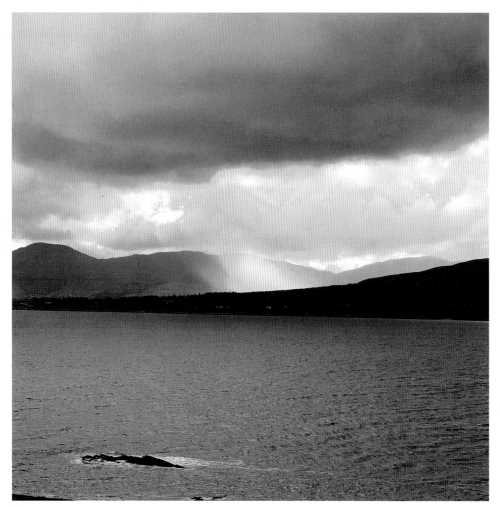

Left: These gathering storm clouds illustrate exactly the type of weather that could be expected: rain! This type of weather can change quite rapidly, so you need to be prepared to take your shot, otherwise it could easily slip through the net.

Opposite top: Even in overcast conditions it is possible to get shots that typify a particular type of weather. Here, the clouds hang in a band across the frame, splitting up an otherwise dull sky. A lens hood prevents raindrops falling on the lens.

Opposite bottom: Sun and snow are the perfect combination for getting good weather pictures. The footprints make an interesting pattern in the fresh snow, and the jetty posts provide a strong sense of perspective.

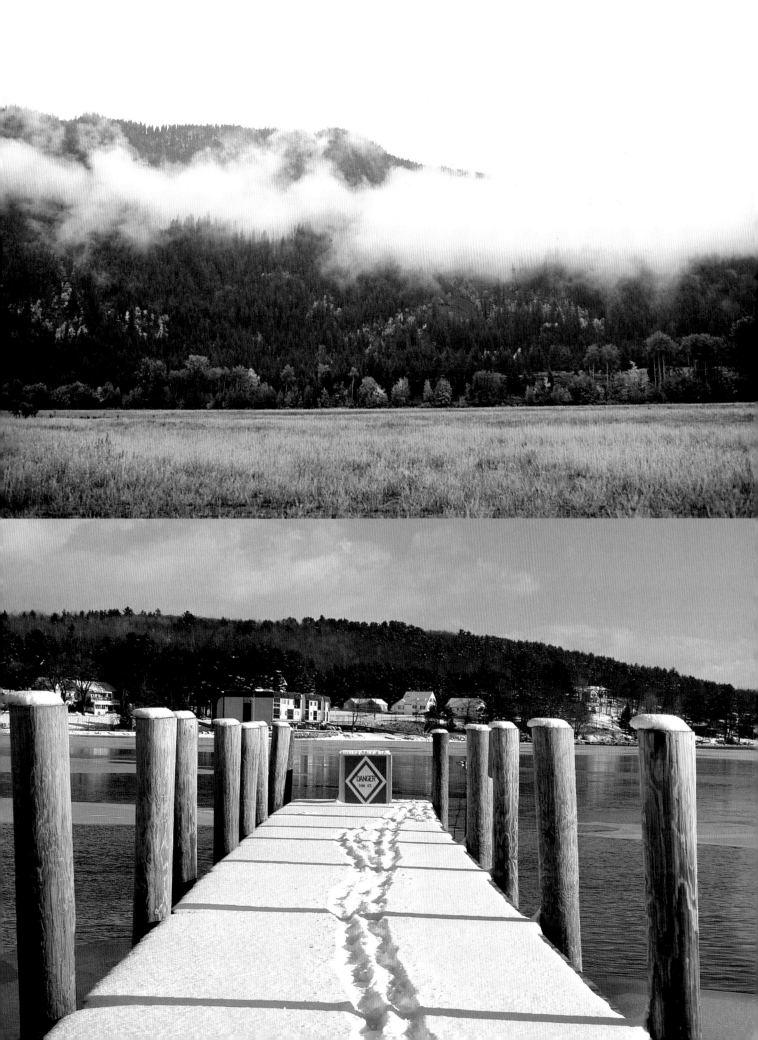

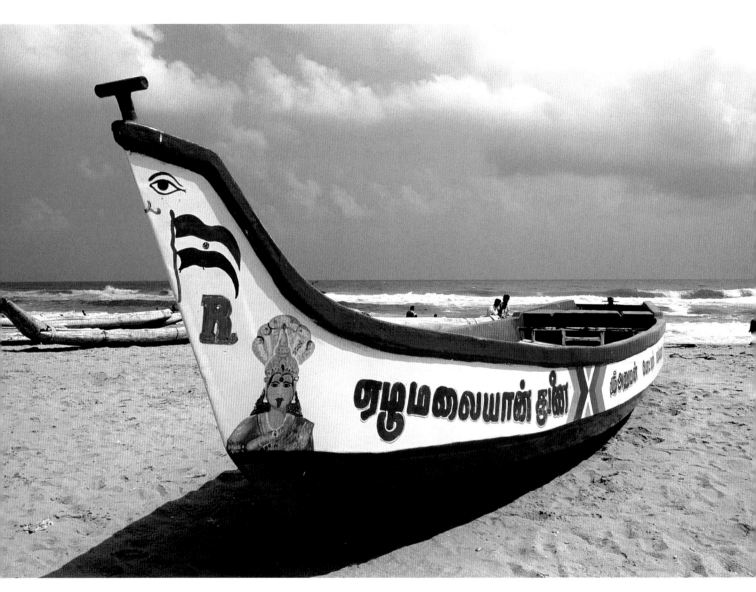

Above: The dark and ominous stormclouds were coming in fast, and formed a dramatic backdrop to this beach scene in eastern India. The colourful fishing boat contrasts well against the backdrop, and a wide-angle lens has made it the centre of interest.

Opposite: In contrast, the radiant blue sky in this shot gives a feeling of warmth and light. A polarizing filter was used to enhance the blue of the sky, and a low viewpoint exaggerates the height of the rock formations.

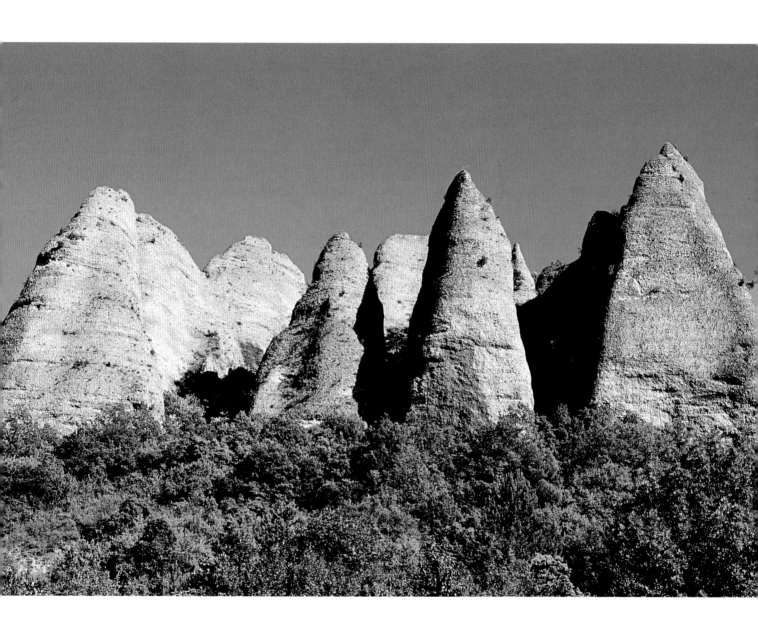

The Changing Day

Daylight changes dramatically from before dawn to well after sunset, creating different shadow patterns and changing colour hues that vary throughout the day. These changes are at their most extreme at dawn and dusk, with dramatic sunrises and sunsets.

It is because these changes vary so quickly that it is vital to be in position long before the sun actually rises. No two days are the same, and a sunrise photograph lost today may not look nearly as good the next morning.

In addition, the quality of light changes throughout the day. On a clear day the rising sun can be quite red or, as we would say in photographic terms, "warm" in colour. This variation in the appearance of light is measured on a scale known as degrees Kelvin (K); in photography this is called colour temperature. These degrees of warmth range from approximately 3,000° K – the output of an average domestic tungsten light bulb – through to about 8,000° K in the shade under hazy or overcast skies.

With colour film, the packaging tells you that it is balanced for daylight and flash, but in actual fact the daylight the film is balanced for is around 5,500° K, or the average summer sun at midday. A difference of just a few degrees either side can cause your pictures to be either redder or bluer – warmer or cooler. With digital cameras you can adjust the "white balance" – or set it to auto – to make sure that these variations in colours are captured accurately, whatever the type of prevailing light.

Throughout the day there is also a difference in shadows. At the beginning and end of the day, shadows are long; at midday, when the sun is at its highest and brightest, shadows are short. If the contrast between the light and shade is too harsh, some of the areas of the photograph can be very dark, with detail lost and some areas so light that detail will be burnt out. Our eyes can usually accommodate this variation in contrast, but the film or sensor cannot. Understanding these variations in colour casts and how shadows will fall are among the most important steps in planning a good photograph.

Left: In the summer the day can change from a clear morning to a hazy afternoon, especially in hot countries such as Greece. In situations like this, it is best to fill the foreground with as much detail as possible, as this is less affected by haze.

Opposite: The late evening sun provided the perfect light for this shot of the Giant's Causeway in Northern Ireland. Apart from the warm aura created by shooting at this time of day, the low light also provided strong shadow detail.

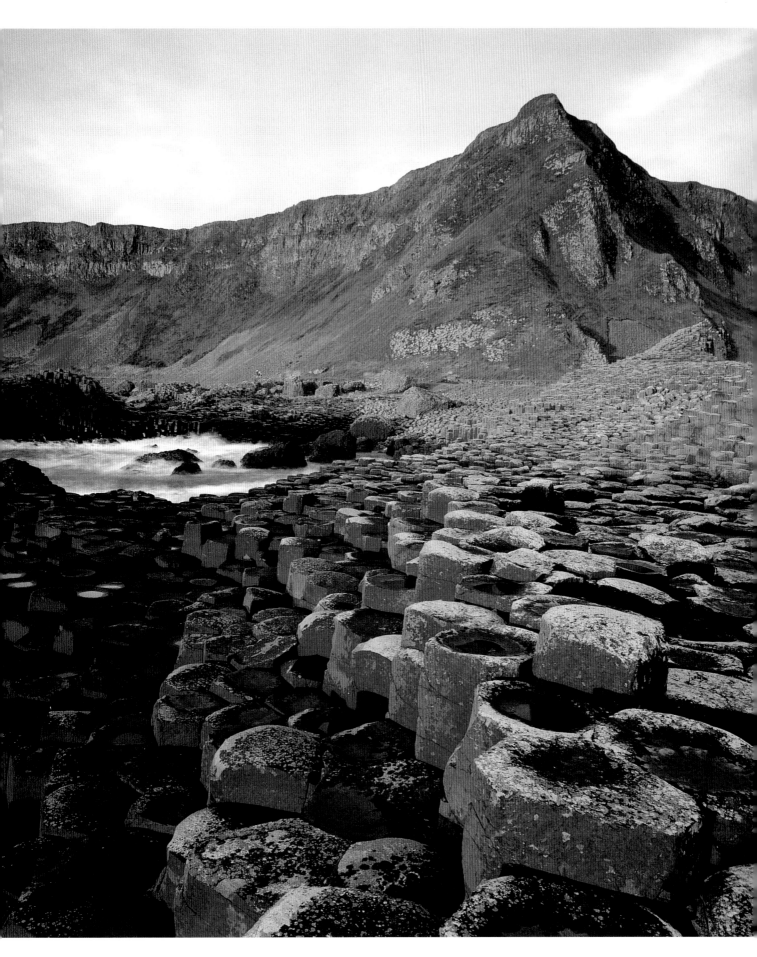

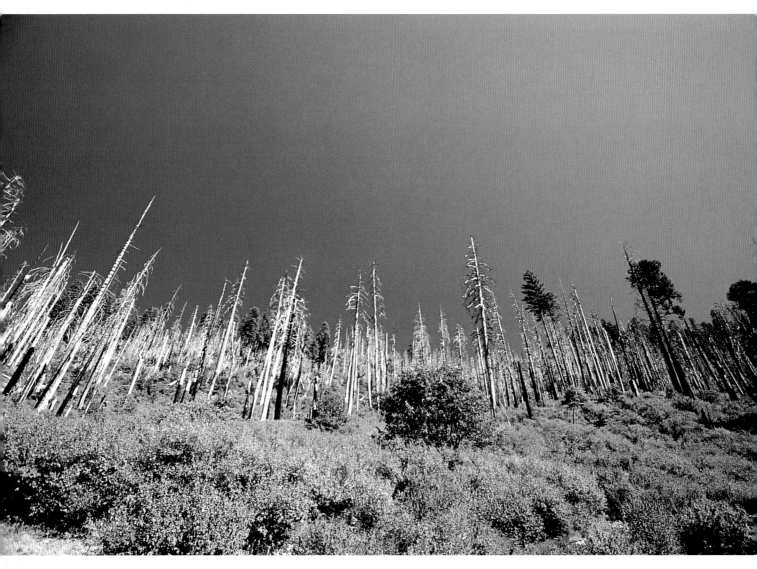

Above: In mid-morning the sun can appear crisp and blue. To enhance this I used a polarizing filter – the circular variety does not create an uneven sky when shooting with a wide-angle lens such as the 17mm used here.

Opposite: The sun setting over the coastal town of Sitges in southern Spain provided the main ingredient for this colourful shot. If you take such a shot with a digital camera, care needs to be taken that the camera's auto white balance does not neutralize the scene. For this reason it is much better to set the white balance to the K setting and in turn set this to 5,200° K.

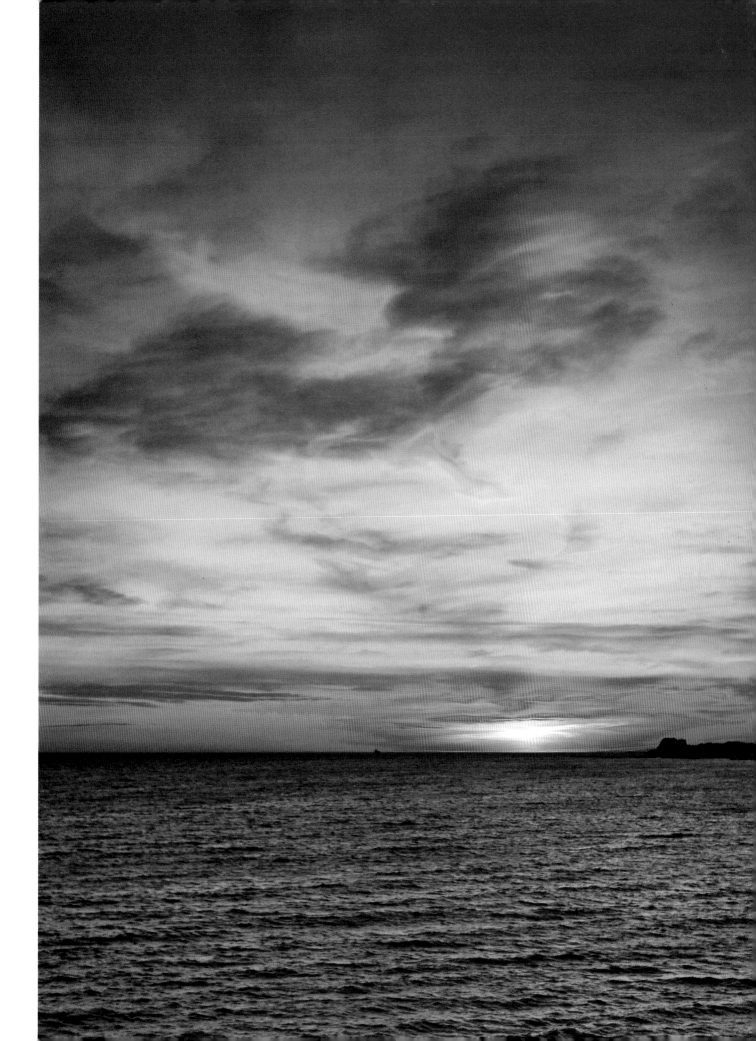

Emphasizing the Sky

Many landscape and seascape pictures fail to live up to the vision that made you stop and take the shot in the first place. How often do you see a dramatic cloud formation or a deep azure blue sky, only for the clouds to be lost and bleached out, or the blue sky to become a pale and hazy version of the vista you first saw?

One common reason for this is the difference between what is required for the sky and for the rest of the picture, which in some cases can be considerable. The trouble with most cameras that have built-in meters or are "automatic" is that they take an average reading, which results most of the time in pictures that have lost the drama of the sky and that have a foreground too dark for you to see any detail.

The best way to correct this imbalance is to use a graduated neutral density filter or a polarizing filter; in black-and-white photography, a yellow or red filter can bring out the detail of a cloudy sky (see pages 122–125). A graduated neutral density filter helps to even out the difference in the exposure of the sky and the foreground by cutting down the amount of light entering the lens from the sky portion of the picture. As with so many accessories, these filters work best with SLRs, since you can see the effect that the filter has as you look through the viewfinder, and you can then get it into the precise position for the most effective result.

A polarizing filter can help to turn the sky a deeper blue while retaining and enhancing the detail in the clouds. When using this filter, you should increase the exposure by about 1 1/2 stops. If you are using a small aperture to gain maximum depth of field with this filter, the shutter speed is likely to be so slow that you need to mount the camera on a tripod or other support, or your picture may come out unsharp.

Of course, once you have downloaded or scanned your shots into the computer, a certain amount of adjustment can be made to these two different areas of the picture. The problem is that this can be time-consuming, and you may find that more time is spent in front of the computer than in taking shots.

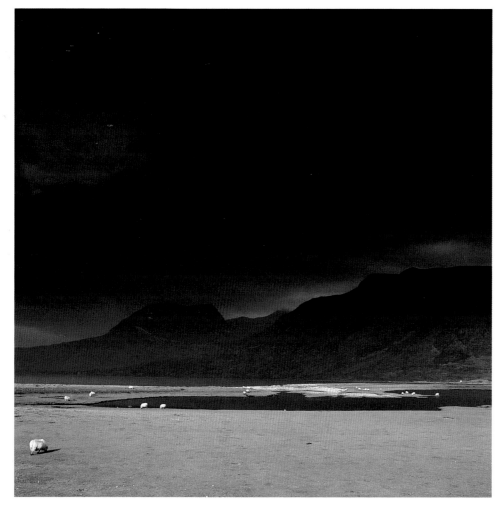

Left: Although these clouds were already very dark, I wanted to make sure they came out like that in my shot. To achieve this I used two graduated neutral density filters, which helped retain the atmosphere. I set the camera's exposure mode to manual, otherwise it would have overexposed the foreground and lightened the sky.

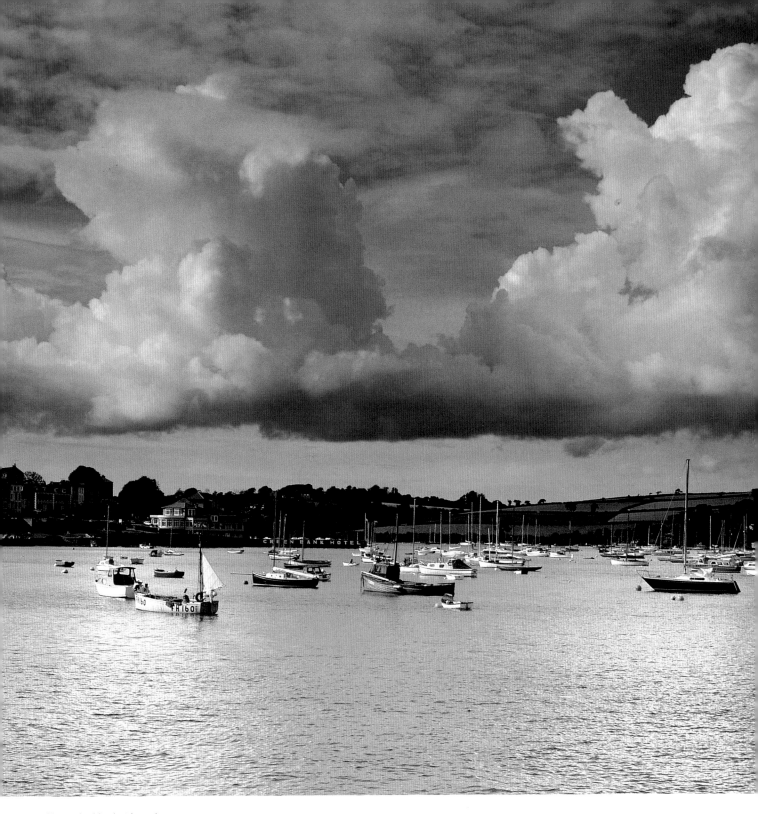

Above: In this shot I used one graduated neutral density filter, which kept the detail in the sky and provided excellent overall contrast. A medium shutter speed was required to keep the boats sharp as they moved on the water.

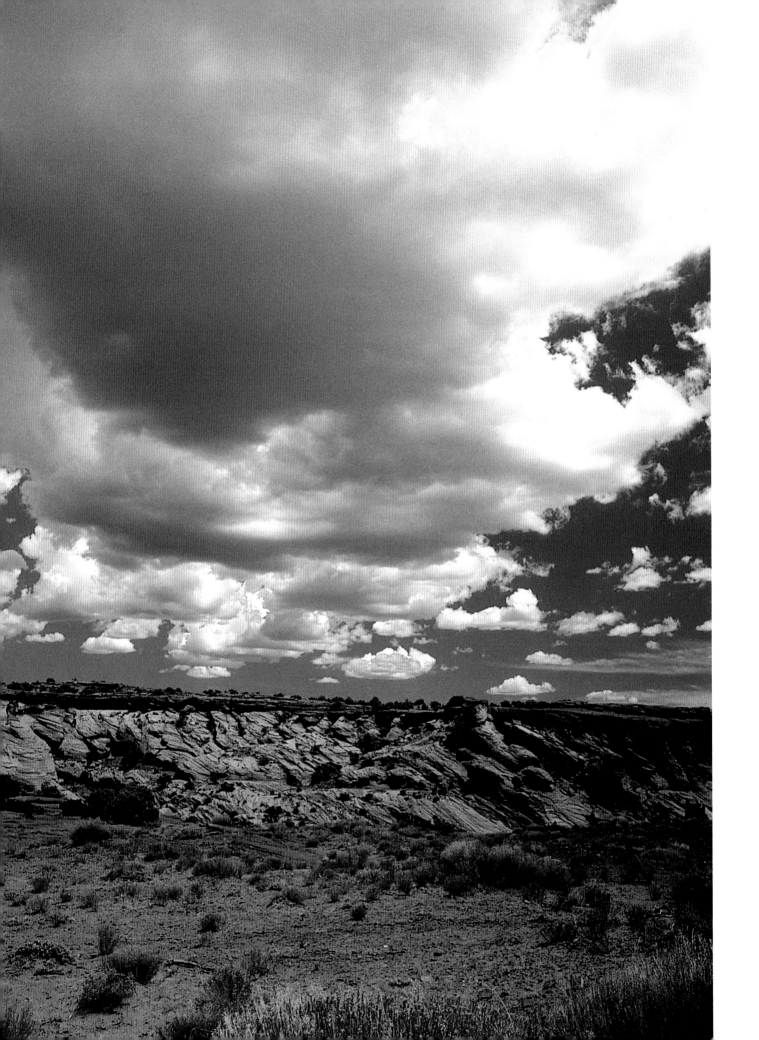

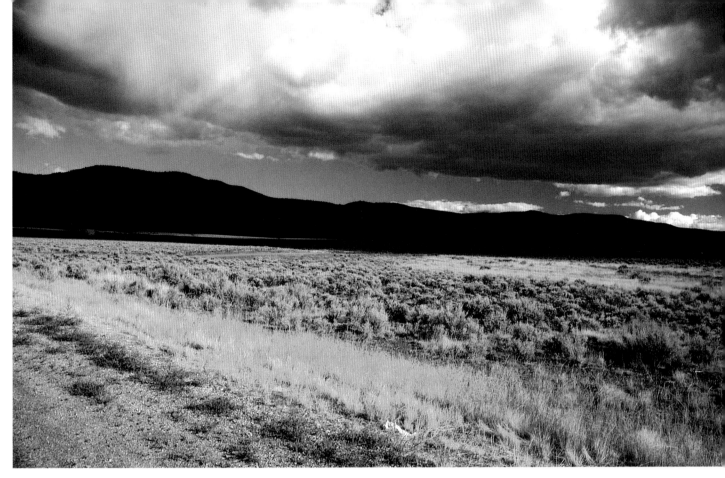

Opposite: I chose a low viewpoint and angled the camera upwards to add more drama to this picture. The clouds totally dominate the shot and have a real sense of movement as the wind blows them overhead. Always look for an angle of this kind, rather than just pointing the camera straight ahead in front of you.

Above: I particularly liked the contrast between these clouds and the bright sunshine falling on the foreground. The hills in the background are in complete shadow and add further drama. You need to be quick, as skies like this can alter rapidly.

Right: A polarizing filter was used to enhance the sky in this shot. To get the optimum effect from this filter, it is best to shoot in mid-morning or mid-afternoon. Remember that you need to increase the exposure by 1 1/2 to 2 stops when shooting with a polarizing filter.

Deserts

If there is one area of landscape photography where it pays to get up early, it is when photographing deserts. The reasons for this are many, but the most important is the position of the sun.

In a desert environment the sun rises quickly, and important shadow detail can be lost. You should therefore spend time working out the shots you want beforehand, and be in position before the sun has even risen. With experience it becomes easy to ascertain where the sun will rise and therefore where your best viewpoint is likely to be.

Try to be in position at least half an hour before the sun rises – doing this means that you can take advantage of every minute of the dawn, as the optimum amount of time for shooting is only going to be about 30 minutes. After this, shadow detail disappears, haze can quickly build up, and the general aspect of the light can make desert pictures look flat.

Another reason for an early start is if you are in a desert where there are many tourists, as you may have to go a considerable distance to find an area free of footprints, which can ruin the sense of isolation and emptiness – the very emotions that make desert pictures work.

On the other hand, animal footprints and reptile tracks made by the nocturnal creatures of the desert can form fascinating patterns in the sand; shot from a low viewpoint with a wide-angle lens, they can create foreground interest. Again, you really need a light that is low on the horizon to pick out the pattern that has been made in the sand. Another way to create foreground interest is to use desert plants, either dead or alive, or weathered rocks.

A word of warning! It is easy to die in deserts from dehydration and sunstroke. Before the sun is up you can feel extremely cold, but once the sun has risen, you can become unbearably hot very quickly. If you have walked over dunes with heavy equipment early in the day, it is disconcerting how long it can take to walk back later. Wear a wide-brimmed hat, take lots of water, and tell someone where you have gone.

Left: Even in the most inhospitable places, flora and fauna can abound. These strange-looking cacti, growing in the Mojave Desert, USA, form an interesting foreground to this shot. I used a 24mm wide-angle lens and got in as close as I could without being pricked!

Opposite: To get this shot I was up before the sun and was in position while it was still dark. I knew I wanted strong shadow detail, and I knew I would only get this within the first 20 minutes of the sun rising. Later, the light would be flat and the effect achieved here would be lost.

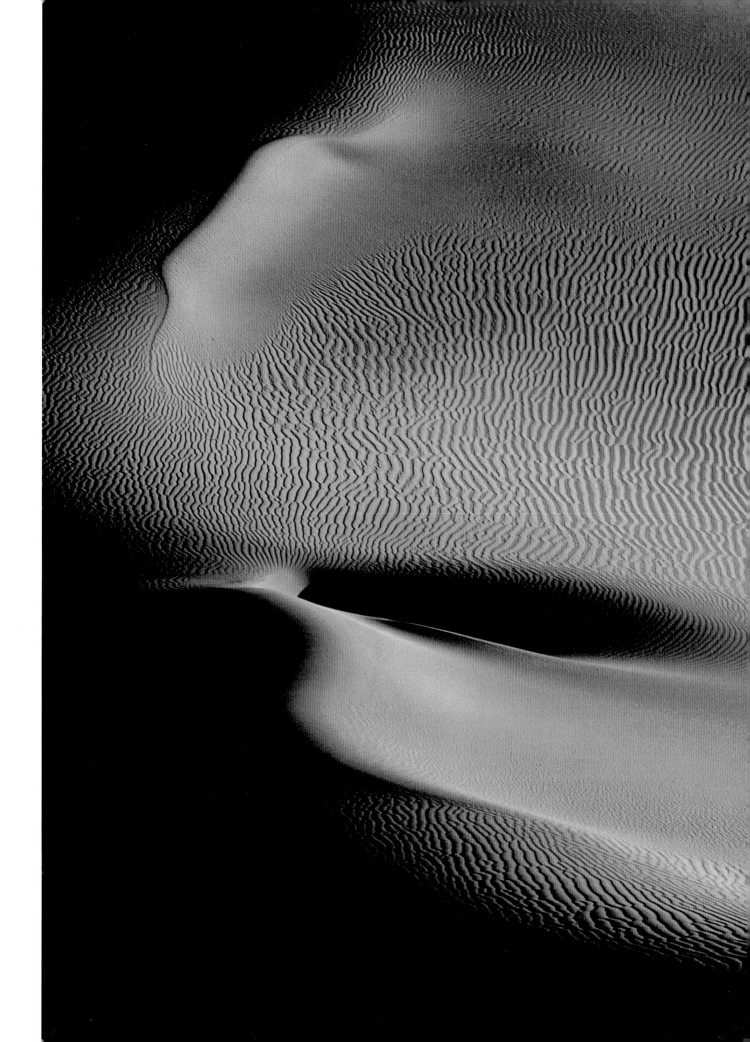

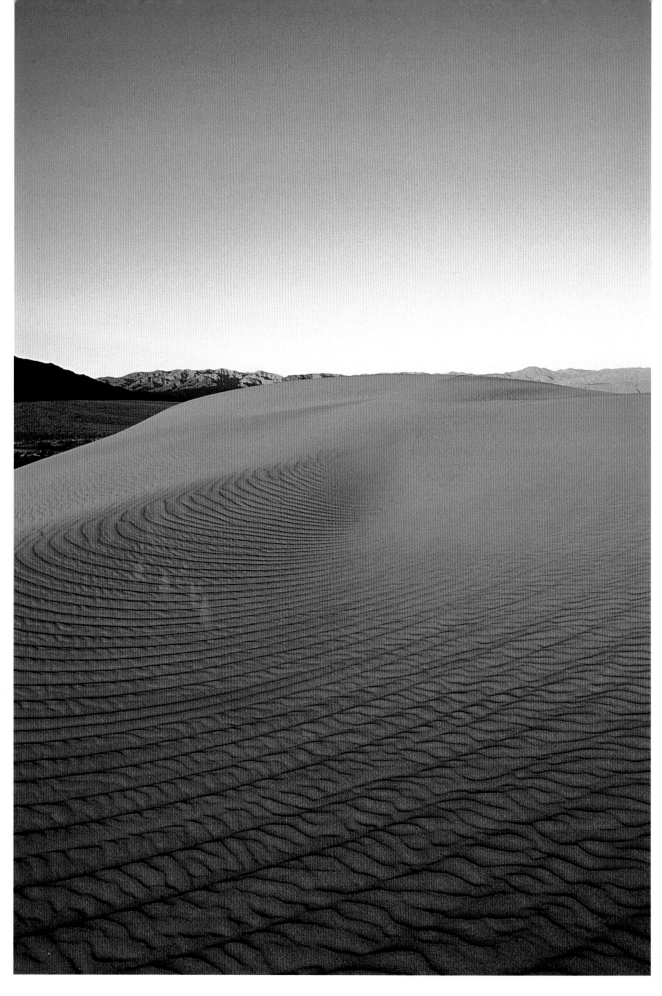

Opposite: This is another example of the benefits of getting up early. At this time of the morning the sun creates a warm glow that enhances the colour of the desert sand, which in turn contrasts well against the blue sky. The low sun brings out the pattern in the sand by providing strong shadows.

Right: I had to look up at quite a steep angle to get this shot of an eroded desert cliff. Although taken quite late in the morning, it works because of the strong shadow detail and the way the colour of the rock contrasts with the blue of the sky.

Below right: The late afternoon or early evening also provide good opportunities for desert shots. You can tell from the length of this shadow, made by the grass in an area known as the Devil's Cornfield, that the shot was not taken anywhere near midday.

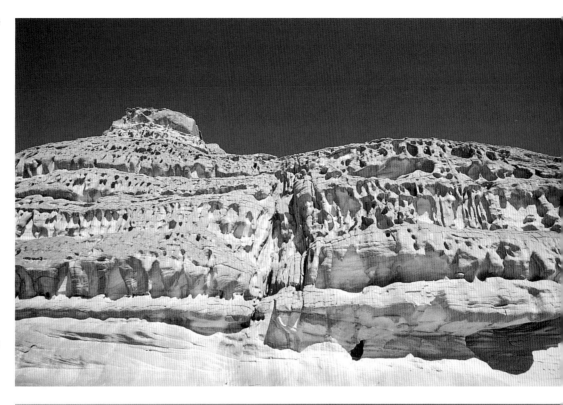

Buildings in Landscapes

Although it is true that some buildings can be a blot on the landscape, it is equally true that many are welcome additions that can enhance your landscape photographs; these are usually churches, barns and other farm buildings. Some modern buildings can provide a wealth of photographic opportunities; and even electricity pylons can, if taken from the right viewpoint, make effective shots.

You can use buildings as a prop: for instance, a building placed in the foreground of a landscape shot can help lead the eye into the rest of the picture. On the other hand, a building can be used to help to give a sense of scale, either to show the enormity of the landscape or the size of the building within the landscape. Part of a building, such as a wall, can be used as a compositional tool and placed to one side of the frame – an old, weathered, timber-framed building or a flint stone wall, for example, can add foreground interest and explain in visual terms how that particular environment has been formed.

Many buildings lend themselves to making a picture series, such as a collection of abandoned houses, which can look haunting and can convey great mystery. Alternatively, you may want to consider a series on stately homes, châteaus, castles or windmills, to give just a few examples.

If the building you are photographing has a lot of glass or other reflective surfaces, be aware of flare. This can enter the camera easily and even a lens hood may not be adequate to keep it out, so check your viewpoint carefully before shooting.

Buildings in rural settings lend themselves to being photographed with infrared film. Using Photoshop, you can replicate this effect after you have downloaded or scanned the image (see pages 134–137). Such images will look particularly effective in black and white, although infrared colour can work well too.

As always, any post-production technique should be used only to enhance and improve an image; it is all too easy to get carried away by the means and lose sight of the ends.

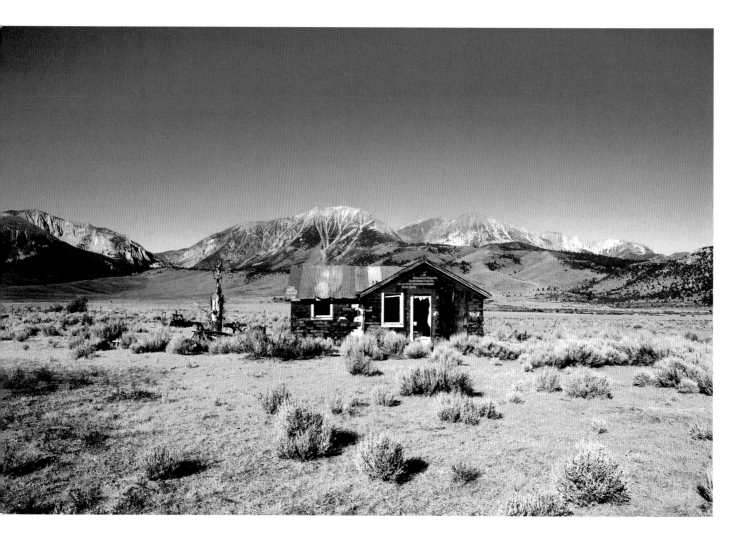

Opposite: Abandoned buildings have always provided an interesting subject for photographers, and such shots can make an intriguing series or can provide foreground interest. I shot this farmhouse near Death Valley, California, USA, in the early morning.

Above: In contrast to the house opposite, which is a relatively recently abandoned building, the Roman ruins shot here in Sicily, predate it by a couple of thousand years. One of the problems when shooting this type of picture is getting it free of tourists. This may involve a long wait and can be a test of your level of patience!

Opposite: I used a 200mm telephoto lens to take this shot of a French château; it compressed the picture and brought the building forward. I used the colonnade of trees as a framing device; the sun filtered through them to create a dappled light on the walls, while the large gates add to the foreground interest.

Right: These cottages were caught in a spotlight and contrasted dramatically with the stormy background. The light changed as soon as I had taken this shot and the buildings looked flat and featureless – speed is of the essence in this type of light.

Below: In contrast to the buildings above, these agricultural silos are bathed in strong sunlight. They make an interesting shape that contrasts with the hills in the background, while the colour of the foreground grass contrasts equally well with the blue of the sky.

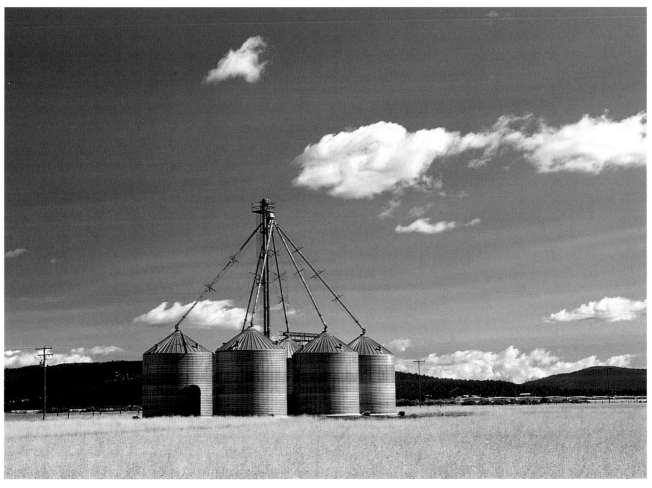

The Urban Landscape

While many people think of landscape photographs as those taken in beautiful or dramatic rural settings, there is another type of landscape that is not rural and definitely not beautiful in the traditional sense. This is the urban landscape. What this type of environment may lack in terms of a romantic idyll, it undoubtedly makes up in gritty energy, and this vitality can create stunning images.

Of course the phrase "the urban landscape" can conjure up the worst aspects of urban living. But there are urban environments that have mellowed into the natural landscape over the years, and we now look at them through the same rose-tinted glasses as we do when we see a beautiful rural landscape. But whether it is this type of environment or one of inner-city decay, the opportunity for descriptive imagery abounds. It may seem obvious to shoot the former in colour and the latter in black and white; however, while both these approaches can be relevant in many situations, it by no means follows that the reverse cannot work equally as well.

In modern cities that have many buildings constructed with highly reflective metal surfaces and prolific use of glass, stray light can be a problem, bouncing off the buildings' surfaces and entering the camera's lens. Depending on the angle at which this happens, even a lens hood may not be enough, so be aware of the potential problem when composing your shots.

When photographing an urban scene at night, try to take your shots in the twilight, the period of time that occurs about half an hour after sunset and lasts for about 20 minutes. During this time the sky turns a deep blue and forms a far more effective backdrop than if you wait until a little later on, when the sky is pitch black.

As with so many situations in landscape photography, it pays to do your research and to be in place for a shot like this well before the light is at its peak; in this way you can critically observe the changing hue and shoot it when it is at its most photogenic. (Of course, the same is true at the beginning of the day, when the sun rises.)

Left: In this shot I deliberately kept the building on the left of the shot completely upright. To do this I used a PC lens, and it contrasts well with the curve of the building on the right. In the middle is London's Tower Bridge which completes an interesting range of architectural styles.

Opposite: This shot was taken from a helicopter high over Los Angeles, and the slip roads to the freeway form an interesting pattern in the foreground. Considering how notorious the smog can be in this city, the view towards the Downtown area is surprisingly clear.

Overleaf: I chose a low viewpoint for this shot of Sydney's Harbour Bridge and timed it so that I would be in position well before the twilight. Once the sky goes dark this type of shot can look dull and flat, and the buildings do not stand out nearly so well against the sky.

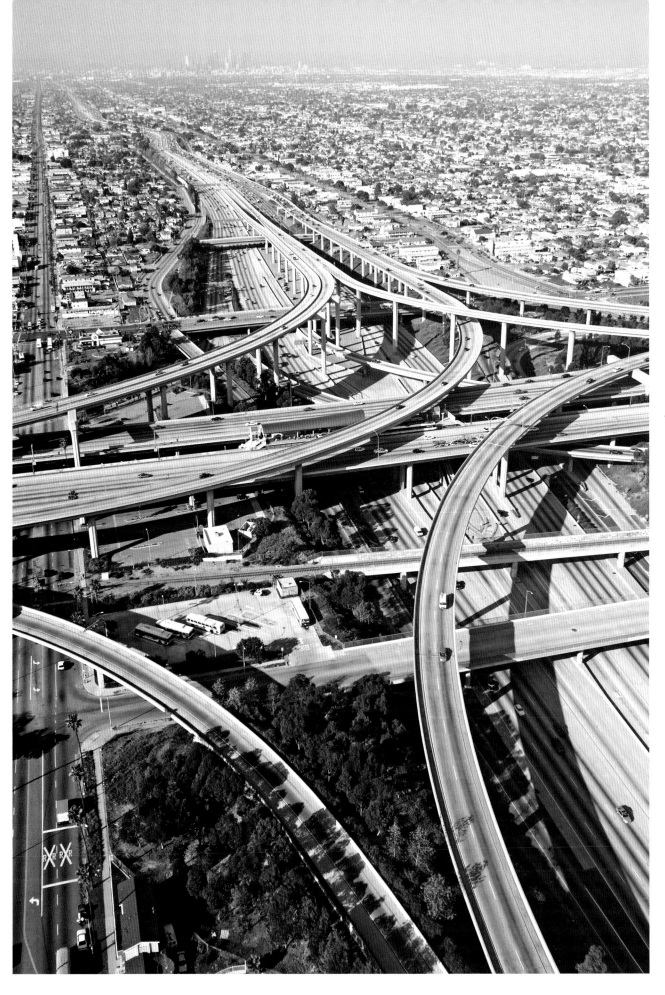

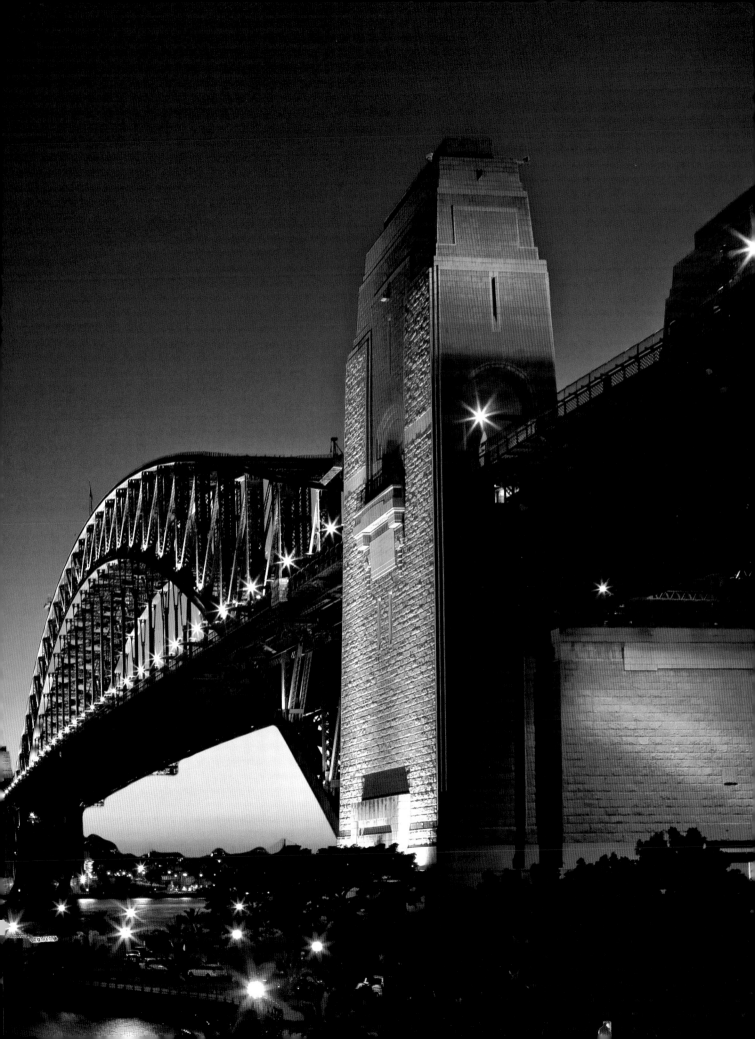

People in Landscapes

People can be a welcome addition to landscape photography for three reasons. The first is that they can give a sense of scale; the second is that they can be used as a compositional tool to enliven what might be an otherwise dull area of foreground; and the third is that they may work the land, so it is natural to include them.

When photographing someone in their environment, such as a shepherd, try to get to know them, rather than trying to shoot them unawares. Many people are only too happy to be photographed, and once you have gained their confidence it becomes much easier to get the shot you really want. The basis for this is that they might not be in the optimum position, and if you can move them, even only slightly, the light, the composition or their pose can be significantly improved.

If you position people close to the camera and you are using a wide-angle lens, be careful that you do not distort their features, especially facial ones. This is easily done, and doesn't look particularly attractive in the majority of situations.

One problem that can occur when your subject is placed close to the camera in landscape photographs, is getting sufficient depth of field. Because this may mean using an aperture of f16 or f22, it can necessitate using a slow shutter speed. It is virtually impossible to hold a camera completely still at shutter speeds of less than 1/30th second, so you have to find some method of supporting the camera; by far the best is a tripod, and if you are at all serious about your landscape photography, this piece of kit will prove its worth time and time again. As with so many aspects of photography, a study of the great photographers is always the benchmark for deciding on the right equipment. Be it Ansel Adams, Edward Weston, Michael Busselle or Charlie Waite, the techniques are similar: they all use a tripod for every shot!

One last point: if your subject is wearing a hat, make sure that this does not cause an ugly shadow to fall across the face. If this is the case, you may have to use a small amount of fill-in flash, or alter their position.

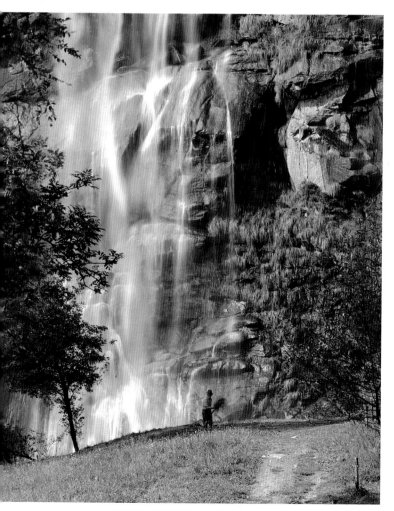

Above: Although this stretch of beach in Tunisia looked attractive, it had very little photographic interest to me until I came across this person with his camel. His colourful clothes contrast well against the blue of the sky and sea, and he provided the foreground interest that had been lacking before.

Left: To get an idea of the height of this waterfall, it definitely helped to include the figure of the farmer cutting the grass. Using people in this way helps to give a sense of scale to your landscape pictures.

Right: In this example I asked a complete stranger if he would mind being in my shot. Again, I wanted to get a sense of scale, and this could only be achieved by including a figure. I waited until the group he was with had moved and then posed him looking as if he was taking a shot himself, which works much better than if he was just standing there.

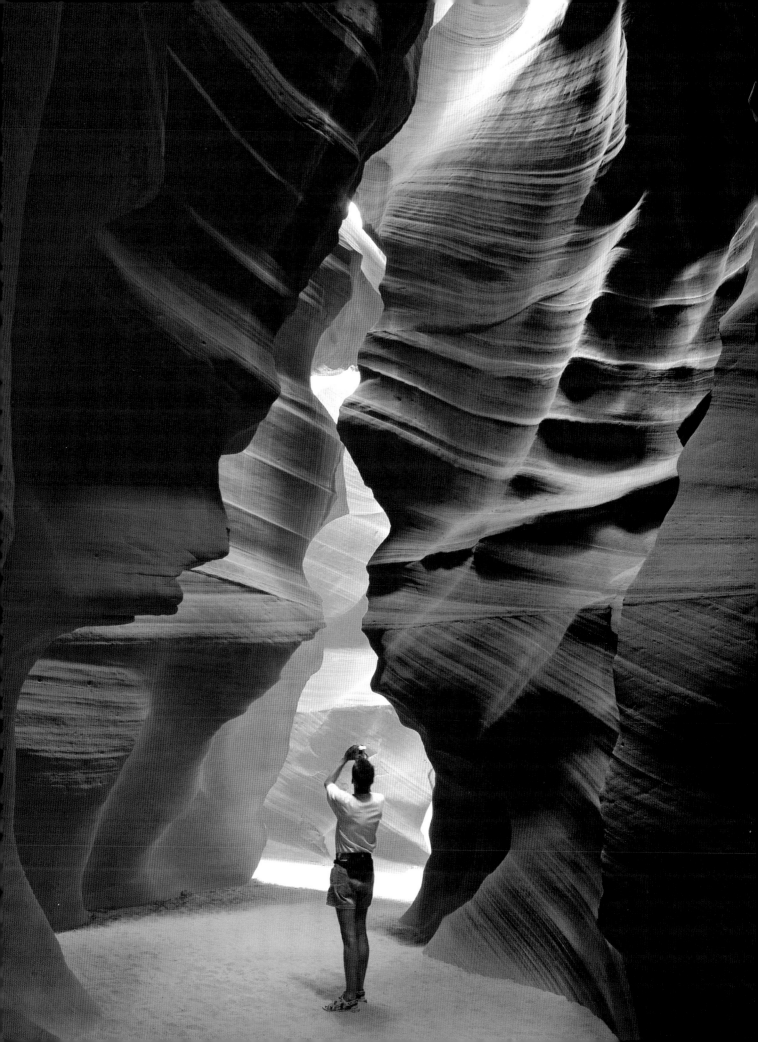

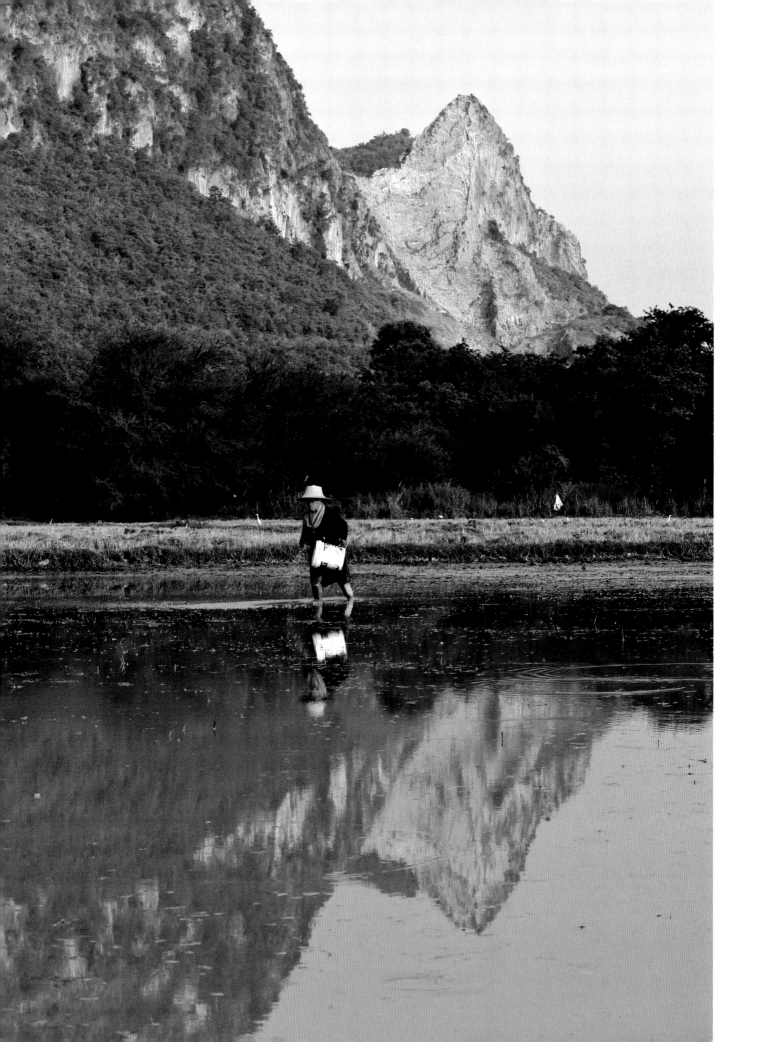

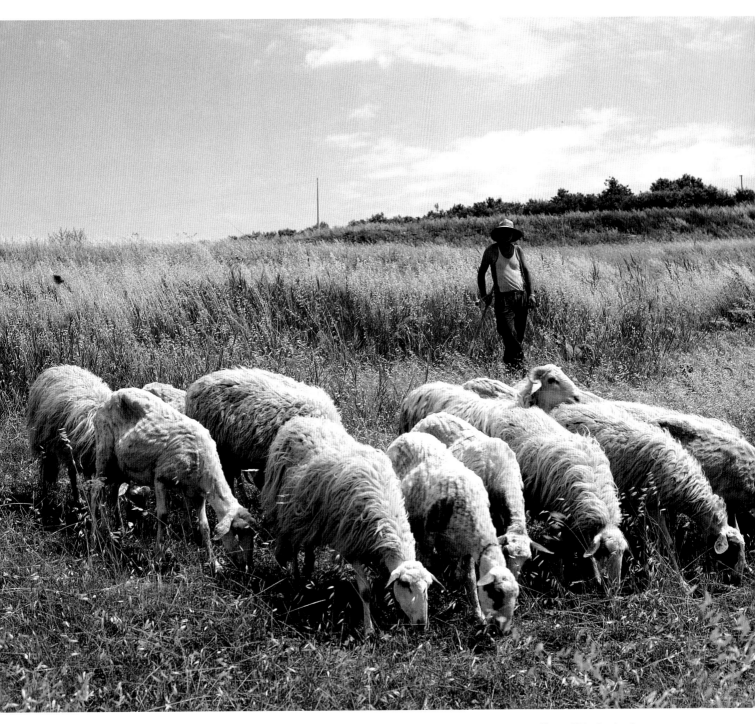

Opposite: I waited until this woman sowing rice had reached what I thought was the optimum position. I had already positioned myself and composed the shot so that I could take advantage of the mountains reflected in the water as well as them providing an interesting backdrop.

Above: This shepherd was as fascinated by me as I was by him and his sheep. I used a wide-angle lens to get as close to the sheep as possible without scaring them, but took care that he did not recede into the background too much. The lens gave good depth of field, even without stopping down.

3 Further Techniques

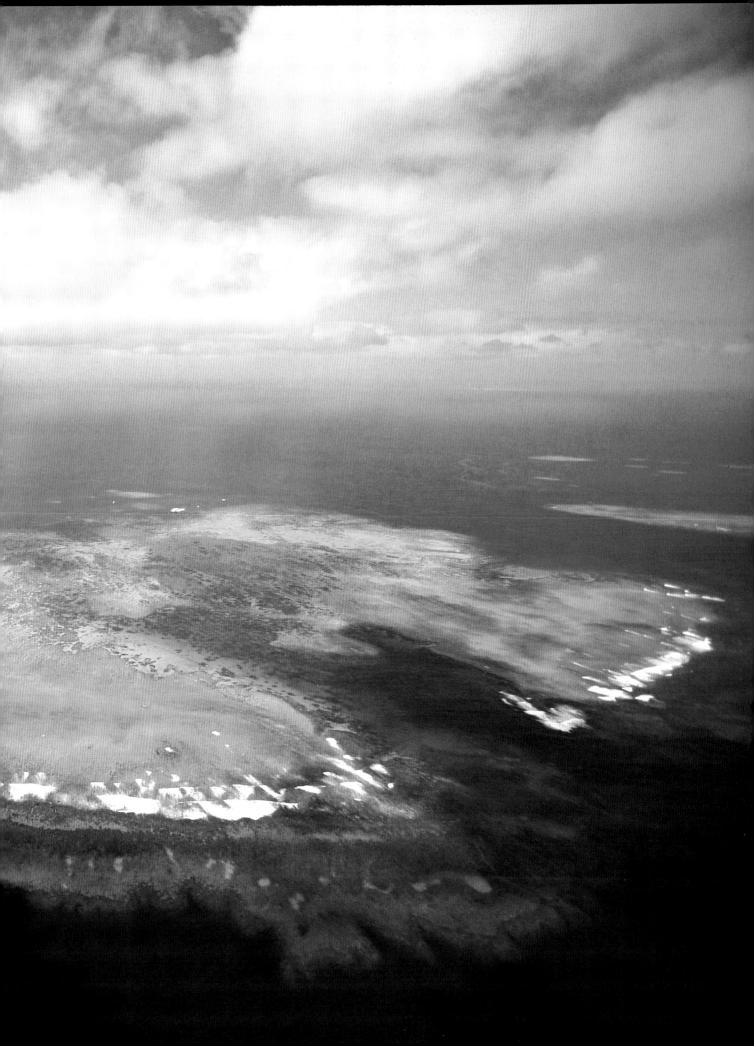

Multiple Images

There are several different ways to produce multiple-image photographs, many of which are particularly well suited to landscape photography. The two most common methods are either to shoot a multiple exposure picture in camera, or create a multiple image picture on the computer. With the former, forethought is essential, as you need to plan carefully and decide well in advance exactly where you want each constituent part to be.

On a camera that allows you to change the focusing screen, it can be helpful to fit a grid screen. This has vertical and horizontal lines running across it to help you to compose your photograph, as you know exactly where to put each shot image.

You may want to take your multiple-image photograph from the same spot with the camera mounted on a tripod if, for instance, you want to build up movement in the sky. If your exposure under normal circumstances would be 1/15th second at f22, you could take,say, six exposures at 1/125th second at f22; and if you take these shots at intervals, the cloud movement will be blurred.

This technique can add real atmosphere to a landscape shot and is especially the case in the late afternoon, when the light gets warmer. For the greatest effect, it is essential that all other detail is completely still, so a tripod is essential.

Another way of creating a multiple landscape image is to use a single photograph downloaded or scanned onto the computer. From this one image you can make a duplicate version and then flip it to make a mirror image. Having done this, both images can be butted up to one another and then printed as a single image. Careful selection of the original image is vital for the finished print to have maximum impact.

You don't have to stop with just two versions – any number of original and mirror images can be treated in this way so that a kaleidoscopic effect can be built up. Working in black and white, you can tone the image as yet another derivative or turn the original into a high-contrast version, which gives the finished print an extremely graphic quality.

Creating a multiple image

1. Although I was pleased with this landscape photograph, I felt that it could also be used to create a multiple image effect: it had lots of detail on the left-hand side, which I felt would be ideal for making a mirror image, so I downloaded it and used Photoshop to manipulate it.

2. I made a duplicate of the image onto a layer and then doubled the canvas size. I then flipped this vertically and joined the two together so that it resembled a valley.

3. I then repeated the process, this time with a mountain effect, which I preferred, as I thought it made a stronger composition, especially with the rock faces' strata.

Right: I created this sky effect in camera by building up the exposure over several shots. To do this effectively you need to have the camera on a tripod, otherwise the picture will just be blurred. The exposure required was 1/15th second @ f22. However, I set the multiple image setting on the camera and took eight separate exposures of 1/125th second @ f22. Each time I took a shot to build up the exposure, the clouds had moved slightly. By the time the final shot had been taken, the clouds looked as though they were moving across the sky. To increase the impact of the final image, I made a composite of the sky with another landscape picture (see pages 118–119). The final result has great impact and a real sense of movement.

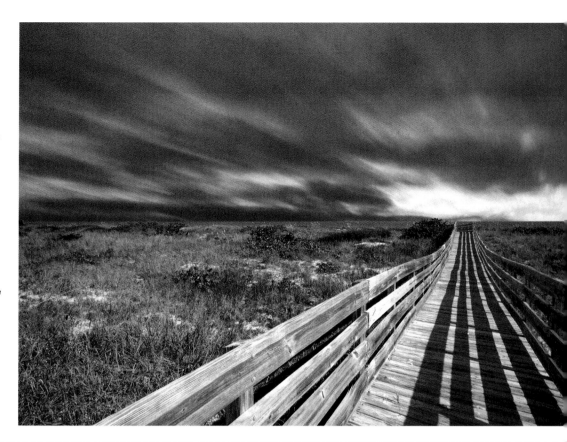

4. I repeated the mountain effect again, but this time I flipped it on the horizontal and butted this up to the other image. I now had a kaleidoscope image. I then added an ocean ripple filter to make it resemble a mirror image as if it was reflected in water.

Overleaf: However, I thought that this was one step too far and that it looked best without the filter. When creating any image like this, the skill is in knowing when to stop.

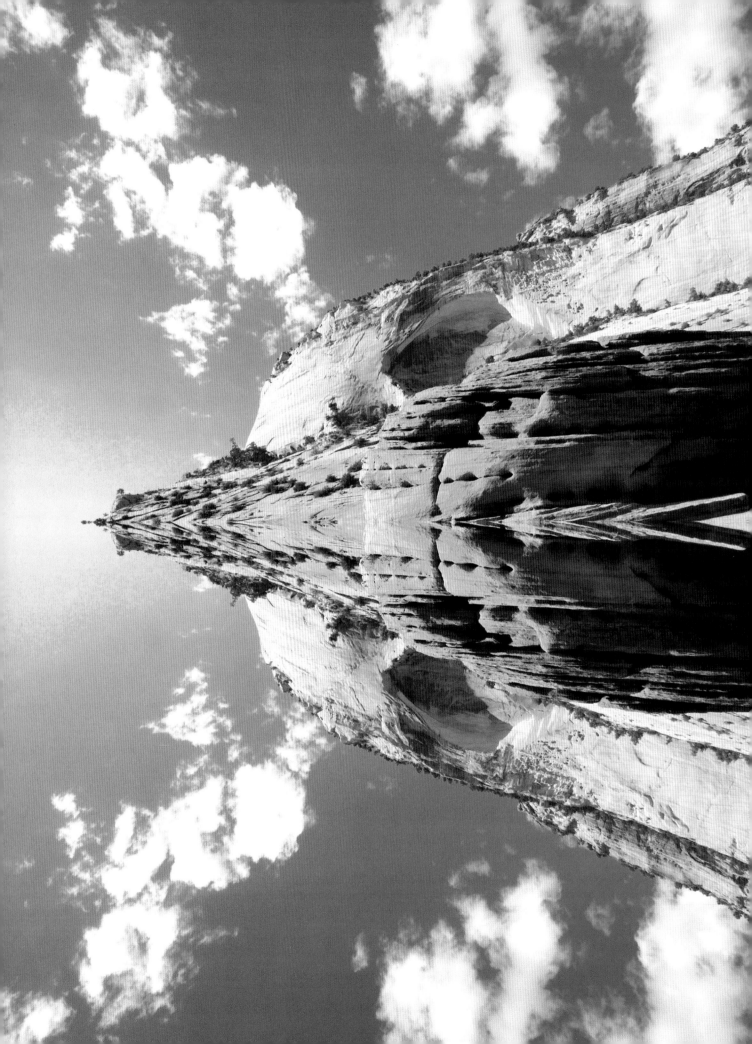

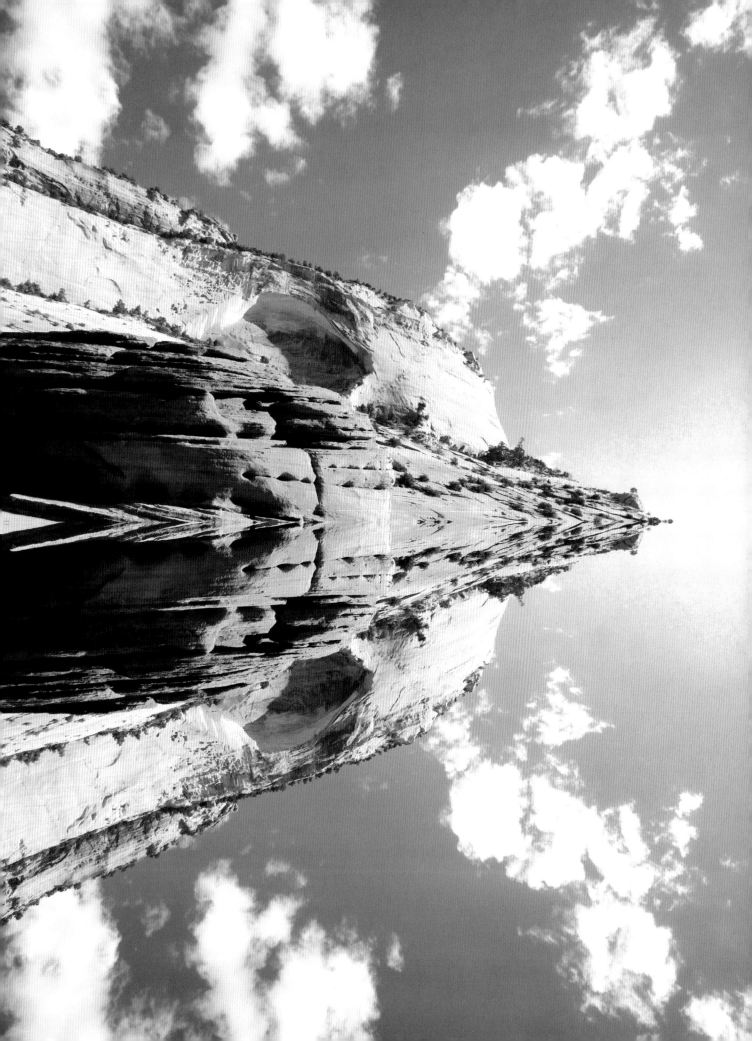

Building Panoramas

Imagine seeing a breathtaking view so wide that you literally can only take it all in by turning your head from one side to the other. The angle of view might be as much as 180°, and although you can use a fish-eye lens to encompass this, everything looks distorted, especially at the edges, which curve from the top to bottom of the frame, with an unattractive end result.

One possibility is to use a panoramic camera (see pages 126–129); however, even with this it still may not be possible to take in the entire view, as most of these cameras have an angle of view in the region of 100°. Another alternative is to photograph the scene in sections and then "stitch" them together on a computer to build them into a single panorama.

Most digital cameras come with a panorama-building program. Under ideal conditions these programs give excellent results, however, more often blurring is visible where textures overlap, or where exposure differences are noticeable due to vignetting by lenses that are not of the highest grade.

When taking photographs to build a panorama, you need to keep the camera completely level. For this reason it is best to work on a tripod with a pan tilt head so that you can smoothly move the camera across your chosen view. Take as many shots as you think are necessary – you do not need to use them all, but it is better to have too many than too few.

Exposure is important, as you want the scene to be as evenly lit as possible, which can mean giving different exposures to the different shots. Because of this, it might be best to bracket each shot that will make up your panorama and to edit them later. If you are using a filter such as a polarizing filter, the effect this has on the sky can diminish or increase as you pan the camera. This can give the sky a very uneven appearance, as can be the case if you use a graduated neutral density filter.

Remember, in the northern hemisphere, if you are looking south the sun moves from left to right; depending on the time of day, one side of your view can be in direct sunlight while the other is in shade. (Vice versa in the southern hemisphere.)

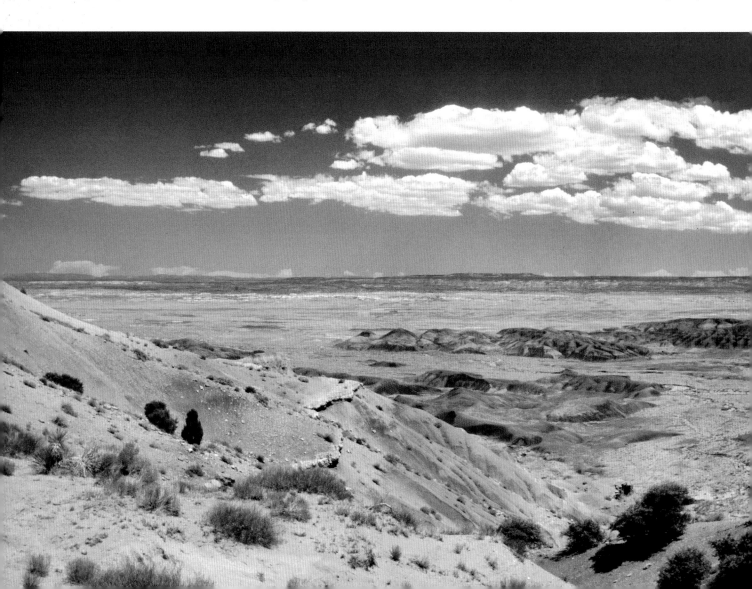

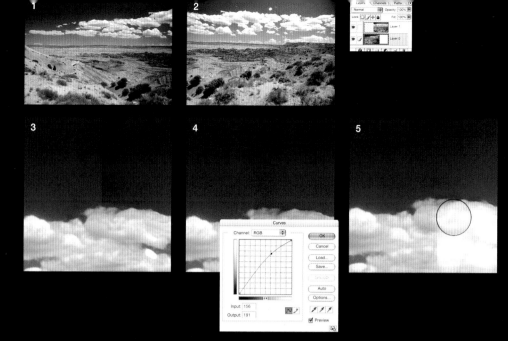

1 **2**

3 **4** **5**

Curves

Channel: RGB

OK
Cancel
Load...
Save...
Auto
Options...

Input: 156
Output: 191

☑ Preview

Left and below. The shots on the left show the separate images I wanted to stitch together to make a panorama. They were originally shot on transparency film, which I scanned and then downloaded into the computer. Some parts of the images overlap and are at different heights. In (3) the sky is different colours at the overlap. To correct this, I used the Curves or Hue Saturation commands to blend the colours together as closely as possible. You can never completely match two hard edges, but with a large Soft Erase tool you can soften one edge, which can then be blended with the other (5).

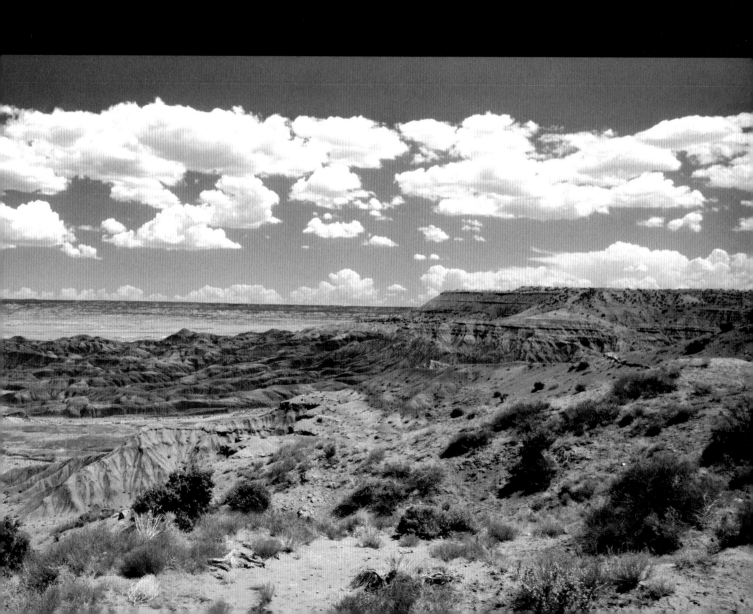

Checking the detail

The image below, shot in the Mojave Desert, is a panorama of five individual shots. This effect would be almost impossible to achieve without shooting on an ultra-wide-angle lens, such as a fish-eye. However, with a fish-eye the sides of the image would curve and the background would appear to recede into the distance, making any detail difficult to see.

I joined images 1–5 together using the panorama-building software that came with my Canon 1DS camera; this automatically composites the pictures almost seamlessly, without any curvature at the edges. At this stage, only the road sign stands out as two badly joined images.

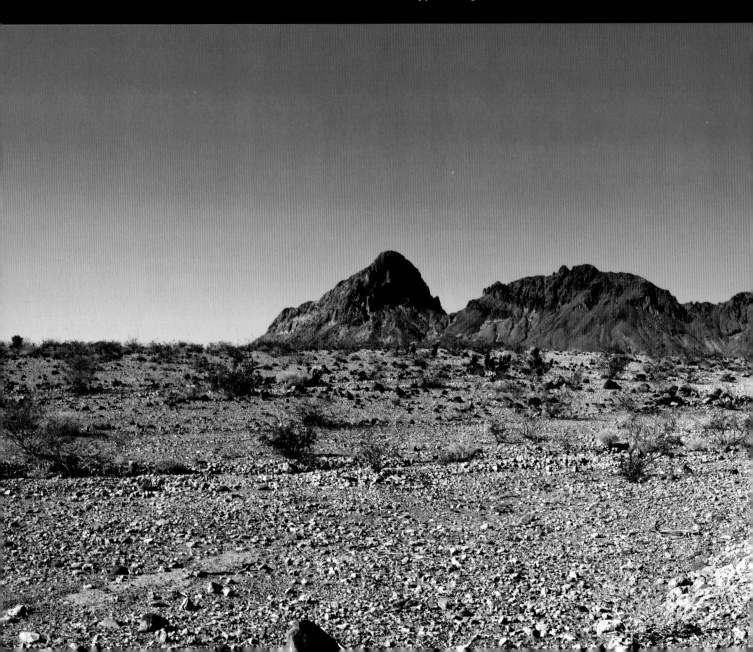

Because the software cannot correct every detail, in (6), we can see that the edges have been poorly blended. To correct this I cut and pasted a part of the original image to disguise the very obvious join (7). The end result (below) looks like a single image shot, where only the most critical eye could detect the joins.

Digital Composites

Nearly all photographers have had the experience of seeing a potentially stunning landscape ruined because the sky was dull and overcast, or the background was an unhappy match with the foreground subject. Many shots that have suffered from these faults can be revitalized by making a composite of one or more shots.

When creating digital composites in landscape photography, the first thing to consider is that the shots you plan to combine must complement one another – for instance, if you are going to replace the sky in your landscape, you need to substitute it with one that has been taken from a realistic and believable angle. You also need to choose shots that have similar ranges of tones – for instance, if you choose a landscape from a picture taken from a low viewpoint and use it with a sky shot from a high viewpoint, the results will look wrong compositionally. To take another example, if you try to combine a shot with a bright, sunny sky with a landscape that has very little shadow detail, the finished picture cannot appear very convincing. Even in countries where the weather is generally dry and rain-free, skies can be flat and uninteresting, possibly due to heat haze or pollution caused by traffic congestion.

However, with the right images new life can be given to mediocre pictures, and so it is important not to give up on a shot just because one of the elements is not how you really want it. As you become more knowledgeable, you may be able to work out at an early stage just how a shot may look with an element of another shot that you already have in your library of photographs. Alternatively, having taken a shot with an offending element, you then look out for the possibility of shooting one specifically to replace it.

With practice and increasing skill it becomes possible to start shooting pictures specifically for making digital composites; these can then be placed in your library under their various categories, such as skies, seashores, foregrounds etc. In addition, some can be used to create more abstract and surreal imagery (see pages 150–153).

Improving an existing image

Often it is not possible to wait for all the ingredients that would make a perfect landscape picture to be in place. For example, an overcast sky could remain for days, but by compositing two separate images, you can create a near-perfect composition.

1. I felt that this landscape, which I shot in Spain, could have been improved if the sky had not been quite so flat. By compositing the sky from another image, which was shot in Scotland, I transformed the original into a far better picture, where the clouds add greater depth (opposite).

2. It is important to select an image where the cloud formation blends in with the landscape and has similar tonal ranges. Remove any blemishes from the two elements; tonal and colour adjustments can be made once the composite is complete. Erase the sky from the main image, and replace it with the alternative sky on a new layer.

3. Having transformed the new sky, you can now enlarge or reduce certain parts of it so that it looks convincing and fits perfectly. Some parts of the sky might have to be cloned or rebuilt, and it can help in this situation to make the main image semi-transparent to aid accurate positioning.

4. The more intricate parts of the sky can now be selected with the Magic Wand tool, then removed. Some areas might need to be removed with the Eraser tool.

5. The two sections of the picture now need to be balanced using a combination of Levels, Curves and Hue/Saturation dialog boxes.

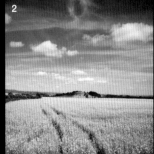

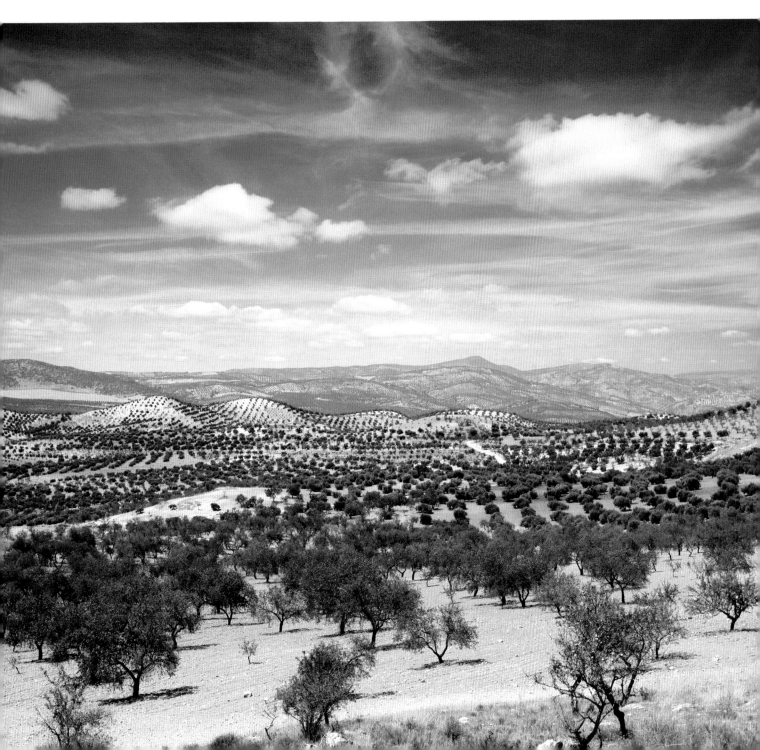

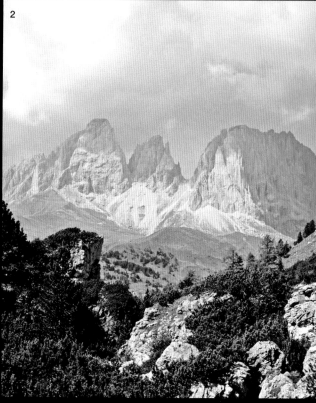

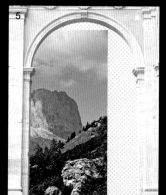

Changing the image

I took both the picture of the arch and the one of the mountains in Italy and thought that if I put the two together, I could create a *trompe l'oeil* effect, normally associated with painting.

1. I retouched the arch and removed the drainpipe, which is visible on the right hand side, by

3. I then replaced this with the mountains and introduced it on a layer behind the arch.

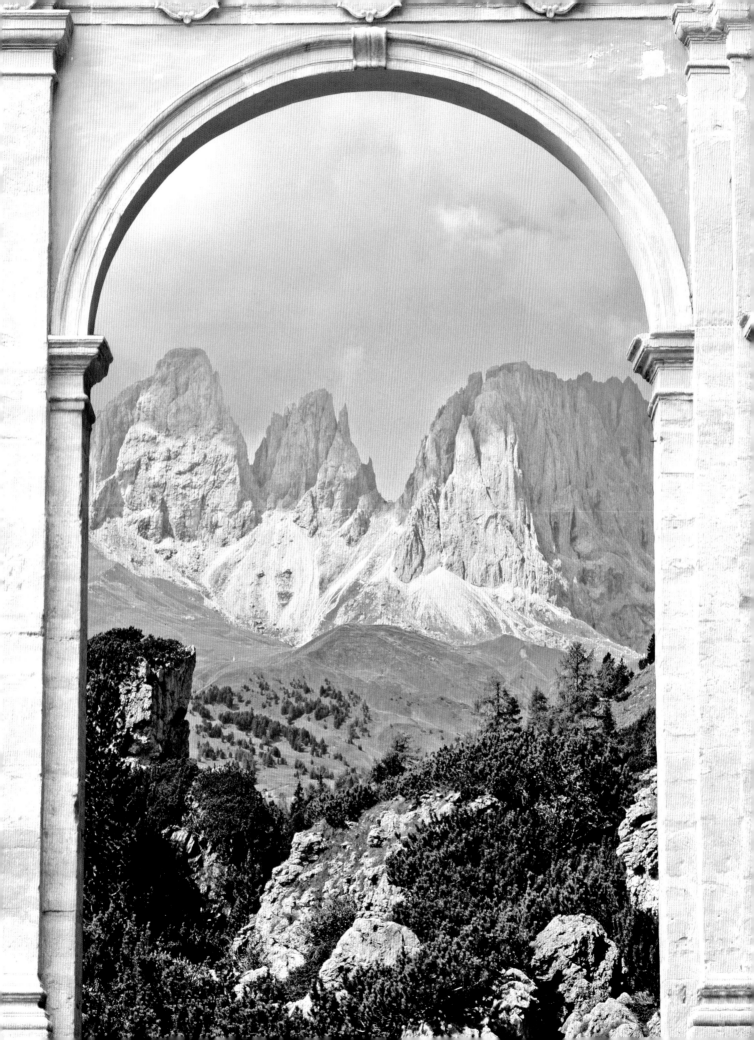

Using Filters

Of all the accessories that can be used to improve and enhance your landscape photography, filters have to be the most effective for the minimum outlay.

First in line are UV or skylight filters, one of which should have a permanent place on all your lenses to protect them from dust, scratches and knocks – if a filter gets damaged it is relatively inexpensive to replace, whereas a lens can cost hundreds, if not thousands, of pounds.

The next filter to consider is a graduated neutral density filter, which, as its name implies, graduates from clear glass or plastic to a band of what looks like a grey coating. This coating comes in various strengths and cuts down the amount of exposure required without causing a colour cast. (Having said that, some cheap varieties might be susceptible to this problem.) A graduated neutral density filter is excellent for photographing landscapes where the difference in exposure between the sky and the foreground can result in either the sky being burnt out or the foreground underexposed.

On an SLR camera, it is easy to see what effect the filter is having and get it in exactly the right place. It is vital when using TTL metering to remember to take your reading before you slide the filter into position and to have the metering mode set on manual, otherwise your shot is likely to be overexposed.

Another important filter is the polarizing filter, which serves two purposes: first, it can eliminate unwanted reflections, and second, it can enhance a blue sky and make clouds stand out with greater clarity. To do this effectively, it is essential that the sun is at the correct angle to your subject and the camera viewpoint – when taking your shot, keep the sun at right angles to the camera and choose a time of day – usually mid-morning – when it is at about 45°. Sometimes a blue sky doesn't need to be enhanced, and if you use this filter the sky can turn almost black. The other point to remember is that with extreme wide-angle lenses the coverage of the polarizing filter is only partial – this means that one side of the frame has a deep blue sky, while the other is unaffected.

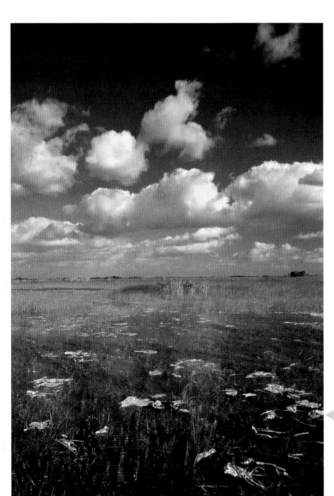

Left: When shooting landscapes on black and white film, a yellow filter helps to enhance the clouds and give your shot greater clarity. A red filter darkens the sky even more. Both these filters are worth keeping with you at all times.

Below: There is an optimum position for taking shots with a polarizing filter, as the diagram shows. Ideally the camera should be at right angles to the sun, which should be at an angle of roughly 45° from the horizon. The best times to get this combination are mid-morning and mid-afternoon – at midday the sun is far too high, and using the polarizing filter is likely to have almost no effect.

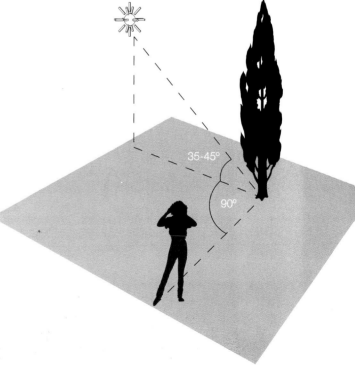

35-45°

90°

Graduated neutral density filter

1. Often in landscape photography there is a difference in the exposure required between the foreground and the sky – if you expose for the foreground, the sky can come out overexposed and all the clarity of the cloud detail is lost. On the other hand, if you expose for the sky, the foreground can be underexposed and lack detail.

2. You can correct this by using a graduated neutral density filter. This cuts down on the exposure required for the sky and balances it more evenly with the foreground, so that the shot has a better overall exposure and both the foreground and the sky detail are recorded.

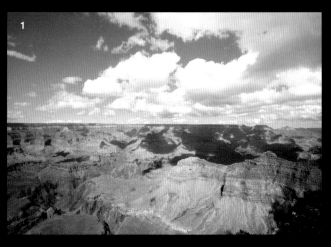

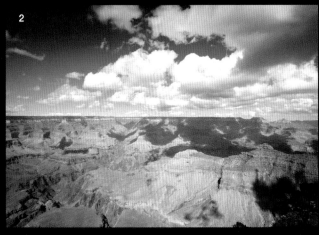

Polarizing filter

1. In this shot, you can see that if you take an average exposure, lots of sky detail can be lost and the clouds can look a pale imitation of how you first envisaged the shot.

2. By using a polarizing filter, the sky has retained its depth and the clouds have retained much more of their detail. However, there is an optimum time of day for this filter to perform at its best (see opposite).

3. There are occasions when polarizing filters can upset the balance of photographs. In this picture of a river, I thought if best to use the filter to bring out the detail of the sky.

4. Although this has happened, it is at the expense of the reflection in the water. This has now been lost, and the river looks like a dark band, especially the nearer it gets to the foreground.

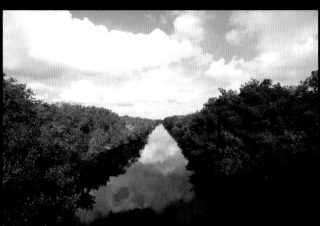

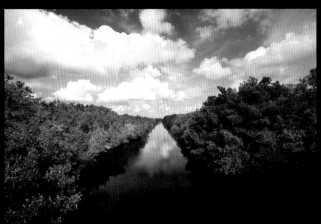

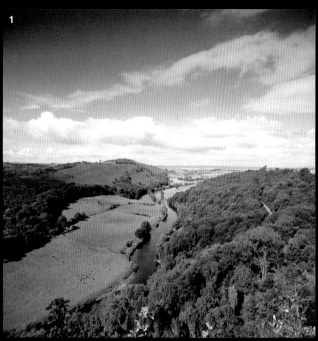

1. Even the most seasoned professional can sometimes forget a piece of kit, such as a filter. In this shot, the sky looks washed out and a bit dull, while the river looks dark and lacks colour and detail.

2. In QuickMask mode I drew a gradient, which I then turned into a selection. This means that I masked out the foreground so that it was not affected by any adjustments made to the sky.

3. I then made a new Curves Adjustment layer so that I could increase the contrast of the sky. This was linked to the mask that I had made previously, so only the sky was affected.

4. Having got the sky to the desired effect, I reversed the mask so that I could now work on the river. I used the Hue/Saturation command to colour the water and intensify the blue.

Opposite: The final image is much more to my liking and nearer to the look it would have had if I had used a graduated neutral density filter. This route was obviously more time-consuming, and there is no substitute for getting the shot right at the outset.

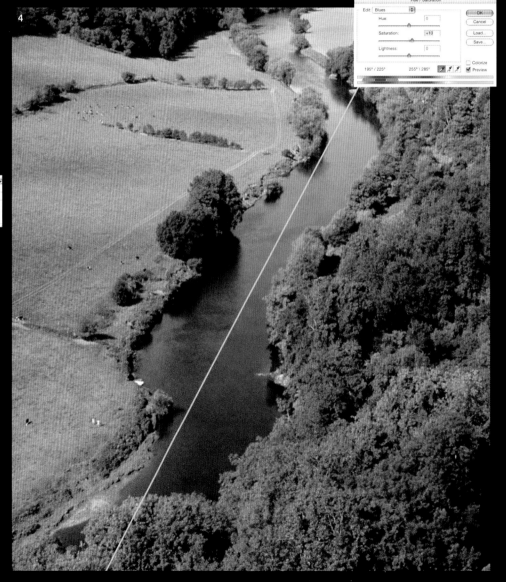

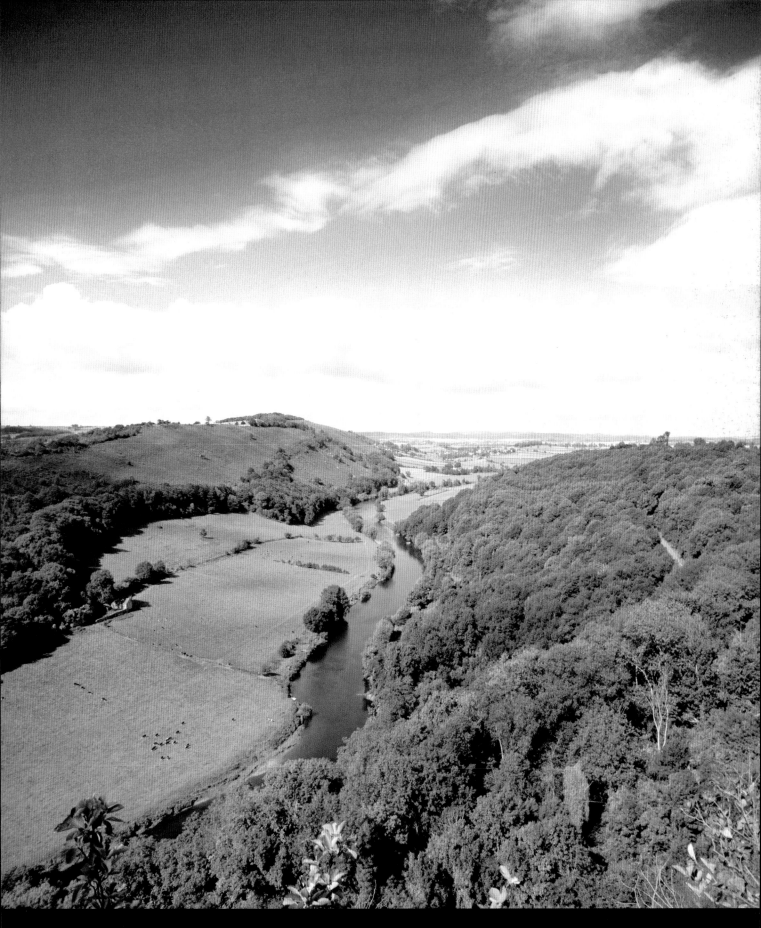

Panoramic Cameras

There are many panoramic cameras on the market today, quite a few of which have found favour with landscape photographers. Although there are some superb digital panoramic cameras available, such as the SpheroCam and the Panoscan, these are likely to be out of the average photographer's price range.

As seen on pages 114–117, it is possible to stitch together shots to make a panoramic picture. However, with a panoramic camera such a picture is possible in a single image.

There are two main types of panoramic camera: in one, the lens actually moves across the scene, much like a scanner, while the other uses a fixed wide-angle lens. The two most common film sizes with the latter are 35mm and 120. The Hasselblad Xpan uses 35mm film and produces a negative that measures 24 x 65mm. It can also shoot conventional-sized 35mm negatives – 24 x 36mm – even in mid-roll, and has three interchangeable lenses: 30, 45 and 90mm. Using the 30mm lens in the panoramic mode, a 94° angle of view is achieved.

The Fuji GX617 is a very different kettle of fish; it is a bulky panoramic camera that produces a negative that measures 6 x 17cm on 120 film. This means that you only get four shots per roll. With the 90mm lens, it can produce images with an 89° angle of view. The Widelux F8 has a rotating lens and produces an image size of 24 x 59mm on 35mm film. When used with the 26mm lens, an angle of view of 140° can be achieved.

With all these cameras, the best results are taken when they are mounted on a tripod; for this reason, they all have built-in spirit levels so that you can be sure that the camera is completely level in both an horizontal and a vertical direction.

Whatever type of panoramic camera you use, it takes practice to get the best result – one common fault when using a camera with such a wide angle of view is a tendency to include a great deal of unwanted foreground detail; exposure also can be tricky, as the light can vary considerably from one side of the frame to the other.

Opposite: A panoramic camera takes a much wider angle of view than does a normal 35mm camera. This shot was taken on a Hasselblad Xpan camera, which takes a negative or transparency that measures 24 x 65mm, as opposed to the standard 35mm format, which is 24 x 36mm.

Below: I took this shot over the Great Barrier Reef on a 35mm SLR camera fitted with a 28mm wide-angle lens. In normal circumstances it could be viewed as a perfectly good shot.

Right: However, when you compare it to virtually the same view taken on the Hasselblad Xpan camera, as here, it turns into a pale version of the shot. Note how much more foreground there is with the panoramic shot. It's not just a case of getting in more detail – the entire shot has more depth and immediately catches the eye.

Overleaf: These two shots illustrate the grand sweep that can be obtained when using a panoramic camera. Nevertheless, it takes a certain amount of practice to gain the skill required to use one of these cameras. At the outset, it's easy to be overwhelmed by the field of view without noticing that you have included lots of unwanted detail. As with all equipment, only continual use and experience can lead you to getting the best results every time.

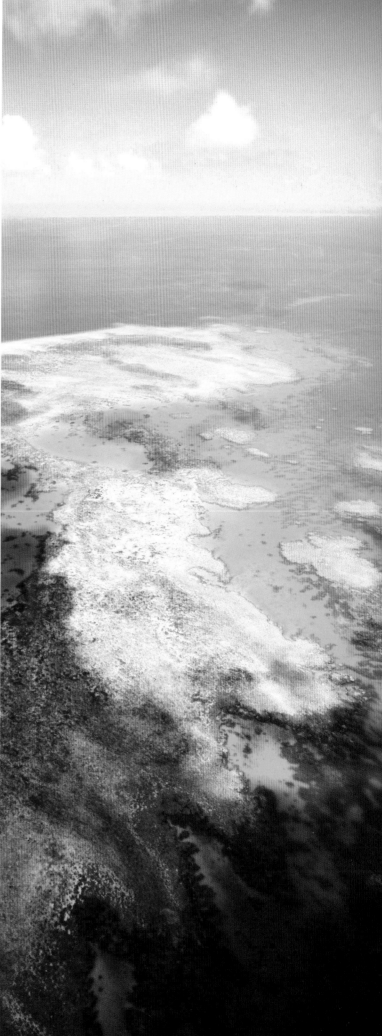

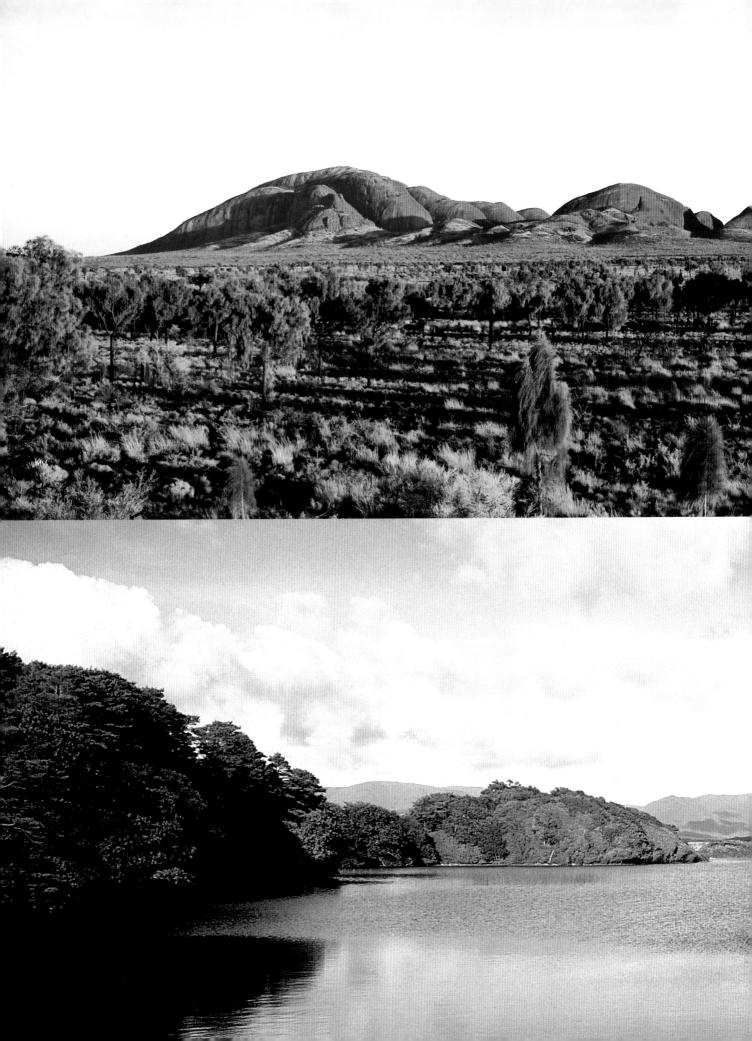

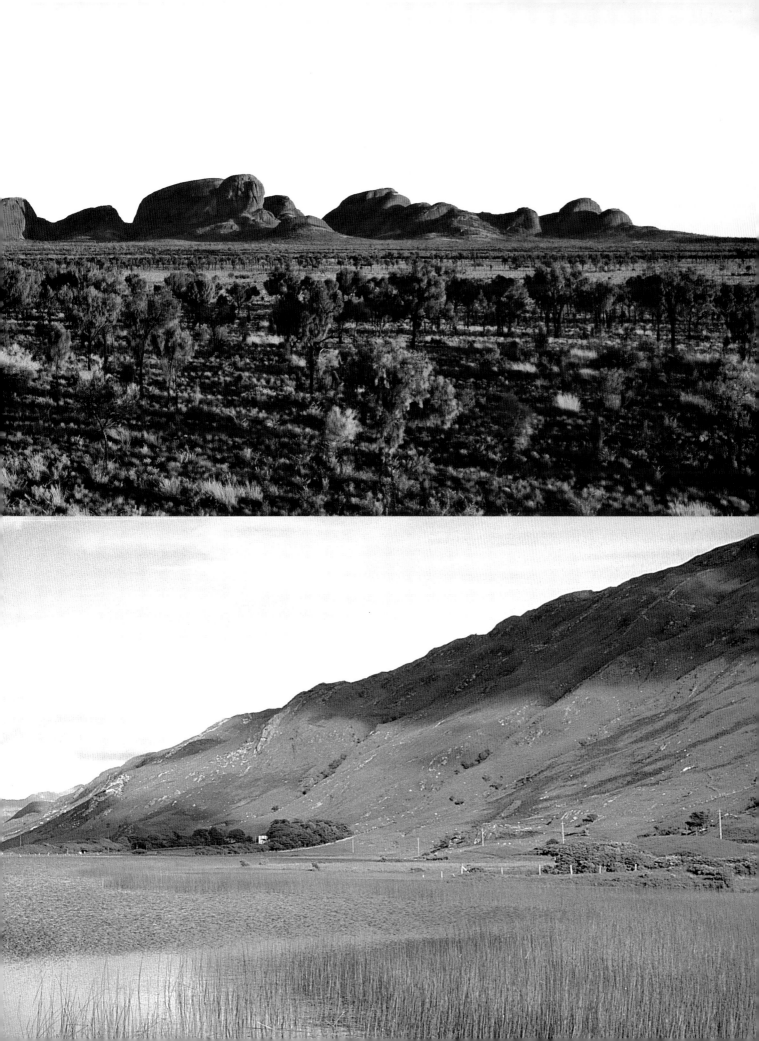

Aerial Shots

Probably the best means of getting effective aerial pictures is from a helicopter. When I shoot in this way, I always arrange for the door to be taken out so that I have an uninterrupted view, and I do not have to shoot through the window, which might give trouble with focusing or flare.

Although this way of working may sound scary, it is surprising how easily you get used to it and quickly realise that the forces of gravity hold you in your seat even when the craft banks steeply. If you do use this method, you need to make sure that your camera is securely fastened, not for the obvious reason that you might drop it – with perhaps fatal consequences if it hit anyone on the ground – but if you were to drop the camera and it hit the rear rotor of the helicopter, the pilot would completely lose control.

The reason I like helicopters so much is that they are so manoeuvrable and that you can get the pilot to hover, bank, go higher/lower and circle your subject with relative ease. If you

miss the best position in a hot-air balloon, for instance, then it is gone forever. Gliders and planes are more manoeuvrable, but they can't hover and do not allow the same uninterrupted view as a helicopter with its door off does.

Whatever method you use, the one thing that all aerial shots have in common is that you need to shoot at a relatively fast shutter speed. This is because helicopters and other flying craft generate a good deal of vibration, which results in blurred images at slow shutter speeds. Therefore you should use a reasonably fast film; if your digital camera has a variable ISO setting, adjust this to a higher speed setting.

If you are taking pictures through the window of an aircraft, keep the lens pressed up against the glass to stop the lens reflecting in the window. Switch off the auto-focus, as the window may confuse the camera as to what it should be focusing on. The same is true with built-in flash: if this fires when you take your shot, it can flare over the glass and ruin what could be a great photograph.

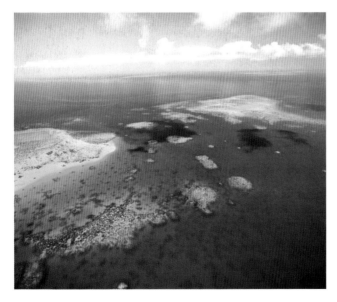

Above: I took this shot from a helicopter, flying at 1,000 feet over the Great Barrier Reef. Because of the vibration I used a shutter speed of 1/1,000th second @ f2.8 to keep the shot sharp. If I had not had a polarizing filter fitted, I would have increased the speed to 1/4,000th second @ f2.8.

Above right: Although this is a perfectly straightforward shot, taken with the camera set on 100 ISO and at 1/1000th second @ f2.8, and a 28mm wide-angle lens, I like it because of its special qualities. It has the feel of having been taken from a greater height than it actually was, and even the clouds look an impressive distance below.

Opposite: I always felt that this shot, taken over the Canyon De Chelly, made a great pattern on the world's surface that could be mistaken for a hieroglyphic. It is, in fact, a field of maize growing in the arid desert. Towards the bottom right it is just possible to make out a farmer on horseback herding his sheep.

Overleaf: While most people watch an in-flight movie, I just can't stop looking out of the window. It never fails to amaze me what you can get when you press your camera up against the cabin window: I took this shot on a regular domestic flight over the Great Australian Desert at 35,000 feet, and the detail of the dried-up river bed is astonishing.

Infrared

Originally used for medical photography, infrared film is available in both colour and black and white versions. When used in 35mm cameras, the results differ somewhat from conventional film.

With colour infrared film, strange and surreal colours, which look quite at odds to what we are used to seeing, can be produced – for instance, the foliage of plants and trees is more likely to reproduce with a magenta hue than the green that we are accustomed to. With infrared black and white film, daytime begins to look like a night time scene lit by the moon, but some foliage can appear white, making the overall appearance reminiscent of an old Hollywood horror movie.

There are certain difficulties when using infrared film, but with experimentation and a methodical working plan, the rewards are well worth it. Because infrared reacts to light coming from the invisible wavelengths of the spectrum, it is not possible to take an exposure meter reading, as normal ISO speed values do not apply; this means that before you can take shots with a

certain level of confidence, a period of trial and error is almost certain to be necessary.

Kodak produce an EktachromeH film called Infrared EIR, where the infrared sensitivity is from 700 to 900nm; although it is not possible to say what the results will definitely look like, it is possible that a shot of a red building surrounded by green trees will appear with magenta-coloured trees, a greenish building and a blue-green sky. You also need to use a Wratten No. 12 filter. With the black and white version, HIE, Kodak recommend that a Wratten No. 25 is used.

It is possible to take effective infrared pictures with some digital cameras. The preliminary step is to see whether your digital camera can capture infrared light in the first place. There is a simple test you can do to find this out: point your television's remote control at the camera and press one of its function buttons. If you can record its LED when it lights up, it is possible to take infrared shots, providing you use the correct, quite opaque filter – for instance, a Wratten No. 87, 87C, 87B or 88A.

Above: These two shots were taken on Kodak EIR film. This needs to be handled with great care, and your camera must be loaded and unloaded in complete darkness; failure to do this will result in the film appearing to be fogged, ruining the infrared effect. I shot the image on the left without a filter, and all the foliage has turned purple. In the shot on the right I used a Kodak Wratten 87 filter. At first glance this filter appears to be completely black and is impossible to see through, so you need to set up your shot and focus the camera manually – to the infrared setting on the focusing ring – before placing the filter over the lens.

Opposite: I shot these pictures using a digital camera. The shot above was taken conventionally, and the scene appears how one would expect it to, with the foliage of the trees recording green. For the shot at the bottom I chose the camera's black and white mode and placed a Kodak Wratten 88A filter over the lens. This captured the scene in much the same way as if I had shot it on conventional black and white infrared film: at first it looks as though it is a negative, but the shadows of the trees are black and the sky is dark, while the clouds are white.

Overleaf: This is one of my favourite digital infrared shots; it has the feeling of time standing still. Like the lower shot (right), you could be fooled into thinking that it was a negative image, but then the tyres on the pick-up would be white and the sky light.

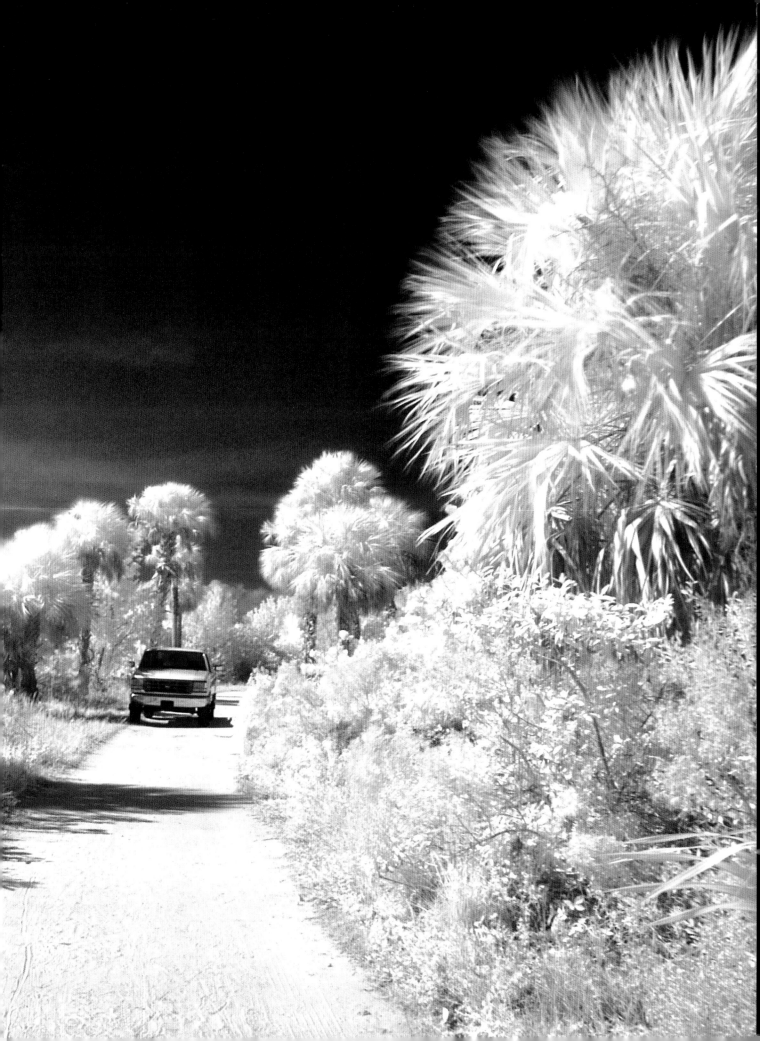

Close-ups

In addition to taking the big view or panorama, there is much that you can find in landscapes that lends itself to being photographed as a close-up, such as the detail in rocks, tree trunks and flowers, or detail that can be found in sand and soil.

Close-ups are fascinating, and there is something captivating in seeing an object enlarged so that its structure takes on a new dimension. Sometimes this enlargement can take on an abstract form and create patterns that are worthy of being printed and displayed for their own beauty; in other cases, the magnification shows us the delicate detail not apparent to the naked eye.

The best method is to use a macro lens, which enables you to get as close as 1–2 ft (30–50cm) to your subject. Strictly speaking, a macro lens should allow you to photograph a subject lifesize - to get closer than this means using extension tubes or bellows. If it is not possible to fit these to your camera, you can use a close-up lens, which fits onto the camera's lens much like a screw-in filter. However, the quality of these lenses is not always the best.

Extension tubes are light and easy to carry around with the rest of your kit when shooting landscapes. They fit between the camera's body and the lens, and are available in various sizes – for example, in sets of two or three – that allow different extents of magnification. Tubes can be used individually or in various combinations; whatever combination you choose the magnification is fixed, while extension bellows have variable magnification and are more versatile in their application. That said, they are not as rugged as tubes and can be damaged.

When shooting this close, the depth of field is minimal, and it is best to work at a small aperture, such as f16 or f22. It can be difficult to focus accurately, and you may find it better to focus the lens to its full extent and then move the entire camera backwards and forwards until the subject is sharp. Of course there may be situations where you still want minimum depth of field, in which case it is essential to use a tripod.

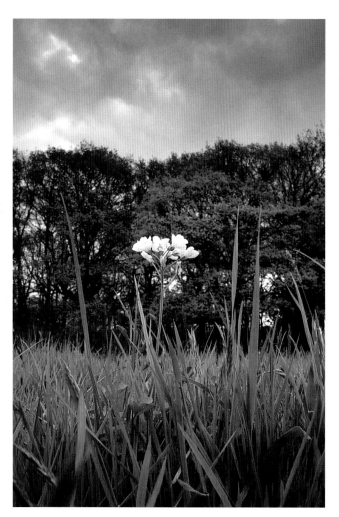

Left: For this shot I needed to lie on my stomach so that I could be as low as possible. I used a 50mm lens with a No. 2 extension tube and supported the camera on a mini-tripod. Because I wanted as much of the shot in focus as possible, I focused on the grass and stopped down to f22.

Opposite: There is so much in any landscape that will make effective close-up shots, as these examples show. The one thing that they all have in common is that they were shot with the camera supported by a tripod, using either a No. 1 or No. 2 extension tube.

Opposite: This close-up of a Saguaro cactus, common in the Sonoran Desert, Arizona, shows the weathered appearance of its outer skin. Shooting this close can give many plants and rocks an abstract quality. With this type of shot, sharpness is essential, and I always use a tripod.

Right: I used a 200mm telephoto lens and a No. 2 extension tube to take this shot of a cactus flower. This combination, together with a wide aperture of f2.8, means that very little is in focus. This draws our eye to the tip of the flower, which can be seen in detail, while the rest of the shot falls out of focus the further it recedes from the camera.

Retouching

No matter how careful you are with your transparencies or negatives, it is possible that some of them can become scratched or damaged. This is why it is so important to keep all your equipment in good working order.

Dust or grit on the inside of a camera can scratch a film along its entire length, causing every shot to be damaged. When using 35mm film, if you do not keep the cassette in its container before and after exposure, dust or grit can get onto the fabric of the opening and cause irreparable damage.

Another possible hazard is that liquid can get spilt over your film and cause damage to the image, even after rewashing. Grease is yet another problem, along with the ultimate damage, which is when a negative or transparency gets torn.

If an original negative or transparency has been lost and you only have a print that has been creased, torn and faded, not long ago this would have meant re-photographing the print and producing further copies from it. However, without spending many hours hand-retouching the new print (which would have

had to be photographed again if you wanted more than one print, thereby reducing the quality still further), you were left with a new version of the damaged image. On a computer it is now possible to scan prints, negatives or transparencies and retouch them by using a program such as Photoshop.

In addition to restoring original pictures to their former glory, you may also want to retouch a landscape photograph for different reasons, for example when an unsightly telegraph pole or pylon spoils the view. Something that you did not see in the first place, such as a waste bin, a road sign, or just irritating branches or other foliage, can be retouched out with relative ease on the computer. If people should comment that this is manipulation, you can point out that landscape painters have taken this approach for years and practically no one has criticized them for it. (In fact, the case could be argued that because painters presented such a rosy view of their surroundings, we have lost sight of so many of the negative aspects of life in previous centuries.)

Retouching

1. I had to take this shot quickly as the light was changing rapidly and what there was would soon be gone. Later, when I looked at it I thought it left a lot to be desired, not least the foreground, which was quite untidy. I decided that I would retouch it to improve on what was there.

2. To begin, I masked out the cacti and those parts of the distant mountains that I could see. I then inverted it and saved the selection.

3. With the cacti, mountains and blue portion of the sky masked, I made, on another layer, a gradient of the colours that I wanted to cover the unwanted branches, imitating as far as I could, the colours of the sky

found in the original image. As this was on another layer, it was easy to delete parts of the gradient covering the sky.

4. I made a layer below the first sky gradient and drew another gradient to give the effect of mist rising off the plane. This gave a good effect, except that the horizon line was a bit rigid.

5. I corrected this using the Gaussian Blur filter. Throughout this procedure the cacti remained untouched because they were still masked out. Finally, I added a warm tone to the mountains using the Hue/Saturation adjustment.

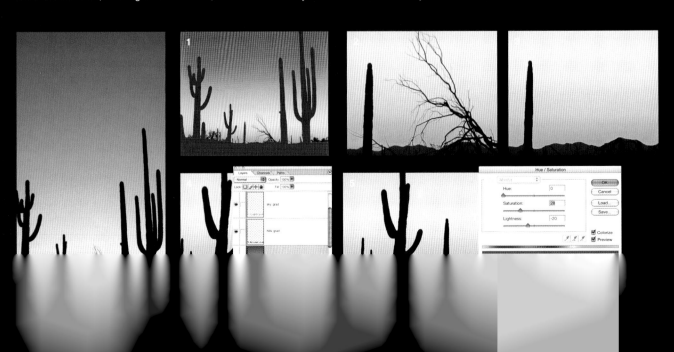

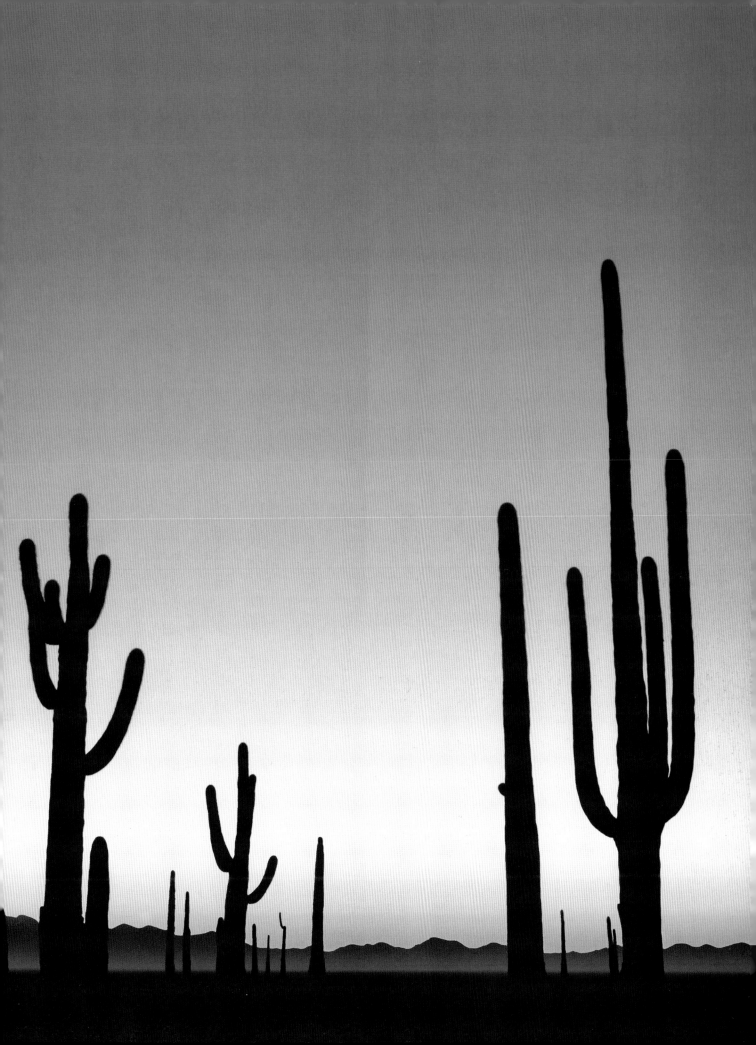

Transparency restoration

No matter how careful you may be with your transparencies and negatives, some are bound to get dirty, scratched and faded over time. Nevertheless, once they have been scanned and downloaded into the computer you can restore them – or even improve them.

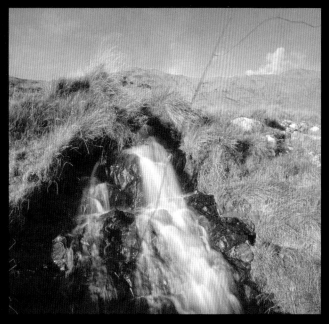

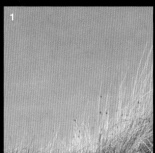

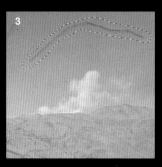

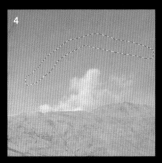

1&2. My first step was to remove the dust and scratches. To do this I used the Dust and Scratches filter. When you do this you need to be careful as you can ruin the texture in other parts of the image. For instance, grass can be a problem because the filter might interpret this as scratches. It is best to work on a small area of flat texture, such as the sky, where these imperfections are more visible.

3&4. To remove the big scratch I used the Clone tool. This allows you to select an area of texture and paint that over the damaged area. It is a much more controllable tool than the Patch/Healing Brush.

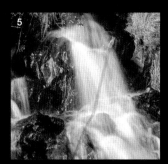

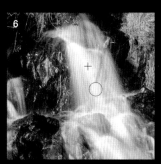

5&6. However, the Patch/Healing Brush can be used as an alternative. The technique here is to draw a selection around the area that needs patching and then move this to an area of undamaged texture to be used for the repair. The computer then blends the new area into the old area.

7&8. Because the original was a bit faded, I used Curves to add contrast. Although the effect is similar to Levels, this allows greater control. Finally, to colour-correct the sky, I used the Selective Colour command, which enabled me to remove the magenta cast from the clouds.

Opposite: The finished image looks better than the original!

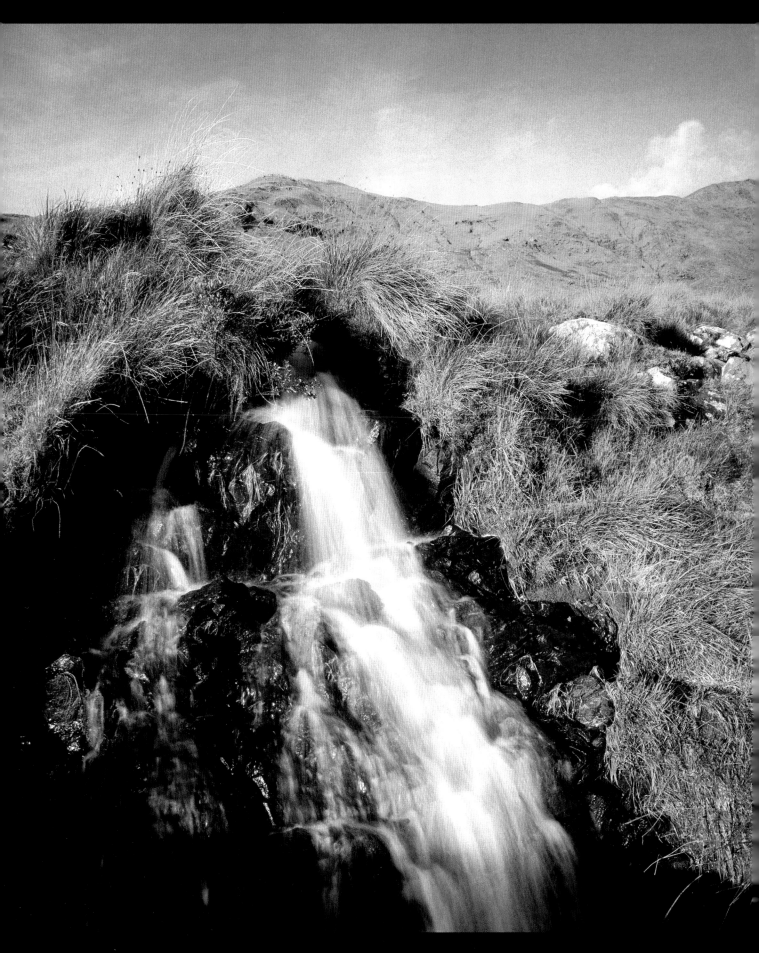

Digital Toning

As photographic computer technology progresses at an ever-increasing pace, you can now use computers, combined with the latest inkjet printers, to act as a digital darkroom, one that is capable of producing prints that surpass anything that can be produced in a traditional wet darkroom.

Of course there are always diehards or traditionalists who argue otherwise and dismiss computers as merely manipulation, needing the minimum of skill. But ever since the first sepia-toned print was created, photography has been about manipulation, and as such is no different from other art forms.

As for needing the minimum of skill, high-end digital printing requires skills far in excess of traditional wet darkroom techniques, which have always had limitations, as there are a finite number of processes that involve one or more chemicals reacting with the print. For this reason alone, digital comes out on top, as darkroom chemicals are incredibly harmful to the environment, whereas digital work is virtually pollution-free.

Digital image processing gives you a great deal of scope and is limited only by your imagination, as you can preview each image to ensure that it is exactly how you want it before making the final print. This does not mean that a digital print is inferior or has less value placed on it – in fact, results are now achievable that a few years ago would have been simply impossible to create or hazardous to health, due to exposure to chemicals.

Many images produced on computers mimic established darkroom techniques, probably because this is what we are used to seeing, but as more people discover and experiment with digital imaging, new standards are bound to evolve and become a natural extension to the photographer's repertoire.

In addition to toning original colour or black and white images, you can also emulate old hand-colouring techniques. Whereas a toned print has an overall effect, as either a duotone, tritone or quadtone, hand-coloured prints can be selectively toned, and individual areas of the image can be given different treatments for contrasting effects.

Digital toning

It is not necessary to start with a black and white picture when producing monochrome images on a computer.

1. Although this is a perfectly acceptable shot, I felt a lot more could be achieved if it were converted to black and white. I used Photoshop Curves to adjust the tones and colour. The curve is plotted on a grid; by default it is a straight line. The bottom left point represents the brightest part of the image and is known as the D-min or the point of minimum density. The top right point is the darkest part of the image, or D-max. Any point between these can be clicked on and dragged with the mouse. The image becomes brighter if pulled down and darker if pushed up. By default the Curves dialog box opens with all the colours (RGB) selected; this means that you alter all the colours together, and only the brightness is adjusted.

2. The image has been converted to black and white but looks very flat because it lacks contrast. You can increase the contrast by clicking and dragging the Curves tool until the desired effect has been achieved.

3. I added contrast using the Curves command. You can also use the Unsharp Mask tool to do this by applying a low amount with a high radius.

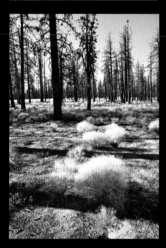

4. I used Curves in the red channel to obtain a lith effect. I then introduced red in the highlights and cyan in the shadows. Lith prints are quite grainy, so I added noise to create grain.

5. To introduce a sepia tone I used the Hue/Saturation control. The Hue slider selects the colour (or chroma), and the Saturation controls the intensity of the colour. For a toned print it is best to keep the Saturation low.

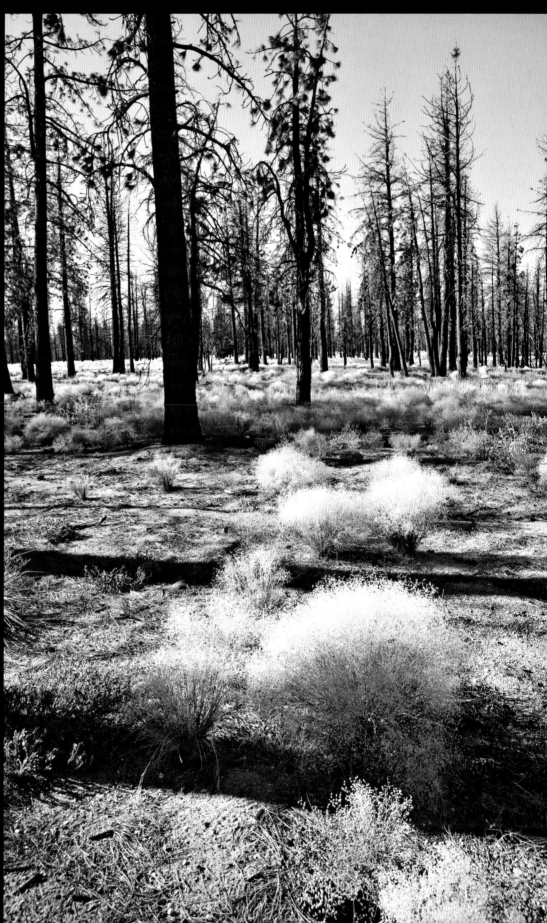

Selective toning
I thought this old shot of Bodiam Castle in Sussex would provide
a good basis for selective toning.

1. I used the techniques described on pages 142–143 to mask off
different areas of the image. To these I added flat colour, each new
one being on a different layer.

2. I then dropped the opacity of the colour to allow the original image to
show through. The light areas of the image need less opacity than the
dark areas.

3. By changing the Layer mode to Overlay, the colour takes on the
tonality of the image.

4. I now raised or lowered the opacity of the colours to get the effect that
I thought looked best. The result opposite is a selectively toned shot
which, unlike the techniques used in the wet darkroom to achieve similar
results, can be saved and printed many times.

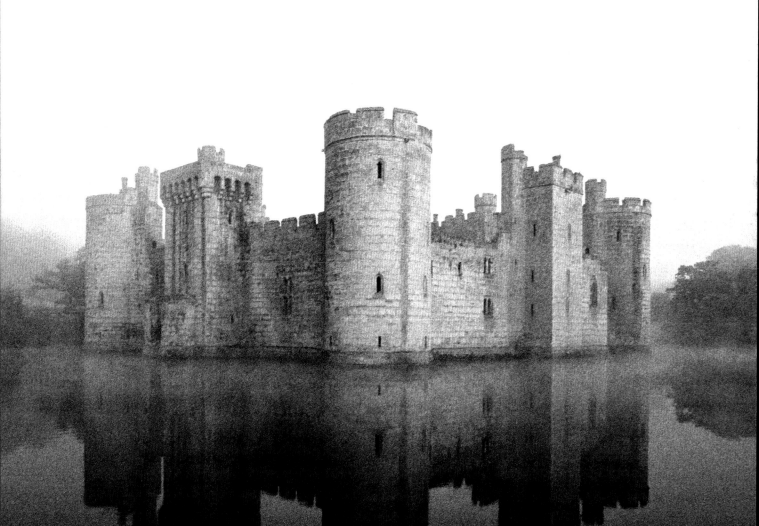

Abstracts

In addition to taking photographs of instantly recognizable landscapes, correctly exposed, composed and printed, you have at your disposal many other photographic possibilities that lend themselves to making fine abstract images of landscapes.

Although some of these shots may be "straight" or unmanipulated photographs, the nature of the subject and the way it has been presented make the results non-representational. The use of strong areas of colour and a degree of draughtsmanship within their composition give many of these pictures a "painterly" feel.

Such abstract landscape pictures can be something as simple as a reflection in a puddle or lake, or a wet area of ground. When you focus on an area such as this to obtain a reflected image and use the auto-focus mechanism, your camera may have difficulty focusing on the reflection and instead may focus on the surface of the wet area. In this case, it is best to turn off the auto-focus and focus manually.

Another way to create an abstract landscape is to photograph deliberately out of focus and with minimum depth of field; as before, it is best to turn off the auto-focus. This method softens the edges of your shot and, depending on the degree of focus, slightly blurs the image, creating a watercolour effect.

Zooming the lens while taking your shot is another method of producing an effective abstract landscape image. This is best done with the camera on a tripod and a shutter speed of about 1/8th second. As soon as you depress the shutter button, adjust the lens's focal length smoothly throughout its range.

Even when you have taken a "straight" landscape shot, the possibilities for abstraction are endless once you have downloaded it into the computer or scanned your transparency or negative. However, it is important to have an idea of the type of image you want to create before you start, otherwise you run the risk of ending up changing a good landscape shot into an unsightly, garish image.

Left: Many landscape features lend themselves to being shot in an abstract fashion. This could be as simple as the light playing on the sea, as here. I had the camera on its manual focus setting, and deliberately put the lens out of focus to highlight the waves.

Below and opposite bottom: Computers provide endless possibilities for creating abstract images out of straight photographs. I downloaded the shot below into Photoshop and used one of the many filters in the program to create an almost painterly effect, which is well suited to this particular shot.

Opposite top: This is an image of a house reflected in water. After I had taken the shot I cropped out all the detail above the river, which was sharp. I then turned the picture upside down so that the house appears to be the correct way up.

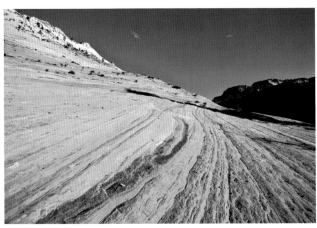

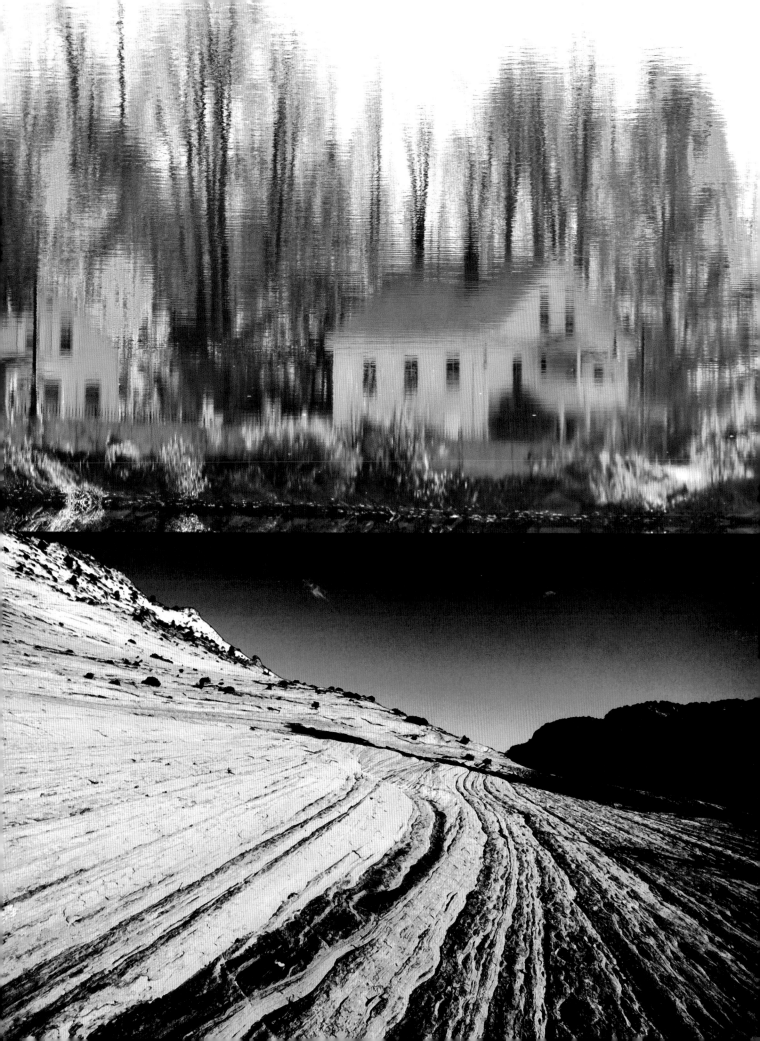

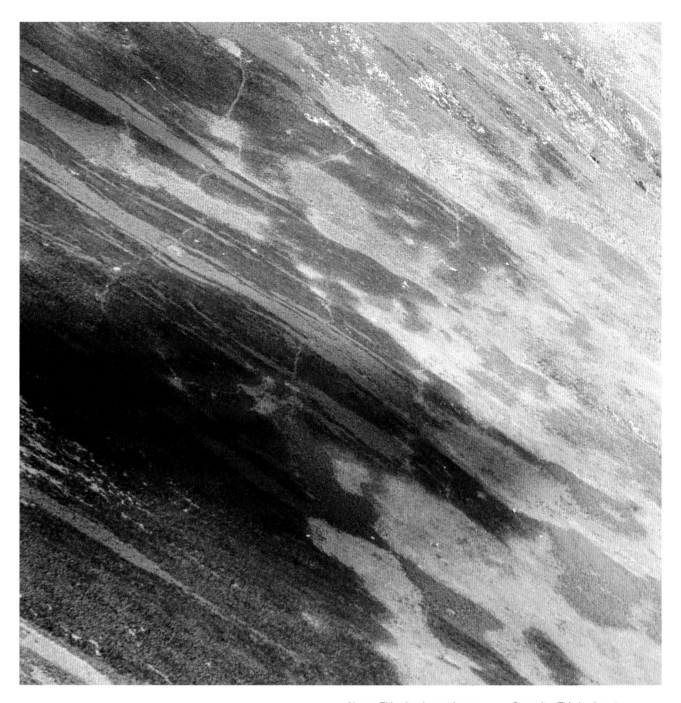

Above: This shot is one from a series I created on hillsides. I used a 400mm telephoto lens and took the shot from the hill on the opposite side of the valley. This meant that I could crop in close on a small section, which made the vegetation undefined in its appearance but abstract in its quality.

Opposite: This is almost a similar effect, except that this is the sky instead of land – the sun had set and the sky had taken on a swathe of subtle hues. At this time of day you need to work quickly, as the light fades fast and lasts just a few minutes.

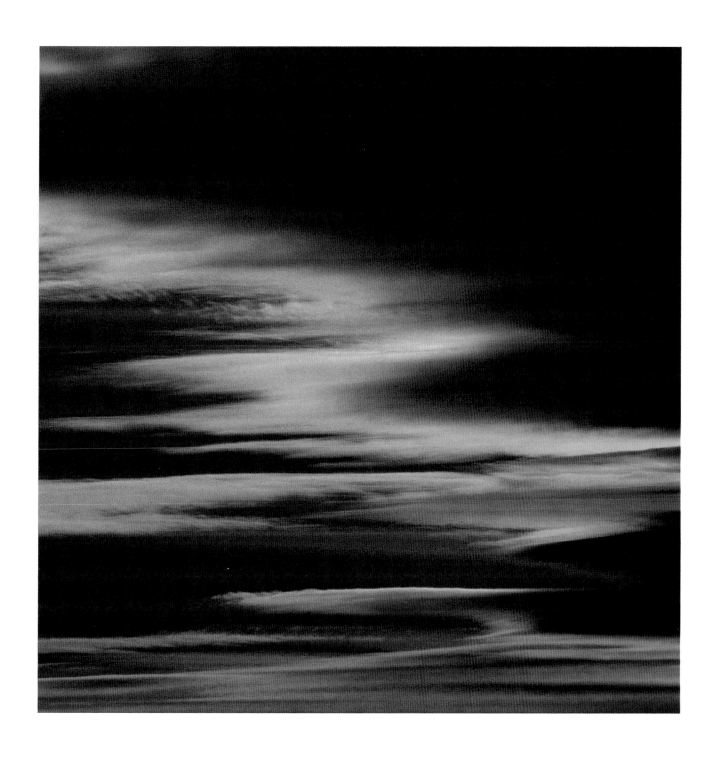

Glossary

Alpha Channel
Extra 8 bit greyscale channel in an image, used for creating masks to isolate part of the image.

Analogue
Continuously variable.

Aperture
A variable opening in the lens determining how much light can pass through the lens on to the film.

Aperture Priority
A camera metering mode that allows you to select the aperture, while the camera automatically selects the shutter speed.

Apo Lens
Apochromatic. Reduces flare and gives greater accuracy in colour rendition.

APS
Advanced Photo System.

ASA
American Standards Association; a series of numbers that denotes the speed of the film. Now superseded by the ISO number, which is identical.

Anti-aliasing
Smoothing the edges of selection or paint tools in digital imaging applications.

Auto-focus
Lenses that focus on the chosen subject automatically.

B Setting
Setting on the camera's shutter speed dial that will allow the shutter to remain open for as long as the shutter release is depressed.

Back Light
Light that is behind your subject and falling on to the front of the camera.

Barn Doors
Moveable pieces of metal that can be attached to the front of a studio light to flag unwanted light.

Between The Lens Shutter
A shutter built into the lens to allow flash synchronization at all shutter speeds.

Bit
A binary digit, either 1 or 0.

Blooming
Halos or streaks visible around bright reflections or light sources in digital pictures.

BMP
File format for bitmapped files used in Windows.

Boom
An attachment for a studio light that allows the light to be suspended at a variable distance from the studio stand.

Bracketing
Method of exposing one or more frames either side of the predicted exposure and at slightly different exposures.

Buffer RAM
Fast memory chip on a digital camera.

Byte
Computer file size measurement.
1024 bits=1 byte
1024 bytes=1 kilobyte
1024 kilobytes=1 megabyte
1024 megabytes=1 gigabyte

C41
Process primarily for developing colour negative film.

Cable Release
An attachment that allows for the smooth operation of the camera's shutter.

Calibration
Means of adjusting screen, scanner, etc, for accurate colour output.

Cassette
A light-tight container for 35mm film.

CC Filter
Colour Correction Filter.

CCD
Charged Coupled Device. The light sensor found in most digital cameras.

CDR
Recordable CD.

CD-ROM
Non-writable digital storage compact disk used to provide software.

CDS
Cadmium sulphide cell used in electronic exposure meters.

Centre-weighted
TTL metering system which is biased towards the centre of the frame.

Cloning
Making exact digital copies of all or part of an image.

Clip Test
Method of cutting off a piece of exposed film and having it processed to judge what the development time should be of the remainder.

CMYK
Cyan, magenta, yellow and black colour printing method used in inkjet printers.

Colour Bit Depth
Number of bits used to represent each pixel in an image.

Colour Negative Film
Colour film which produces a negative from which positive prints can be made.

Colour Reversal Film
Colour film which produces positive images called transparencies or slides.

Colour Temperature
A scale for measuring the colour temperature of light in degrees Kelvin.

Compact Flash Card
Removable storage media used in digital cameras.

Compression
Various methods used to reduce file size. Often achieved by removing colour data (see JPEG).

Contact Sheet
A positive printed sheet of a whole processed film so that selected negatives can be chosen for enlargements.

Contrast
Range of tones in an image.

CPU
Central Processing Unit. This performs all the instructions and calculations needed for a computer to work.

Cross-processing
Method of processing colour film in different developers, ie colour reversal film in C41 and colour negative in E6.

Cyan
Blue-green light whose complementary colour is red.

Dark Slide
A holder for sheet film used in large format cameras.

Data
Information used in computing.

Daylight Balanced Film
Colour film that is balanced for use in daylight sources at 5400 degrees Kelvin.

Dedicated Flash

Method by which the camera assesses the amount of light required and adjusts flash output accordingly.

Default

The standard setting for a software tool or command, which is used by a computer if settings are not changed by the user.

Depth of Field

The distance in front of the point of focus and the distance beyond that is acceptably sharp.

Dialog Box

Window in a computer application where the user can change settings.

Diaphragm

Adjustable blades in the lens determining the aperture size.

Diffuser

Material such as tracing paper placed over the light source to soften the light.

Digital Zoom

Digital camera feature that enlarges central part of the image at the expense of quality.

DIN

Deutsche Industrie Norm. German method of numbering film speed, now superseded by ISO number.

Download

Transfer of information from one piece of computer equipment to another.

DPI

Dots Per Inch. Describes resolution of printed image (see PPI).

DPOF

Digital Print Order Format.

Driver

Software that operates an external or peripheral device.

DX

Code marking on 35mm film cassettes that tells the camera the film speed, etc.

E6

Process for developing colour reversal film.

Emulsion

Light sensitive side of film.

EV

Exposure Value.

EVF

Electronic View Finder found in top-quality digital cameras.

Exposure Meter

Instrument that measures the amount of light falling on the subject.

Extension Bellows

Attachment that enables the lens to focus at a closer distance than normal.

Extension Tubes

Attachments that fit between the camera and the lens to allow close-up photography.

F Numbers

Also known as stops. They refer to the aperture setting of the lens.

Feathered Edge

Soft edge to a mask or selection that allows seamless montage effects.

File Format

Method of storing information in a computer file such as JPEG, TIFF, etc.
Film Speed
See ISO.

Filter

A device fitted over or behind the camera lens to correct or enhance the final photograph. Also photo-editing software function that alters the appearance of an image being worked on.

Filter Factor

The amount of exposure increase required to compensate for a particular filter.

Firewire™

High-speed data transfer device up to 800 mbps (mega bits per second), also known as IEEE 1394.

Fisheye Lens

A lens that has an angle of view of 180 degrees.

Fixed Focus

A lens whose focusing cannot be adjusted.

Flag

A piece of material used to stop light spill.

Flare

Effect of light entering the lens and ruining the photograph.

Flash Memory

Fast-memory chip that retains all its data, even when the power supply is switched off.

Focal Plane Shutter

Shutter system that uses blinds close to the focal plane.

Fresnal Lens

Condenser lens that aids focusing.

Fringe

Unwanted border of extra pixels around a selection caused by the lack of a hard edge.

Gel

Coloured material that can be placed over lights either for an effect or to colour correct or balance.

GIF

Graphic file format for the exchange of image files.

Gobo

Used in a spotlight to create different patterns of light.

Grain

Exposed and developed silver halides that form grains of black metallic silver.

Greyscale

Image that comprises 256 shades of grey.

Hard Drive

Computer's internal permanent storage system.

High Key

Photographs where most of the tones are taken from the light end of the scale.

Histogram

Diagram in which columns represent frequencies of various ranges of values of a quantity.

HMI

Continuous flicker-free light source balanced to daylight.

Hot Shoe

Device usually mounted on the top of the camera for attaching accessories such as flash.

Incident Light Reading

Method of reading the exposure required by measuring the light falling on the subject.

Internal Storage

Built-in memory found on some digital cameras.

Interpolation

Increasing the number of pixels in an image.

Invercone

Attachment placed over the exposure meter for taking incident light readings.

ISO

International Standards Organization. Rating used for film speed.

Jaggies
Images where individual pixels are visible due to low resolution.

JPEG
A file format for storing digital photographs where the original image is compressed to a fraction of its original size.

Kelvin
Unit of measurement of colour temperature.

Latitude
Usable film tolerance that is greater with negative film than reversal film.

LCD
Liquid Crystal Display screen.

Light Box
A light with a diffused screen used for viewing colour transparencies.

Lossless
File compression, such as LZW used in TIFF files, that involves no loss of data or quality in an image.

Lossy
File compression, such as JPEG, that involves some loss of data and thus some quality in an image.

Low Key
Photographs where most of the tones are taken from the dark end of the scale.

Macro Lens
A lens that enables you to take close-up photographs.

Magenta
Complementary colour to green, formed by a mixture of red and blue light.

Marquee
An outline of dots created by an image-editing program to show an area selected for manipulation or work.

Mask
An 8-bit overlay that isolates part of an image prior to processing; the isolated area is protected from change. The areas outside the mask are called the selection.

Megapixel
1,000,000 pixels.

Mirror Lock
A device available on some SLR cameras which allows you to lock the mirror in the up position before taking your shot in order to minimize vibration.

Moiré
An interference pattern similar to the clouded appearance of watered silk.

Monobloc
Flash unit with the power pack built into the head.

Montage
Image formed from a number of different photographs.

Morphing
Special effect where one image changes into another.

Network
Group of computers linked by cable or wireless system so they can share files. The most common form is ethernet. The web is a huge network.

Neutral Density
A filter that can be placed over the lens or light source to reduce the required exposure.

Noise
In digital photography, an effect that occurs in low light that looks like grain.

Optical resolution
In scanners, the maximum resolution possible without resorting to interpolation.

Pan Tilt Head
Accessory placed on the top of a tripod that allows smooth camera movements in a variety of directions.

Panning
Method of moving the camera in line with a fast moving subject to create the feeling of speed.

Parallax Correction
Movement necessary to eliminate the difference between what the viewfinder sees and what the camera lens sees.

PC Card
Removable cards that have been superseded by flash cards.

PC Lens
Perspective control or shift lens.

Peripherals
Items connected to a computer, such as scanners.

Photoshop
Industry standard image manipulation package.

Pixel
The element that a digitized image is made up from.

Plug-in
Software that adds extra features to image-editing programs.

Polarizing Filter
A filter that darkens blue skies and cuts out unwanted reflections.

Power-up Time
Measure of a digital camera's speed of operation from being switched on to being ready to take a photograph.

Predictive Focus
Method of auto-focus that tracks a chosen subject, keeping it continuously sharp.

Prop
An item included in a photograph that enhances the final composition.

Pulling
Decreasing the development of the film.

Pushing
Rating the film at a higher ISO and then increasing the development time.

Quick Mask
Photoshop mode that allows a mask to be viewed as a colour overlay on top of an image.

RAM
Random Access Memory.
Rangefinder Camera
A camera that uses a system which allows sharp focusing of a subject by aligning two images in the camera's viewfinder.

Reciprocity Failure
The condition where, at slow shutter speeds, the given ISO does not relate to the increase in shutter speed.

Refresh Rate
How many times per second the display on an LCD preview monitor is updated.

Resizing
Altering the resolution or physical size of an image without changing the number of pixels.

Resolution
The measure of the amount of pixels in an image.

RGB
Red, Green and Blue, which digital cameras use to represent the colour spectrum.

Ring Flash
A flash unit where the tube fits around the camera lens, giving almost shadowless lighting.

ROM

Read Only Memory.

Saturation

The amount of grey in a colour; the more grey present, the lower the resolution.

Selection

In image-editing, an area of a picture isolated before an effect is applied; selections are areas left uncovered by a mask.

Shift and Tilt Lens

Lens that allows you to shift its axis to control perspective and tilt to control the plane of sharp focus.

Shutter

Means of controlling the amount of time that light is allowed to pass through the lens onto the film.

Shutter lag

The delay between pressing the shutter release and the picture being taken.

Shutter Priority

Metering system in the camera that allows the photographer to set the shutter speed while the camera sets the aperture automatically.

Slave Unit

Device for synchronizing one flash unit to another.

SLR

Single Lens Reflex camera.

Smart Media

Type of digital camera removable media used by some camera manufacturers.

Snoot

Lighting attachment that enables a beam of light to be concentrated in a small circle.

Spill

Lighting attachment for controlling the spread of light.

Spot Meter

Method of exposure meter reading over a very small area.

Step Wedge

A greyscale that ranges from white to black with various shades of grey inbetween.

Stop

Aperture setting on a lens.

T Setting

Used for long time exposures to save draining the camera's battery.

Tele Converter

Device that fits between the camera and lens to extend the lens' focal length.

Thumbnail

A small, low-resolution version of an image, used like a contact sheet for quick identification.

TIFF

Tagged Inventory File Format. The standard way to store digital images.

TLR

Twin Lens Reflex camera.

TTL

Through The Lens exposure metering system.

Tungsten Balanced Film

Film balanced for tungsten light to give correct colour rendition.

TWAIN

Industry standard for image acquisition devices.

Unsharp Masking

Software feature that sharpens areas of high contrast in a digital image while having little effect on areas of solid colour.

USB

Universal Serial Bus. Industry standard connector for attaching peripherals with date transfer rates up to 450 mbps (mega bits per second).

Vignetting

A darkening of the corners of the frame if a device such as a lens hood or filter is used that is too small for the angle of view of the lens.

White Balance

Method used in digital cameras for accurately recording the correct colours in different light sources.

ZIP

An external storage device which accepts cartridges between 100 and 750 megabytes.

Zoom Lens

Lens whose focal length is variable.

Index

Acknowledgements

John Freeman and Chrysalis Books would like to thank Calumet Photographic UK and Fuji UK for their assistance in the production of this book.

This book would not have been possible without the help of many people. In particular I would like to thank Alex Dow for his dedication to the project and his technical expertise, especially in the area of digital photography. There are few people who have his knowledge. I would also like to thank Chris Stone, my commissioning editor, for making it happen on time; Teresa Neenan for faultless travel arrangements through Trailfinders; Nigel Atherton and Jamie Harrison at *What Digital Camera* magazine; Gomed Jangframol; Chumsak Kanoknan; Mr Kim; Michy; Dr Nilpem Pramoth; Varan Suwanno and Vanessa Freeman for being there.